skilled work

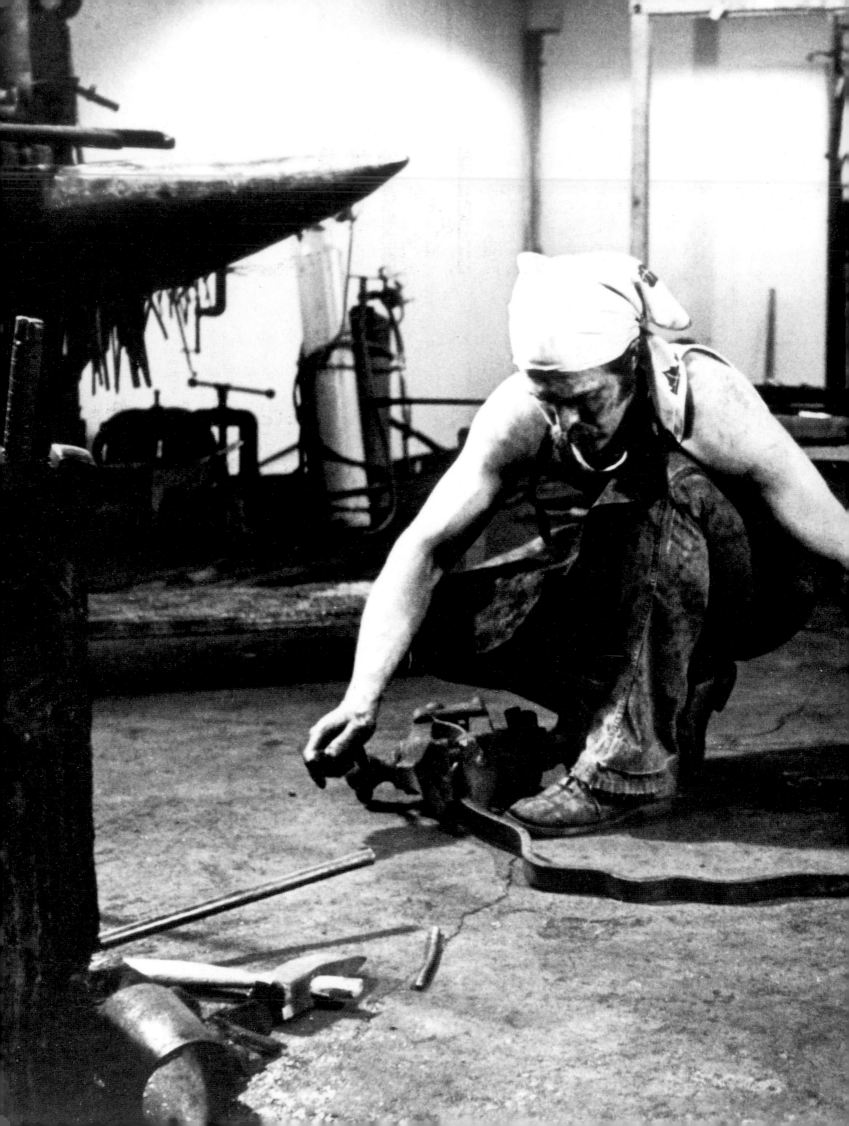

skilled work

american craft in the renwick gallery

national museum

of american art

smithsonian institution

smithsonian

institution press

washington and london

This book is dedicated to the craft artists of America,
past, present, and future.

Published by the Renwick Gallery, National Museum of American Art, Smithsonian Institution, and Smithsonian Institution Press, Washington, D.C.

Editor: Janet Wilson
Designer: Steve Bell
Project Manager: Theresa Slowik
Printed by Amilcare Pizzi, S.P.A., Milan, Italy

Front cover: Fritz Dreisbach, *Ruby Wet Foot Mongo* (detail)
Back cover: Bruce Metcalf, *Wood Necklace #11*
Frontispiece: Albert Paley at work on *Portal Gates*

ISBN 1-56098-831-2 (cloth)
ISBN 1-56098-806-1 (paper)

Renwick Gallery.
 Skilled work : American craft in the Renwick Gallery, National
 Museum of American Art, Smithsonian Institution.
 p. cm.
ISBN 1-56098-831-2. — ISBN 1-56098-806-1 (pbk.)
- 1. Renwick Gallery—Catalogs. 2. Decorative arts—United States-
-Catalogs. 3. Decorative arts—Washington (D.C.)—Catalogs.
I. Title
NK460.W3R467 1998
745'.0973'074753—dc21 - 97-32357
 CIP

The National Museum of American Art, Smithsonian Institution, is dedicated to the preservation, exhibition, and study of the visual arts in America. The museum, whose publications program also includes the scholarly journal *American Art*, has extensive research resources: the databases of the Inventories of American Painting and Sculpture, several image archives, and a variety of fellowships for scholars. The Renwick Gallery, one of the nation's premier craft museums, is part of NMAA. For more information or a catalogue of publications, write: Office of Publications, MRC 230, National Museum of American Art, Smithsonian Institution, Washington, D.C. 20560.

NMAA also maintains a a World Wide Web site at **http://www.nmaa.si.edu** and a gopher site at **nmaa-ryder.si.edu** For further information, send e-mail to **NMAA/NMAAinfo@ic.si.edu**

contents

foreword

This book, published to celebrate the twenty-fifth anniversary of the Renwick Gallery, tells how the Smithsonian Institution created a showcase for modern crafts under the auspices of the National Museum of American Art. In the 1970s this was not an obvious thing to do, and even today few museums seriously explore the intellectual excitement and profound emotional joy that crafts offer. Yet the Renwick Gallery's quarter-century of experience confirms that audiences respond immediately to the infinite formal variations and to the interplay of material and technique in these special objects.

In his essay for the book, curator-in-charge Kenneth R. Trapp describes the ambitious development of the gallery from a *kunstalle* for exhibitions to a museum dedicated to collecting, research, publications, exhibitions, and education. He traces the steps taken and partnerships created to turn the Renwick into the nation's premier study center and showcase for objects made of metal, fiber, wood, clay, and glass. As the third person to head the Renwick since its opening, Trapp discusses the achievements of his two predecessors, Lloyd E. Herman and Michael W. Monroe, whose vision and dedication to crafts helped ensure the gallery's success. His essay highlights the accomplishments of many others—the artists, curators, collectors, patrons, and scholars—who contributed to the story.

Thanks to all of these people and the expanding Renwick initiatives, crafts have emerged as a vital part of the National Museum of American Art—as central to our mission as paintings, sculptures, graphic arts, photography, and folk art. Learning the vocabulary of craft media and techniques through the Renwick's exhibitions and collections, and coming to understand the special way they tell the story of our common experience, has been one of the most rewarding aspects of my years at the Smithsonian.

The deep meaning that crafts have for all of us is discussed in the essay by Howard Risatti, professor of art history at Virginia Commonwealth University. People intuitively understand the way crafts are related to the human body. No matter how industrialized the technique used to make an object, an artist's working of glass, fiber, wood, clay, or metal evokes traditions of handcraftsmanship dating to the earliest makers of useful things. Many of the Renwick's artworks come fully to life only when they are worn, used, or held, but even when a museum setting makes this impossible, they still convey a sense of that personal experience.

Beyond these associations are deeper levels of meaning that have become embedded in traditional forms over centuries of refinement. Chalices, urns, vases, and cauldrons are vessels of transformation, like the human body itself. Sometimes a transformation takes place as one material miraculously assumes the characteristics of another. Albert Paley's *Portal Gates* translate the fibrous stalks, leafy fronds, and curling tendrils of plants into the intense language of forged steel and brass.

The emphatic materiality and significant investment in medium and technique of crafts might seem at first to preclude the philosophical ideas and layered meanings that are associated with great art. Yet technical brilliance conveys its own message of challenge, aspiration, and triumph. Wendell Castle's *Ghost Clock* is at once a very real carved block of laminated mahogany and an enigma that calls into question all existence. At first glance, it is a plain white sheet draped over a grandfather clock. A deeper look, however, reveals a shroud obscuring time and change—a symbol of what is unknowable and veiled.

The Renwick Gallery's collections and programs continue to surprise and delight viewers, as craft artists mine their elemental substances and timeless traditions for new expressions of experience. This book is both an introduction to the world of modern crafts and a compendium of favorites from the collection for those knowledgeable in the field. Since crafts are first and foremost objects rather than simply printed images, we hope the book will also serve as an invitation to become personally acquainted with the national collections at the Renwick Gallery.

Elizabeth Broun
Director
National Museum of American Art

acknowledgments

The invitation from Smithsonian Institution Press to publish this book came to us unexpectedly. A number of staff members in the National Museum of American Art gladly accepted the challenge to produce a book worthy of the Renwick Gallery's collection. I would like to thank all who are responsible for bringing this eagerly awaited book to realization. Elizabeth Broun, director of the National Museum of American Art, championed this project from the start and paved the way for its publication. Theresa Slowik, editor and head of the publications department, facilitated matters with impressive tact and kindness when faced with difficult situations. Janet Wilson edited the manuscript in a race against time, bringing clarity and grace to the writing. Steven Bell created a handsome design that harmonizes images with text, highlighting many of the beloved works of art in the Renwick.

At the Renwick Gallery the staff rallied around this project with enthusiasm. I am especially grateful to Ellen Myette, operations manager, for her thorough research into files to help me write a history of the Renwick Gallery, for assistance in selecting photographs for the book, and for arranging to bring Bruce Miller here from Rochester, New York, to photograph objects. Having worked at the Renwick more than twenty-six years, Ellen is the gallery's institutional memory. Bruce Miller understands the complexities of photographing three-dimensional objects; his stunning images are a significant contribution to this book. Marguerite Hergesheimer, museum technician, ably undertook most of the research and writing of artists' biographies, assisted by Jeremy Adamson, curator, and Christine O. Donlon, secretary. I thank Allen Bassing, public programs coordinator, and Shelly Brunner, docent and education volunteer, for their help with research.

Charles J. Robertson, deputy director of the National Museum of American Art, generously answered questions about the history of the museum and the Renwick Gallery and directed me to resources outside the NMAA. His secretary, Shelley Block, carefully searched through National Museum of American Art files to answer my queries. I am greatly indebted to Elmerina Parkman. Without her encyclopedic knowledge of the James Renwick Alliance and its history, which she shared willingly, my writing would have been seriously impeded. Marisa Keller, archivist at the Corcoran Gallery of Art, provided copious research information.

Responding liberally to our request for funding on short notice, the James Renwick Alliance provided a generous contribution of $20,000 to help move this project forward in its earliest stages.

It is perhaps folly to undertake writing the history of an institution when the people who played a key role in its development are alive. Nevertheless, I want to thank Lloyd E. Herman, Michael Monroe, Harry Lowe, Charles Eldredge, Elizabeth Broun, and Ellen Myette, all of whom graciously took the time to read my essay for accuracy. I thank them for their spirited good humor and assistance.

I am also indebted to family and friends who listened to me when that was all that was necessary. I am most grateful to Nicholas Crevecoeur, Christine Droll, Shelby Gans, Donald F. Mahan, Gretchen Mehring, Elmerina and Paul Parkman, and Eleanor and Samuel Rosenfeld for their kindness.

Kenneth R. Trapp
Curator-in-Charge

Kenneth R. Trapp

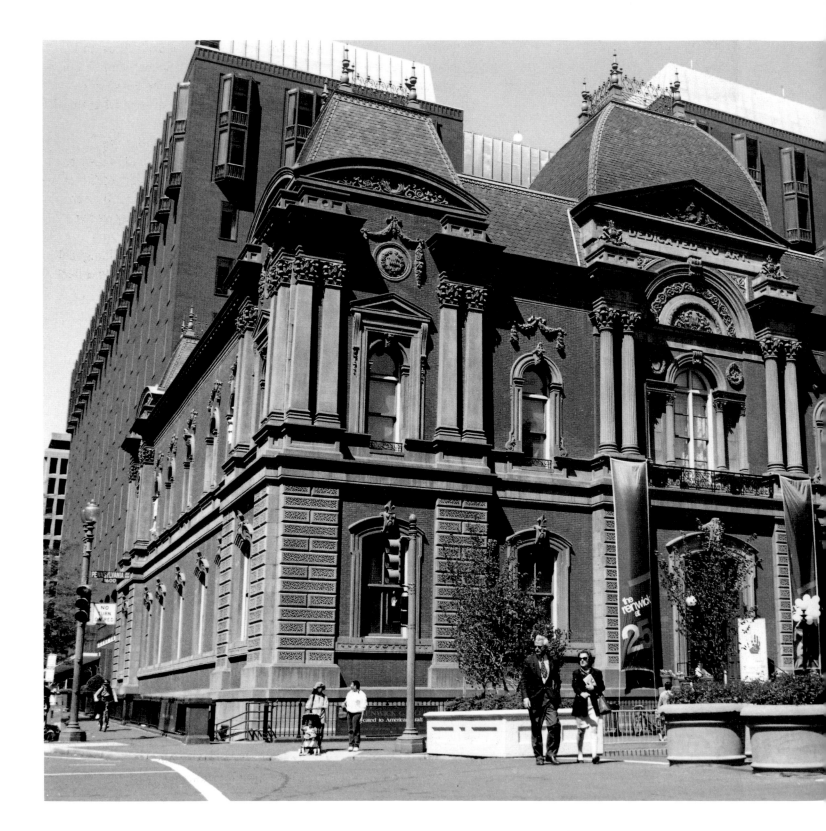

dedicated to art: twenty-five years
at the renwick gallery

A visitor to the nation's capital strolling along Pennsylvania Avenue and pausing to inspect the facade of the handsome French Second Empire building at the corner of 17th Street sees high above its entrance the simple words "Dedicated to Art." Quite reasonably the stroller assumes that this structure houses an old museum.

In truth, the Renwick Gallery is a mere youth among American art museums. Although the building that is its home was designed in 1858 to be Washington's first art museum—the original Corcoran Gallery of Art—the vicissitudes of civil war, the fickleness of personal fortune, the utilitarian needs of government, and later the ravages of long neglect conspired to mock the dedicatory words.

The Renwick Gallery, now occupying the elegantly restored building, celebrated its twenty-fifth anniversary in 1997—an appropriate time to reflect on the path it has traveled since being established.

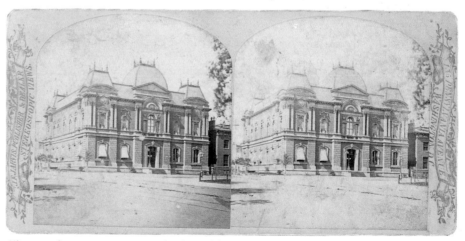

Nineteenth-century stereoscopic view of the Corcoran Gallery of Art

The Renwick Gallery is three entities in one. First, it is a curatorial department within the National Museum of American Art (NMAA). Second, the Renwick functions as a museum that collects, exhibits, studies, and preserves the finest work in American craft and design. Because the Renwick Gallery is physically separated from its parent institution by nine city blocks, the public tends to perceive it as an independent museum. Third, the Renwick is housed in a historic building that is maintained as an architectural landmark.

The Renwick Gallery, 1997

Architect James Renwick, Jr. (1818–1895)

On June 23, 1965, President Lyndon B. Johnson signed an executive order that transferred the building—then federal property that had housed the U.S. Court of Claims—to the Smithsonian Institution. In a letter to Smithsonian Secretary S. Dillon Ripley, President Johnson wrote:

> I am enthusiastic about your suggestion that the Smithsonian Institution take over the old U.S. Court of Claims Building and establish it as a gallery of arts, crafts and design.
>
> No more appropriate purpose for the building could be proposed than to exhibit, in the restored gallery, examples of the ingenuity of our people and to present exhibits from other nations, whose citizens are so proud of their arts.
>
> I would hope that tours of this Gallery might play a memorable part in the official Washington visits of foreign heads of State, offering them not only a glimpse of our art but an opportunity to enjoy the friendliness and hospitality of our people.[1]

President Johnson concluded by informing Ripley that the transfer was contingent "upon your obtaining authorization for the funds necessary to renovate the building for use as a gallery."[2]

The building, adjacent to the Blair-Lee House, was erected by William Wilson Corcoran to showcase his collection of paintings and sculptures. Renamed the Renwick Gallery in honor of its architect, James Renwick, Jr., the newest addition to the Smithsonian Institution in 1965 is the third oldest building in the Smithsonian complex. Construction began in 1859 but was interrupted in 1861 by the outbreak of the Civil War. The Renwick Gallery is predated by the Old Patent Office Building (1836–67), which houses the National Museum of American Art and the National Portrait Gallery, and by the Smithsonian building commonly referred to as the Castle, built between 1852 and 1865, also designed by Renwick.

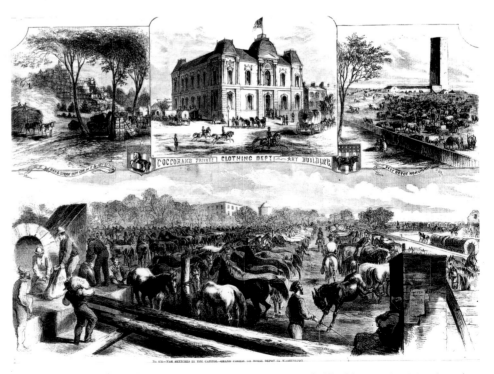

War Sketches in the Capitol—Grand Corral or Horse Depot in Washington. In 1861 when the Civil War began, the U.S. Army seized the Corcoran Gallery of Art building to use as a warehouse for the storage of uniforms and records.

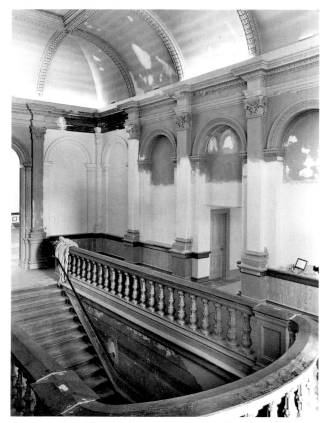

The Renwick Gallery's second-floor stairhall undergoes renovation in 1971.

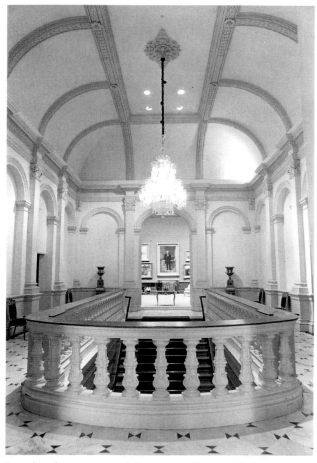

Completed renovation of the second-floor stairhall

Public and federal interest in saving the Renwick building began in the mid-1950s and intensified over the decade as the restoration of historic buildings surrounding Lafayette Square became an issue. On several occasions President and Mrs. John F. Kennedy expressed support for restoring the Renwick building, not only to protect and preserve it as a historic structure but also to maintain the residential scale and architectural integrity of Pennsylvania Avenue between 15th and 17th Streets—an expanse that defines the northern boundary of the White House grounds.

Lloyd E. Herman, who became the Renwick's first administrator in 1971, recalls that in the late 1960s he submitted a written proposal to make the Renwick Gallery a showcase for design—"The Renwick Design Centre," as he called it.[3] Although this memo received no immediate response, the idea resurfaced several years later, culminating in Ripley's proposal to President Johnson that the Renwick be used "as a gallery of arts, crafts and design." Ripley succeeded in persuading Johnson, but it was never made clear how the Renwick Gallery would interpret "arts, crafts and design."

The timing of the restoration of the Renwick edifice and its resurrection as a museum were no historical accident. Weary of the corporate glass box that typified modern architecture and of design with little or no character, Americans in the 1960s turned increasingly to period architecture and design for visual and spiritual relief. The historic-preservation movement that swept across the country beginning in the 1950s was an intense reaction to the sterile conformity of urban renewal and suburban sprawl as much as it was a passion to protect and preserve the nation's architectural heritage.

Also no historical accident was the inclusion of crafts and design in the Renwick mission. A study of large American art museums from the 1940s through the 1960s reveals that they commonly exhibited the craft and design of their city or region. The application of art to industry, nationally and internationally, was a topic frequently addressed. By the 1960s the post-World War II contemporary studio craft movement was gaining ascendancy as a vital force in American visual arts.

With its transfer to the Smithsonian Institution in 1965, the Renwick Gallery underwent massive renovations to restore its badly deteriorated exterior and to convert the interior spaces into exhibition galleries. Washington, D.C., architect Hugh Newell Jacobsen was in charge of the interior restoration. Decorated to evoke the opulence of the 1870s and 1880s, the Grand Salon on the second floor was returned to its original function as a picture gallery, displaying many of the paintings that had hung there in the 1880s. The choice of works and their placement were based on documentary photographs; thus the paintings were "skied"—hung one above the other—in the manner of Victorian salons. Display cases were filled with fine glass and ceramic pieces. Many of the paintings and much of the

furniture would have been familiar to William Corcoran. The small Octagon Room on the second floor directly opposite the entrance to the Grand Salon — originally designed as a showcase for Hiram Powers's *Greek Slave* — was restored to its original Renaissance Revival splendor.

The architectural firm of John Carl Warnecke and Associates of San Francisco, in conjunction with Universal Restorations, Inc., of Washington, D.C., carried out the extensive exterior restoration. In view of the poor condition of the building and the need for someone to monitor the progress of its restoration, and at the same time develop exhibitions and public programs, the appointment of an administrative head of the Renwick Gallery seems to have been somewhat belated. In January 1970 Dr. Joshua C. Taylor, William Rainey Harper Professor of Humanities and Professor of Art at the University of Chicago, assumed the directorship of the National Collection of Fine Arts (NCFA), which was renamed the National Museum of American Art in 1980. With this position he inherited the Renwick as part of his jurisdiction. Persuaded by Herman's idea that it should function as a design center, Taylor appointed him administrator of the gallery in February 1971; the title was changed to director in 1974.

The thirty-five-year-old Herman had a bachelor's degree in speech and drama from American University in Washington, D.C. Since 1966 he had worked for the Smithsonian as director of the Office of Exposition Hall Programs. In that capacity he had guided the development of the Arts and Industries Building as a hall for changing exhibitions. That Herman had no formal education in the visual arts was not a great impediment. For one thing, he came to the Renwick open-minded and unencumbered by any rigid design or art doctrine. More to the point, it should be remembered that in the museum world of the early 1970s most people with a broad knowledge of craft — and there were few — did not have academic credentials in the field because most American universities did not confer degrees in craft as a legitimate branch of art history.

On January 28, 1972, the Renwick Gallery opened its doors to the public. Eight disparate exhibitions of varying size and ambition were on view, offering a synthesis of Herman's panaesthetic approach to design and forecasting the great variety of shows that he would present during his administration. Curated by Herman, *Woodenworks: Furniture Objects by Five Contemporary Craftsmen* was the principal exhibition. It featured fifty custom-designed pieces of furniture by five American master woodworkers who represented the first generation of woodworking in the United States in the post-World War II movement: Arthur Espenet Carpenter, Wendell Castle, Wharton Esherick, George Nakashima, and Sam Maloof.

Reviewing *Woodenworks*, *Craft Horizons* reported: "The reaction of Washingtonians to *Woodenworks* was one of surprise and delight, and there was great response to the tactile quality of the pieces. In a sense, their surprise was distressing, for it reinforced a realization of how really few Americans are aware of such craftsmen's existence in our country."[4]

Three of the Renwick's inaugural exhibitions were drawn from other Smithsonian museums. Paul V. Gardner, curator of glass and ceramics at the National Museum of History and Technology (subsequently renamed the National Museum of American History), curated *The Glass of Frederick Carder*. Founder of the Steuben glassworks in Corning, New York, in 1903, Carder is considered a seminal figure in the evolution of glass as an artistic medium in

The Renwick Gallery opened in 1972 with eight exhibitions, including *Woodenworks: Furniture Objects by Five Contemporary Craftsmen* (above) and *Design Is...* (below).

the twentieth century. *Pueblo Pottery: Zuni and Acoma Designs from Smithsonian Collections* featured fifty objects collected in the 1880s by the National Museum of Natural History. *Four Continents: From the Collection of James Hazen Hyde*, drawn from the Cooper-Hewitt National Design Museum in New York City, presented a variety of European objects, from the seventeenth to the twentieth centuries, featuring allegorical or symbolic representations of the four continents—the Americas (treated as an entity), Africa, Asia, and Europe.

Four of the inaugural exhibitions addressed design and architecture: *Design Is. . .*; *Selections from the Index of American Design*; *American Architecture: Photos by Frank Roos*; and *James Renwick in Washington*. The latter two were composed of documentary photographs. *Design Is. . .* consisted of forty plastic pylon display cases, each seven feet high. At the entrance to the exhibition stood a column of Coca-Cola bottles, topped by a similarly shaped Tiffany glass vase. Other memorable objects included a Shaker yarn winder, a Project Mercury helmet, and a Louis Sullivan doorknob. The exhibition concept was simple: to jar the viewer into seeing the unfamiliar in the familiar and to affirm that the manmade is consciously planned and deliberately designed. In design, as in nature, nothing just happens.

A press release issued on the occasion of the opening of the Renwick noted that the gallery in which *Four Continents* was displayed "will often show exhibitions from foreign nations. Some of these will coincide with visits by heads of state to Washington, who will be staying in Blair House."[5] Outlining some of the future exhibitions under consideration, the announcement stated, "Until space was allocated in the Renwick Gallery to provide hospitality for non-American exhibitions, there was no provision in the Smithsonian Institution's museums of American art, history, and technology where they could appropriately be shown."[6]

Some efforts were made to present exhibitions to coincide with visits from foreign heads of state, but over the long term, this practice proved unfeasible. Even small exhibitions require months to organize, whereas visiting foreign dignitaries often arrive in Washington on short notice and stay for less than a week.

The wide-ranging, eclectic exhibitions shown at the Renwick during Herman's tenure represented a conscious effort to demonstrate that the disparate subjects were the embodiment of a deeply rooted human need to control the built environment through design and to express in tangible, visual form collectively held social values. Herman sought to emphasize the fact that design is common to all cultures and predates recorded human history. As *Craft Horizons* observed: "The Gallery has taken as its guide the broadest possible view of design, and its administrator, Lloyd E. Herman, believes design is everywhere in all things made by man, though the implication certainly is not that everything man makes is well designed."[7]

Because the Renwick opened as an exhibition site without a mandate to form a collection, the issue of defining decorative arts, design, and crafts was not yet the concern it would later become. The gallery opened with the idea of functioning like a German *kunsthalle*—a series of spaces within a single building where temporary exhibitions would be presented on a regularly changing schedule. Because the Renwick had no permanent collection, its identity and the public perception of the gallery were formed by the temporary exhibition schedule. For this reason, the exhibitions assumed particular importance.

As director, Herman was responsible for organizing and selecting the exhibitions, with the approval of the NMAA director. The criteria Herman used in making his choices were never rigidly codified, but it is apparent that his guiding principles were imagination in design and excellence in handcraftsmanship. That Taylor gave Herman considerable leeway in how he could administer the Renwick is obvious, and nowhere was that freedom greater than in the development of the exhibition schedule, which clearly bears the imprint of his taste.

In his fifteen years at the Renwick Gallery, Herman created an exhibition program of considerable imagination. From January 1972, when the Renwick opened, to May 1986, when he retired as director, Herman was responsible for the presentation of 116 exhibitions. Eighty of them featured art objects from the United States. Thirty-one exhibitions—about one-fourth of the total—presented foreign objects. Pan-global in the truest sense, these foreign exhibitions presented material from six continents.

Of particular note was the 1976 exhibition *Signs of Life: Symbols in the City*, curated by architects Robert Venturi and Denise Scott Brown. An important part of the Smithsonian's celebration of the United States Bicentennial, the show examined the evolution of American symbolism in the home, on the commercial strip, and in the nineteenth-century city through objects such as signs, paintings, billboards, and home and street furnishings.

Another memorable exhibition was *Celebration: A World of Art and Ritual*, which Herman organized in 1982 in collaboration with Ralph Rinzler, director of the Office of Folklife Programs. This wide-ranging effort drew artifacts from every Smithsonian museum, bringing together a diverse array of experts, from anthropologists to folklorists to scholars concerned with material culture.

Twenty-nine of the 116 exhibitions Herman brought to the Renwick featured individual artists or, in a few instances, pairs of artists. This included American and foreign architects and designers, although most of the shows featured renowned American craftspeople. A list of some of the American craft artists shown at the Renwick during Herman's administration reads like a *Who's Who* of the field: Jack Lenor Larsen (textiles), 1972; Gertrud and Otto Natzler (ceramics), 1973; Albert Paley (jewelry and metalwork), 1977; William Harper (jewelry),

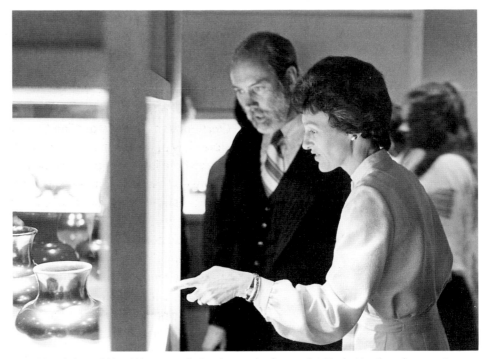

Joan Mondale and Lloyd Herman admire the work of ceramist Maria Martinez in a 1978 Renwick exhibition.

1977–78; Maria Martinez (ceramics), 1978; Ronald Hayes Pearson (jewelry and metalwork), 1978 and 1982–83; Dale Chihuly (glass), 1978–79; Neda Al Hilali and Lia Cook (fiber), 1980–81; Harvey K. Littleton (glass), 1984; Anni Albers (textiles), 1985–86; and Wendell Castle (furniture and sculptural objects), 1985–86.

The exhibition schedule was an eclectic mixture of subjects and historical periods that defies easy analysis. Because the exhibitions were selected from a platter of disparate shows organized elsewhere (and available for only a specified period of time determined by the organizer), considerable randomness was inevitable in the gallery's presentations. A scholarly exhibition by a noted authority at a prestigious museum or university might accompany a show that was highly eccentric but popularly appealing. For example, in 1977 *Twenty-two Polish Textile Artists* was presented in tandem with *Grass*, an exhibition of objects made of plant materials, which was organized by the Los Angeles County Museum of Art.

Having opened in 1972 with no intention of collecting art, by 1981 the Renwick had become convinced that collecting craft was an appropriate mission. A concern, of course, was that the Renwick's collecting would overlap or compete with the Cooper-Hewitt and the National Museum of American History. More to the point, at the very time the Renwick decided to collect craft with a seriousness of purpose, it was clear that the Cooper-Hewitt and the NMAH had both reversed their previously stated positions not to collect craft. Of course these institutions could just as easily have charged that the NCFA and the Renwick Gallery were abandoning their decision not to collect craft, a decision that had been widely publicized in *Craft Horizons* in 1972: "The Renwick Gallery does not have a collecting function and will be utilized only as a gallery rather than a gallery and repository."[8]

Despite the fact that the collecting and exhibiting of decorative arts and design among the Smithsonian museums seemed to overlap, Herman believed that distinct differences, albeit perhaps semantic and subtle, separated the

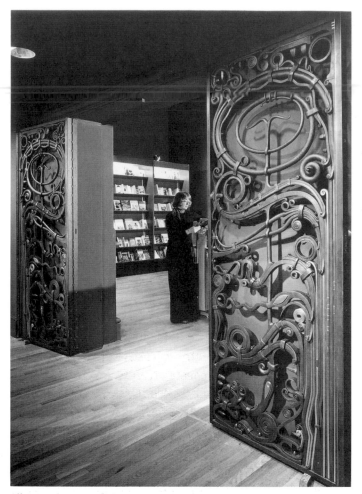

Albert Paley's *Portal Gates* grace the entrance to the gallery shop.

intentions of these museums. The Cooper-Hewitt collects design as cultural documents and industrial technologies; the NMAH focuses on the decorative arts as material culture and the evolution of human skills; and the NMNH acquires objects as anthropological and ethnological artifacts. For Herman, all of these collecting concepts and activities must ineluctably entail the acquisition of objects that command appreciation as art. And *art* was to be the focus of the Renwick Gallery.

In retrospect, one wonders why this competition in collecting became an issue among Smithsonian museums. There were certainly enough craft objects available to keep one museum from putting the others at a disadvantage. Moreover, attempts to define collecting areas and patterns are often futile, for such definitions are unenforceable limitations.

Despite Herman's assertion that the Renwick Gallery opened with no intention to add objects to the NCFA collections, some were acquired from the very start. He continued to acquire the occasional craft object just as the NCFA had done before the Renwick opened. In 1965, three years before the NCFA moved into the newly renovated Old Patent Office Building, a handsome glazed stoneware jar by David Shaner was given to the museum by the Montana State Society. That same year the NCFA received two ceramic bowls by Acoma Indian potters Lucy M. Lewis and Marie Z. Chino from the International Art Program through the State Department. In 1969 the NCFA purchased a white gold and baroque pearl ring by the San Francisco Bay Area craft artist Margaret DePatta, who played a major role in transforming contemporary jewelry making into an art. Also in 1969 the NCFA presented the exhibition *Objects: USA*, which traveled for several years from coast to coast. In 1977 and 1978 ten works from that show were given to the museum, including Sheila Hicks's 1969 soft fiber sculpture *The Principal Wife Goes On*.

In 1970 James Prestini, a professor of design at the University of California, Berkeley—considered the father of contemporary woodturning in America— gave a major gift of twenty of his works to the NCFA.[9] Deceptively simple in form and devoid of any decoration, these objects form a significant discrete collection that time has redeemed as historically and artistically meritorious.

In 1972 the NCFA accepted Katherine Westphal's gift of her 1964 fiber wallpiece *The Unveiling of the Statue of Liberty*. That same year the NCFA purchased Kay Sekimachi's hanging monofilament soft sculpture *Nagare VII* of 1970. The latter work had been included in the Renwick Gallery's inaugural exhibition *Design Is. . . .* Tyrone Larson's hexagonal, domed-lid stoneware jar with glazes and gilding was purchased in 1972 from the NCFA's International Art Program exhibition *Mountain Craftsmen: The Southern Appalachians*.

Herman developed the Renwick's permanent collection primarily through limited purchases and donations solicited from artists. It is important to remember that in the early 1970s there was no extensive national network of galleries promoting craft and bringing noteworthy artists to the attention of curators and major collectors. It was not uncommon for Herman to select

objects for the permanent collection from exhibitions he had organized or brought to the Renwick from elsewhere.

One of Herman's first major exhibitions was *Craft Multiples,* which opened in July 1975 and remained on view for seven months. Juried by Hedy Landman, director of the Danforth Museum in Framingham, Massachusetts, Lois Moran, director of the Research and Education Department of the American Craft Council in New York, and Herman, the exhibition consisted of 133 objects by 126 craftspeople. From that exhibition, sixty-three pieces were purchased for the permanent collection. From another exhibition, *American Porcelain: New Expressions in an Ancient Art*, on view from November 1980 to August 1981, forty-eight pieces were added to the permanent collection as gifts from the artists.

Without a doubt Herman's single most significant addition to the Renwick Gallery's permanent collection was Albert Paley's *Portal Gates*.[10] Along with Wendell Castle's *Ghost Clock* and Larry Fuente's *Game Fish*, this is a signature work of art that identifies the Renwick Gallery in the public mind. In 1972 Herman invited artists to submit designs for a gate at the entrance to the gallery's shop. Four artists participated: John Fix, Ronald Hayes Pearson, L. Brent Kington, and Albert Paley. The winning entry was submitted by Paley, a young jewelry maker and metalsmith from Rochester, New York. Constructed of forged and fabricated steel, bronze, and copper, *Portal Gates*, completed in 1974, not only heralded a turning point in Paley's career but also helped to animate the nascent blacksmithing movement in the United States. Composed of rhythmically sinuous lines and forms orchestrated in interwoven patterns inspired by the organic designs of the nineteenth-century art nouveau, *Portal Gates* bears the unmistakable stamp of Paley's genius. Amazingly Paley was only thirty-one when the gates were installed in January 1976.

To presume that the addition of these objects to the NCFA collections constituted a clearly defined plan for the development of a national collection of craft is to misunderstand the nature of museums and of a particular moment in time. These disparate, unrelated objects were random donations and purchases that conformed to no apparent design or objective.

In the early 1980s four events occurred that were to redirect the future of the Renwick Gallery. By an act of Congress, the National Collection of Fine Arts was renamed the National Museum of American Art in 1980. On April 26, 1981, Joshua Taylor died unexpectedly. In the summer of 1981 Lloyd Herman met with several craft collectors and enthusiasts in Washington, D.C., to discuss the formation of a support group for the Renwick Gallery. And in July 1982 Dr. Charles C. Eldredge, director of the Spencer Museum of Art and professor of art history at the University of Kansas, became director of the National Museum of American Art.

The renaming of the NCFA was far more than a new appellation. It redefined the focus of the museum solely on American art, and that signaled a major change for the Renwick Gallery. As a department of a museum of American art, the gallery could no longer justify the presentation of international exhibitions. Thus the Renwick program became centered on American craft, a development foreshadowed in its earlier acquisitions. It is interesting to note that even before the NMAA's mission was changed, the Renwick had not collected non-American craft objects.

Taylor's death in April 1981 left a void that was to challenge his successor, Charles Eldredge, who became director at the age of thirty-eight. In October

1983 Eldredge appointed Dr. Elizabeth Broun, who had worked with him as curator of prints at the Spencer Museum of Art, as assistant director and chief curator. Together they worked to forge a vision for the NMAA as a national center for the collecting, exhibiting, and study of American art, including craft.

The founding of the James Renwick Collectors Alliance would also significantly affect the Renwick's future. The genesis of the Alliance occurred without fanfare at a dinner party in the early spring of 1981.[11] At the Kensington, Maryland, home of Paul and Elmerina Parkman—both avid collectors of contemporary art glass—Lloyd Herman mentioned in passing that he had been unable to find Smithsonian funds for a public program. Sparked by Herman's comment and his opinion that a support group for the Renwick would be of great help, Charles Gailis, then a trustee of the Haystack Mountain School of Crafts in Deer Isle, Maine, wrote to Herman on April 23, 1981, recommending the establishment of an ad hoc committee to investigate the formation of such a group.[12] Through the summer and into the fall of 1981 several meetings were held by approximately twelve craft collectors and enthusiasts to develop the idea for a support organization. At first they expressed a desire to be affiliated with the Smithsonian Institution, but its extensive rules and regulations made the group decide to organize as an independent nonprofit agency.

The James Renwick Collectors Alliance—renamed the James Renwick Alliance in 1987—was incorporated in the District of Columbia as a nonprofit organization on March 17, 1982. The Articles of Incorporation define the purpose of the group as follows:

> Its purpose is to advance education in the history of and appreciation for American crafts by supporting programs directed toward this purpose and by encouraging connoisseurship and collecting. The Alliance also will assist institutions, such as the National Museum of American Art and its Renwick Gallery, to establish permanent collections of American crafts of artistic significance and superior workmanship. Emphasis shall be on objects made primarily of clay, fiber, glass, metal, and wood which were made intentionally as objects of art or are recognized for their artistic merit, whether functional or purely expressive.[13]

Although the impetus for the founding of the Alliance was certainly to help the Renwick Gallery, its statement of purpose leaves the nature of that support undefined. Founding members have stated that they wanted the Alliance to be a national support group for the advancement and promotion of American craft rather than a group established to assist only one museum. In fact, in 1984 the Alliance gave the American Craft Museum in New York a fiber piece by Diane Itter for its permanent collection. Eventually, however, the Alliance decided to support the Renwick Gallery exclusively and committed itself to furthering the growth of the collection and its educational programs.

The Alliance was founded during the period after Taylor's death and before the appointment of Eldredge as director of the NMAA. Necessarily, then, it envisioned its role as supporting the broad program goals emphasizing exhibitions that Herman had established. When Eldredge arrived in 1982, however, he set about completing the "Americanization" of the old NCFA, including an exclusive focus on American craft artists at the Renwick. He articulated new priorities for the entire museum, with an emphasis on collecting and research. These priorities were reinforced by the arrival of Dr. Robert McCormick Adams as secretary of the Smithsonian in 1983. Adams, formerly provost at the

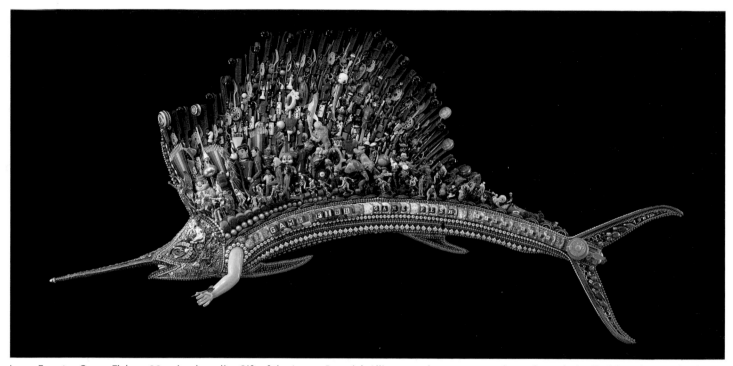

Larry Fuente, *Game Fish,* 1988, mixed media, Gift of the James Renwick Alliance and museum purchase through the Smithsonian Institution Collections Acquisition Program

University of Chicago, announced his goal to strengthen scholarship at the Smithsonian. These changes affecting all aspects of the NMAA made it increasingly less viable to maintain the Renwick as a *kunsthalle* for craft exhibitions.

Beginning in 1983, assistant director Elizabeth Broun assumed curatorial supervision of the Renwick. With the new emphasis on American crafts and design, Broun and Eldredge were also committed to building a program at the Renwick that emphasized strong academic research, scholarly publications, and important exhibitions.

These changes came to a head in 1986. Since exhibitions are planned two to four years in advance, the first shows reflecting Eldredge's views were just beginning to appear at the Renwick. In the meantime, others began to cast a covetous eye on the historic galleries of the Renwick, situated at the epicenter of federal Washington across from the White House. The space was mentioned as suitable for collections pertaining to the presidents and first ladies, or musical instruments, or as a showcase for exhibitions organized by the Smithsonian Institution Traveling Exhibition Service. One persistent idea was to fold crafts into the NMAA's American art program, losing their separate space in the Renwick building in favor of more "relatedness" to the rest of American art.

Adding to the growing insecurity about the future of the Renwick was the announcement of Lloyd Herman's retirement in 1986. After fifteen successful years at the Renwick, he decided to move to Washington State to continue organizing imaginative, wide-ranging craft shows as a free-lance curator.

The board of the James Renwick Alliance acted decisively to support the existing craft program. Letters to collectors, curators, artists, galleries, university professors, writers, and others urged them to add their voices to the campaign to save the Renwick Gallery. As the letters and calls mounted, Secretary Adams asked Tom L. Freudenheim, newly appointed assistant secretary for museums, to invite a Visiting Craft Committee composed of a museum director, two cura-

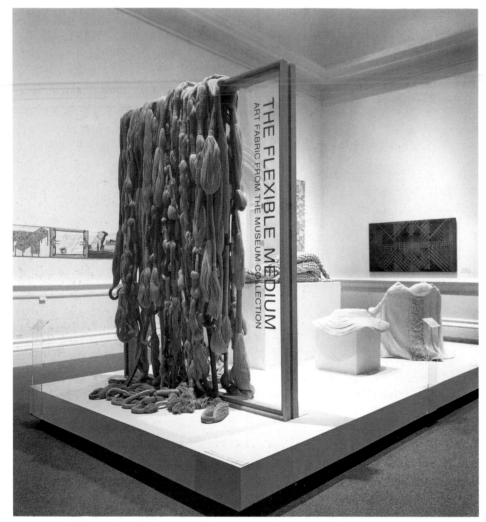

Installation view of *The Flexible Medium* exhibition in 1984–85, with Sheila Hicks's soft fiber sculpture *The Principal Wife Goes On* in the foreground.

tors, and a craft artist to evaluate the Renwick program. Meeting in May 1986, the committee interviewed many people, from scholars to the general public, and issued a report recommending that the Renwick's craft program be continued and strengthened through additional support and a more clearly defined mandate.

Following this satisfactory resolution, the Renwick codified several goals, notably to collect the work of twentieth-century craft artists of the highest caliber, to showcase exhibitions on all aspects of American craft and the historic traditions that preceded them, and to undertake and publish research that extends knowledge about American crafts. Gratified that its goals had been achieved, the Alliance became even more dedicated to supporting the fledgling collecting program, in addition to its traditional educational focus.

At its May 1986 meeting the Visiting Craft Committee recommended that the NMAA keep the Renwick Gallery as a showcase for American craft and strengthen its commitment to scholarly and substantive exhibitions and publications. To represent the dynamic studio craft movement, the committee deemed it was essential to build a nationally recognized craft collection in a systematic manner to reflect the scope of craft art from coast to coast. And what better place for such a national collection than in the nation's capital? The Renwick Gallery was special in that it represented a field that had been largely dismissed within academe and ignored by most museums.

The committee recommended that the curator-in-charge—the new title of the Renwick's administrator, replacing that of director—become a department head reporting to the director of the NMAA and not to the chief curator, as previously done. The committee's most sweeping suggestion (and one dear to the heart of the Alliance) was that the Renwick Gallery be established as a museum, separate from the NMAA. "Although the Committee would prefer establishment of the Renwick Gallery as a separate 'bureau,' it understands that political, budgetary and other considerations may make such a recommendation impractical."[14] The Renwick Gallery had an identity as a craft museum but lacked the freedom to develop its own destiny within that identity.

Did the Visiting Craft Committee's recommendations lead to noticeable and positive changes? While it might seem that none were perceived immediately, subtle and significant changes were, in fact, under way. Under Michael W. Monroe, who replaced Herman as the Renwick's second administrator in the

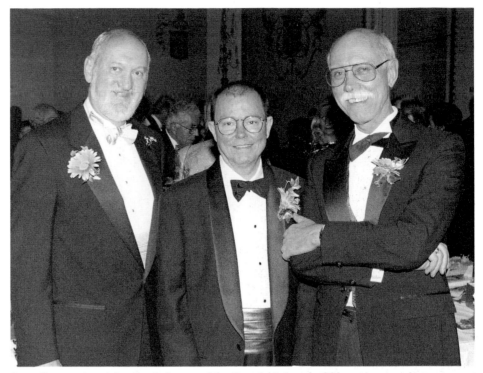

Attending a gala celebration in honor of the Renwick's twenty-fifth anniversary in 1997 were (left to right) Michael Monroe, Kenneth Trapp, and Lloyd Herman.

fall of 1986, the Renwick Gallery began to develop a permanent collection in a systematic manner, to cultivate donors and collectors, and to make scholarship a significant part of the gallery's purpose.

Monroe, a graduate of the Cranbrook Academy of Art in Michigan, had come to the Renwick in January 1974 from the State University of New York at Oneonta, where he served as gallery director. Having worked for twelve years under Herman as associate curator, he was thoroughly versed in the history and purpose of the Renwick. With graduate and undergraduate degrees in the visual arts, Monroe was knowledgeable about modern crafts and organized several exhibitions linking them to historic decorative-arts traditions. The Renwick emerged from its period of insecurity stronger than before, more closely aligned to the NMAA, with a more substantive program and a more active and dedicated support group.

Monroe began to institute and carry out plans consonant with the NMAA's mission. For one, foreign exhibitions were discontinued. Second, he began to develop a permanent collection of crafts in a determined and thoughtful way, identifying artists and particular objects to be targeted for acquisition. To raise funds for the purchase of choice works of art, Monroe nurtured the relationship between the Renwick Gallery and the Alliance, and together they forged a dynamic partnership. As its membership and funds increased, the Alliance was able to provide for more acquisitions, thereby becoming central to the development of the collection. The importance of the James Renwick Alliance in the development of the Renwick Gallery's permanent collection cannot be overestimated.

Eldredge petitioned the Smithsonian to include the Renwick as a full participant in the institution's Collections Acquisition Program (SICAP). His success is documented in the fact that for fiscal year 1988 the Renwick Gallery received from SICAP an unprecedented $750,000 for art acquisitions. The first major

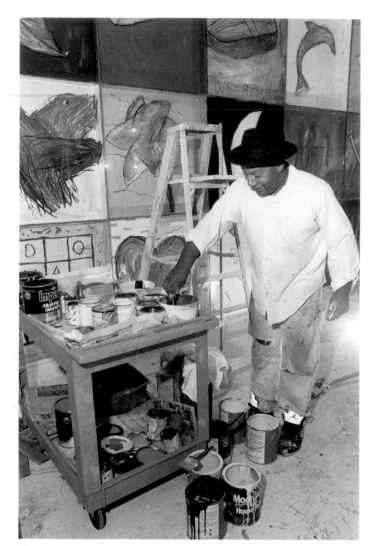

Therman Statom puts the finishing touches on his *Washington, D.C. Installation* for the 1990–91 *Glassworks* exhibition.

purchase through the program was Wendell Castle's haunting *Ghost Clock*, a tour de force in trompe-l'oeil illusion. One of the most popular pieces at the Renwick, *Ghost Clock* probably would never have entered the collection without the SICAP funds. By 1992, when the last of these funds were spent, the Renwick had purchased forty objects, six exclusively with SICAP money.

In addition to outright gifts of objects or the donation of money for the purchase of art, a third important way that art enters a museum today is exemplified by the Howard Kottler Estate. On January 19, 1989, Howard Kottler, a ceramist and professor of art at the University of Washington, died from cancer. His will established the Howard Kottler Testamentary Trust, which provided $75,000 for the Howard Kottler Endowment for Ceramic Art in 1995, to be administered by the Smithsonian Institution. In setting up this endowment to purchase works of art "to recognize young emerging artists and artists in mid-career," Kottler ensured that deserving ceramic artists will be included in the NMAA collection. Since the Kottler endowment was established, the Renwick has acquired a wood-fired stoneware jar by Rob Barnard, a small glazed porcelain vessel by Kathy Butterly, and a porcelain teapot with china-painted decoration by Kurt Weiser.

These acquisitions notably enhanced the Renwick's collection, but also on the gallery's agenda was the encouragement of scholarship in American craft. An important step in this direction was the establishment in 1987 of the James Renwick Fellowship in American Craft, funded by the Alliance. In recognition of the importance of this grant, the National Museum of American Art ensured its continuation in 1988 by making a commitment to cover the fellows' annual stipends, with the Alliance providing additional money when needed. Fellows pursue their studies at the National Museum of American Art, the Renwick Gallery, and other research facilities in the nation's capital. For some years, this prestigious fellowship was the only one devoted to the scholarly study of American craft.

Upon the resignation of Charles Eldredge in mid-1988, Elizabeth Broun became acting director of the NMAA, and in 1989 she was appointed director. Sensitive to the unusual founding of the Renwick Gallery and its unique history, Broun has been careful to strengthen it as an invaluable curatorial department in the NMAA that is unparalleled in any other American art museum. She has encouraged the systematic development of the craft collection by making limited funds available for acquisitions whenever possible. Further, Broun has continued funding the Renwick fellowship program and has championed innovative ideas in the organization of exhibitions.

In 1988 Dr. Jeremy Adamson, who had been a fellow at the NMAA in 1978, was hired as a guest curator for two major exhibitions. *The Boat Show: Fantastic Vessels, Fictional Voyages* opened in 1989, featuring eighteen "boats" created by sixteen artists. The promotional material for this highly popular show observed, "Each 'boat' resonates with poetic meaning because the artists have weighted their works with symbolic, metaphoric, and associative allu-

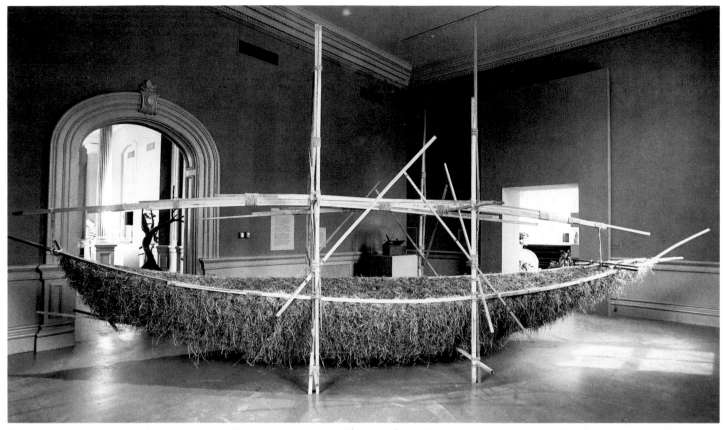

Michael Shaughnessy's *Hayboat* was among the eighteen works in *The Boat Show: Fantastic Vessels, Fictional Voyages*, presented in 1989.

sions. The legacy of maritime imagery is both deliberate and unconscious." The second exhibition organized by Adamson, with Alastair Duncan as guest curator, was *Masterworks of Louis Comfort Tiffany,* which opened in September 1989 and attracted almost 235,000 visitors in five months—the highest attendance in the Renwick's history. On view were sixty-five of the rarest and most technically brilliant creations of Tiffany, including leaded-glass windows and lamps and other objects, many never before seen by the public. Following the close of the exhibition in Washington, it traveled to the Metropolitan Museum of Art.

The Tiffany exhibition was a magnificent segue into the 1990s. On the occasion of the Renwick Gallery's twentieth anniversary in 1992, Monroe organized *American Craft: The Nation's Collection,* highlighting 150 objects from the permanent collection. In honor of the Renwick's anniversary, NMAA commissioner Patricia Frost and her husband, Phillip Frost, donated funds for a prize to be awarded every two years to the author of a published work of outstanding scholarship in American crafts.

After working as a guest curator at the Renwick for four years, Jeremy Adamson joined the staff as curator in 1992. The appointment of a scholar of Adamson's stature provided an infusion of energy that the gallery needed to help fulfill its commitment to scholarship and education. In addition to taking charge of the James Renwick Fellowship Program, Adamson began to organize substantive exhibitions accompanied by noteworthy publications. In 1993 he organized the exhibition *American Wicker* and wrote the accompanying book. Taking a scholarly approach to the subject, he explored the fascinating history of American woven furnishings from the mid-nineteenth century to the Great Depression, using groups of commonplace objects to tell a story of technological innovation, entrepreneurial spirit, and the evolution of American design.

A more recent publication from Adamson, *Calico & Chintz: Antique Quilts from the Collection of Patricia S. Smith*, accompanied an exhibition presented at the Renwick in 1996–97. In a comprehensive essay, Adamson discussed the origins and history of printed textiles in early American quilts.

In 1993 the Clinton White House staff approached Michael Monroe about organizing a collection of contemporary American craft for the White House to pay tribute to the "Year of American Craft: A Celebration of the Creative Work of the Hand." President George W. Bush had signed the proclamation in 1992 designating 1993 as the "Year of American Craft" in order to recognize the work of artists in the United States whose creativity has often been overlooked. Monroe selected seventy-two works by seventy craft artists, which each of them donated to the White House. When *The White House Collection of American Crafts* was shown at the National Museum of American Art for four months in 1995 (the Renwick Gallery had no available space in the appropriate time frame), it proved to be one of the most popular exhibitions there in recent years.

Having steered the Renwick Gallery on its fruitful course for nine years, Monroe resigned as curator-in-charge in June 1995. His major contributions to the growth of the Renwick, as well as those of his predecessor, Lloyd Herman, have helped ensure the future of the gallery in the new century.

afterword

In September 1995 I left my position as curator of decorative arts at the Oakland Museum of California to become the third head of the Renwick Gallery. Over the course of two eventful and rewarding years, I have worked to carry out the mission of the Renwick Gallery: to foster greater appreciation and understanding of American art in craft media. In the spring of 1997 the Renwick celebrated its twenty-fifth anniversary with a glorious exhibition, *The Renwick at 25*, which showcased one hundred and one objects in the permanent collection representing all craft media. That same year part of the permanent collection was reinstalled on the second floor in newly refurbished galleries designed to highlight each object displayed in the elegant architectural setting.

As we look back, it is evident that the Renwick Gallery has been ably guided by its caretakers. Lloyd Herman's legacy is in the numerous exhibitions he brought to the public, introducing viewers to aspects of craft from around the world. Building on that foundation, Michael Monroe began to develop a national collection of American craft worthy of the name. And importantly he ensured that scholarship, publishing, and an awareness of historical contexts would become established features of the Renwick Gallery's mission, in effect, transforming the gallery into a full museum program of the National Museum of American Art. I hope that during my tenure we can continue to build on the foundations laid by my predecessors.

As we peer unknowingly into the future, it is important to keep in mind that museums are not mausoleums frozen in time but are alive and ever changing, just as the times in which they exist are in constant flux. More than three decades after the derelict U.S. Court of Claims building was transferred to the Smithsonian Institution to be restored as the Renwick Gallery, and twenty-five years after the Renwick opened as a gallery of American craft, we can be happy that its original proud claim—Dedicated to Art—remains a fact.

—K. R. T.

notes

1. *Public Papers of the Presidents of the United States. Lyndon B. Johnson. Containing the Public Messages, Speeches and Statements of the President*, 1965 (two books) Book II—June 1 to December 31, 1965. Washington, D.C.: U.S. Government Printing Office, 1966. no. 328, p. 694. I wish to thank the Lyndon B. Johnson Presidential Library in Austin, Texas, for this information.

2. Ibid.

3. Interview with Lloyd E. Herman, April 10, 1997, Portland, Oregon.

4. Joan Pearson Watkins, "Pomp and Circumstance," *Craft Horizons* 32, no. 2 (April 1972): 68.

5. Undated press release, no. 33, files of Office of External Affairs, National Museum of American Art.

6. Ibid.

7. Watkins, *Craft Horizons* (April 1972): 45.

8. Ibid., 68.

9. In a letter of August 30, 1967, to Adelyn D. Breeskin, curator of contemporary art at the NCFA, Prestini wrote: "I turned wooden pieces from 1933 to 1953. These items have not been available on the market since 1953. I am thinking about giving the remaining stock to museums." Breeskin had included Prestini's turned wood bowls and plates in an exhibition at the Baltimore Museum of Art in 1944.

In a letter to Prestini written February 8, 1968, David Scott, director of the NCFA, wrote: "Your work, which has the highest reputation, would therefore fit right into our needs and interests." Scott informed Prestini that the Smithsonian was restoring the Renwick as "a gallery of American arts and crafts." It is interesting to note that Scott saw the Renwick as a gallery for *American* art before the mandate of 1980. These letters are in the Registration files, Renwick Gallery.

10. For more about the *Portal Gates*, see Edward Lucie-Smith, *The Art of Albert Paley: Iron & Bronze & Steel* (New York: Harry N. Abrams, 1996), 26–33, 40, 42, 43, 54, 57, 78, 104.

11. I am grateful to Elmerina Parkman for her generous help with the history of the James Renwick Alliance. She provided me with a copy of a ten-page typescript, "Partial Transcript of Orientation Meeting for New Members of the Board. James Renwick Alliance, September 12, 1989, A Review of the History of the Alliance," which was of invaluable help.

12. This information was supplied by Elmerina Parkman from a document dated March 15, 1996.

13. Articles of Incorporation of the James Renwick Collectors Alliance, Office of Recorder of Deeds, Washington, D. C., March 17, 1982, [1].

14. See *Report of the Smithsonian Visiting Craft Committee, July, 1986*, 5 pages. Submitted to Assistant Secretary Tom Freudenheim by Patricia Doran, Jonathan Fairbanks, William Harper, and Marcia Y. Manhart.

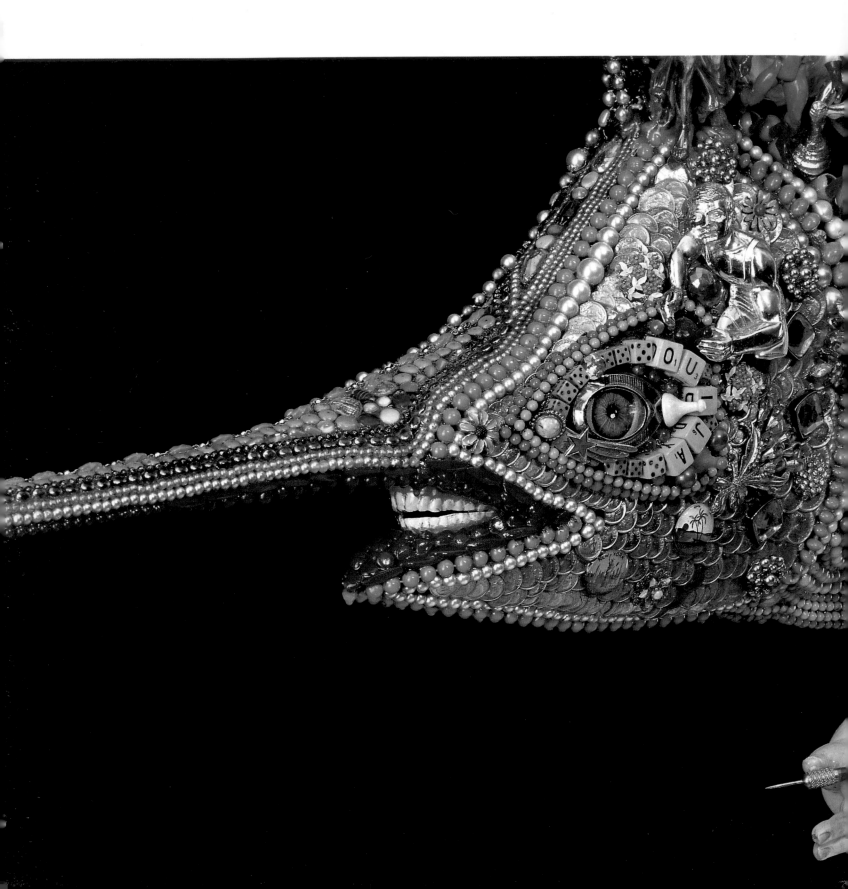

Howard Risatti

metaphysical implications of function, material, and technique in craft

introduction: modernism to postmodernism

By now it is well known how the abstract expressionist artists such as Jackson Pollock and Willem de Kooning reached maturity in the late 1940s and by the mid-1950s had established American preeminence in the art world. This tradition provides the context for an understanding of the work of a ceramist like Robert Turner. His avoidance of the delicate and overly refined in the object titled *Akan* reflects the direct working process of abstract expressionist gestural painting; the thickness of the stoneware and its coarse, rough-hewn quality communicate a sense of the gravity and physical presence of a de Kooning brushstroke.

In the early 1960s the high seriousness of de Kooning's generation was supplanted by a younger group of American artists who had launched their careers during the postwar prosperity that began in the fifties. Pop artists such as Andy Warhol, Roy Lichtenstein, and James Rosenquist embraced popular culture (movies, comic books, rock'n'roll) and mass-produced commodities from everyday life such as canned foods, soft drinks, and automobiles, which became the subjects of their art. Craft artists have also been influenced by popular and mass culture, as reflected in such works as Richard Shaw's *Carrie,* a glazed porcelain figure composed of a mayonnaise jar, book, and paint can. It is also apparent in the work of Patti Warashina and Larry Fuente. Warashina's *Convertible Car Kiln*, made of glazed clay and plastic but resembling brick, is a humorous Magritte-like image, while Fuente's *Game Fish* is a playful trophy covered with a colorful array of toys, trinkets, beads, and poker chips.

Bright, brash, and bold, the American version of pop art received immediate attention across the United States. Soon its attitude toward commercial subject matter, combined with an emblematic look taken from advertising, spawned an international movement that spread from Europe to Asia and further enhanced the image of American art. Pop art quickly became symbolic of a youthful, dynamic, and confident America whose prosperity was the envy of the world.

In the wake of this prosperity, prices for works of art began to escalate in the late 1970s. According to Calvin Goodman, the estimated value of the American art market in 1981 was $2.5 billion; by 1991 it had grown to approximately $5 billion.[1] At the height of the art boom in 1987, Vincent van Gogh's painting *Irises* sold at Sotheby's New York auction for $49 million.[2] Even the prices for contemporary American art began setting new records, especially works by pop artists. Jasper Johns's encaustic painting *Out the Window,* which had sold for $2,250 in 1960, fetched $3.63 million at a Sotheby's auction in 1986. This was the highest price ever paid for a work of contemporary art. Two years later that record was toppled when his painting *False Start* was sold at Sotheby's auction for $15.5 million.[3]

Larry Fuente, *Game Fish*

Robert Turner, *Akan*

Richard Shaw, *Carrie*

This market activity reflected the growing worldwide prosperity and a renewed interest in art, especially that of the modern period. In America this interest can be seen in the revival of both fine art and craft in the postwar years. After World War II, as veterans returned to school on the G.I. Bill, universities expanded old programs and added new ones. Among these were programs in the arts, which generated the expanded activity in the field that occurred in the late 1950s and 1960s and led to the euphoria of the 1970s. Crafts became an important part of many university curricula, offering programs in ceramics, glass, fiber, metals, and wood to students eager to become practitioners in these areas. Despite the new interest in crafts, the field did not fully share the prestige and market euphoria that the fine arts enjoyed in the ensuing decades. While paintings were sold for millions of dollars and artists like Julian Schnabel were treated as celebrities in *Vogue* magazine, crafts still fetched prices in the hundreds or, at best, in the thousands of dollars, and their makers remained virtually anonymous.[4] This situation, as much as anything, accounts for the self-scrutiny and criticality that developed in the field of craft, which came to a head in the early 1990s.

Partly in response to this situation, those in the field developed a tendency either to declare that crafts are the same as fine art (a point of view advocated by critic Matthew Kangas)[5] or to abandon traditional craft concepts and move in the direction of sculpture. The latter position is evident in Shaw's *Carrie* and Dan Dailey's *Huntress*, a figurine of bronze, blown glass, and plate glass. Ironically, at the time this was happening in the craft world, the fine arts were also in disarray, as no single style or attitude seemed capable of gaining intellectual and stylistic prominence. In contrast to the 1960s, when minimalism and pop art dominated the contemporary art scene, the 1970s became known as the pluralist decade. In the absence of a sense of historical/cultural necessity, it seemed that one was now free to do almost anything. As critic Arthur Danto states in his essay provocatively titled "Art after the End of Art," "It is the mark of what I have termed the posthistorical period in art that everything is possible at this time, or that anything is."[6] Installations, performances, videos, and even the human body were being called sculpture. Pure abstract painting fell out of favor, while photography, video, and mixed-media works became highly visible in the galleries. The modernist theories of Clement Greenberg, which insisted that the arts remain pure within their individual boundaries, were attacked as promoting an art irrelevant to the issues facing contemporary society. The boundaries between the various arts, both materially and conceptually, seemed to be dissolving, making it increasingly difficult to distinguish one from another. Suddenly all traditional artistic values seemed suspended or in flux.

Against this backdrop the Renwick Gallery was established in 1972 as part of the National Museum of American Art. Its purpose is to promote contemporary American craft and establish its credibility as a genuine form of artistic expression, one just as worthy of preservation as the paintings and sculptures in other Smithsonian collections. To do this was no small matter, for it was a momentous time. Not only was the art world in great confusion, but as the decade unfolded, it became increasingly apparent that the pluralist decade marked more than just a significant watershed in the arts; it also signaled a major change in society. As Octavio Paz states in his book *Children of the Mire*, "We are living the end of the idea of modern art."[7] The pluralist decade was demarcating not only a change of art styles but also the end of the idea of the

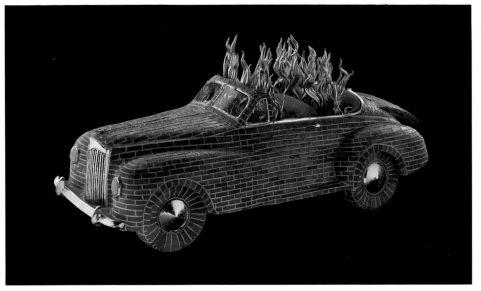

Patti Warashina, *Convertible Car Kiln*

Dan Dailey, *Huntress*

modern industrial world and the beginning of what has become known as the postmodern world, dominated by electronic media and technology.

the arts in a postmodern society

In many ways, the postmodern is the antimodern. While the modern focused on purity of form and means (on the literariness of literature, the painterliness of painting, and the sculptural qualities of sculpture), the postmodern insisted on the impure, on the mixing and matching of these qualities, as well as of forms, styles, and materials.

This became apparent in the renewed interest in historical styles, but not in history itself. Devices and effects were appropriated from the history of art to create novelties and spectacles, so that a typical postmodern building could include a Palladian window from the Italian Renaissance, an International Style glass-curtain wall, and a Romanesque barrel vault. This collage effect severed style from its historical connections by cavalierly ignoring the religious, social, cultural, and political ideas that had generated the diverse styles as vehicles of metaphorical meaning.[8] As a result, style was emptied of meaning, a situation that soon became apparent in painting as well, when this medium regained gallery prominence in the early 1980s.[9] A series of "neo" styles were appropriated from art history by artists in Europe and America. Neo-baroque, neo-surrealism, neo-expressionism, neo-geo (geometric), and neo-op (optical), among others, became the new fashions of an art world obsessed with fashion, an art world that mistook novelty for the genuinely new and creative.

The deeper significance of this was made clear by German social philosopher Jürgen Habermas. In his essay "Modernity versus Postmodernity" he argued that the postmodern was a symptom in Western society of the widespread rejection of the value of rational thought and reasoned action, which had been established by the eighteenth-century Enlightenment and transmitted to the twentieth century by the culture of modernity.[10] In short, he stated, the idea that reason and rational thought can lead to a brighter future was being questioned and also rejected by many in the pluralist decade. The result, according to English literary theorist Terry Eagleton, is that "the Pluralist usually turns out to be the disillusioned offspring of the absolutist, believing as he does that if there is not one truth then there is none at all."[11]

As the Vietnam War, the energy crisis of the early 1970s, and environmental concerns increasingly became part of public consciousness, a shadow of doubt slowly crept into the national spirit, profoundly affecting our outlook on the world and on art. As painter and critic Thomas Lawson wrote in 1981, "We are living in an age of skepticism and as a result the practice of art is inevitably crippled by the suspension of belief."[12]

This "suspension of belief," as well as the disillusionment of the "Pluralist," is reflected in the critical theory prominent since the mid-1980s, especially the

suggestion that our relationship to the world is no longer one of direct experience. In the postmodern world, so the argument goes, the natural hardly exists, and reality itself is always mediated in some way. This is apparent in a world filled with endless duplicates (of mass-produced objects without originals) and advertisements for brand-name items that cater to our every need, real and imagined. Whatever remains of the "real" world is generally experienced secondhand, predigested via the media, TV, and the movies so that "real" life experience tends to be overwhelmed by lifestyle images. Theorists and critics such as Hal Foster and Jean Baudrillard speak in terms of simulacra and the hyperreal, which cut off our access to real experience by simulations of the real, faked experiences, contrived needs, and pseudo-events that bombard us on TV and in the movies.[13]

According to Baudrillard, nothing can escape this situation, not even the arts. As he puts it, "Then the whole system becomes weightless, it is no longer anything but a gigantic simulacrum—not the unreal, but a simulacrum, never again exchanging for what is real, but exchanging in itself, in an uninterrupted circuit without reference or circumference."[14]

Despite Baudrillard's pessimism, the situation is far from hopeless. Craft offers an important way to negotiate this predicament and return to experiences that are real—real because necessary, direct, and genuinely meaningful. Because of their origin and purpose, traditional crafts are less susceptible to the crippling doubt that results from a life constructed of vicarious experiences, contrived needs, and pseudoreality.

nature, function, and the origin of craft tradition

The role and identity of crafts in modern and postmodern society are probably the most important issues facing the field today. They can best be addressed by first considering the originating impulse for craft and the tradition that subsequently developed. It is also essential to examine how the development of tradition in craft has shaped its identity as an artistic practice to the present day.

Because we tend to refer to the various crafts according to their materials— clay, glass, wood, fiber, and metal—we sometimes forget that it was once common to think of crafts in terms of function, which led to their being known as the applied arts. Many people in the field consider this term pejorative, especially in relation to the fine arts, whose practitioners emphasize the uselessness of fine art as an essential feature of its aesthetic quality. As a consequence, crafts people often feel compelled to emulate fine artists. Sometimes this is done simply by dismissing or ignoring critical discussions about function in relation to their work; at other times, their work essentially abandons the craft tradition for what seems like sculpture in craft materials. By taking either course, crafts people give up a great deal, perhaps too much. On the one hand, to align oneself with sculpture is, as previously noted, to become involved in an enterprise made problematical by the crippling doubt and suspension of belief that have characterized the postmodern world. On the other hand, to stay within the crafts field and ignore function (whether in its practical or conceptual/metaphorical sense) is to abandon the field's single most important element. The origin and identity of crafts as a discrete artistic practice is intricately bound to function. Function is so crucial that it gives crafts their identiy, an identity that not only links the physical form of traditional objects to sources in nature but also becomes the *raison d'être* that links them to the human body.

Approaching crafts from the point of view of function, we can divide them into several simple categories: containers, shelters, and supports. Containers, as the term implies, refers to such objects as vases, baskets, bowls, and boxes, as well as furniture such as bureaus and desks. The category of shelter refers to things that protect the human body, such as blankets, clothing, shoes, quilts, hats, and structures like tents and huts. Houses might even be included here. Because houses are fundamentally shelters, architecture may be considered one of the applied arts closely related to crafts. The category of supports includes objects such as chairs, stools, beds, shelves, thrones, and tables.

All of these categories are fundamental to crafts worldwide because they exist in nature and developed from their natural forms into manmade objects as human beings organized themselves into social groups. Lakes, pools, gourds, bird nests, shells, even riverbeds are natural containers that early peoples found in their environment and exploited. Eventually they made more convenient versions of these containers, such as the bowls, cups, and baskets used today. Early people also learned how to protect themselves from the elements and the danger of predators by living in caves, hollows, and cliff overhangs. As they became more settled and domesticated animals and grains, these natural shelters evolved into huts, tents, and houses. Similarly, the flat stones, logs, and tree branches that had been used as supports took on more comfortable and useful shapes, eventually becoming beds, stools, chairs, and tables.

All of these objects were developed to serve essential physical needs, which are still necessary if the human organism is to survive. One cannot say the same about fine art. People can live without paintings or sculptures. Many societies, in fact, do not have paintings, for example, the Eskimos in the Arctic and the Bushmen of sub-Saharan Africa. Sculpture is nonexistent in many societies, especially among nomads, because it is simply too heavy to carry from place to place. That people can survive without painting and sculpture is not to say that the fine arts are useless, but rather that they are in some fundamental ways different in origin and use from the applied arts. The fine arts are believed to have originated in rituals connected with fertility and the hunt. Performed to ensure success in these endeavors, they were directed to the intangible, the human psyche, or the spirit world. Even today we would consider the fine arts as enrichments of our mental rather than our physical or material well-being. Although the applied and fine arts work together to ensure a healthy and sound mind and body, each does this in its own particular ways; the differences should not be overlooked or ignored because meaning is intricately tied to purpose.

While physical needs do not change over the lifetime of an individual or over the course of centuries, psychic needs do change in relation to altered social, political, and economic situations. These changes are reflected in the fine arts. One has only to compare the confident, realistic portraits of the early Roman Empire with the anxiety-ridden, formalistic portraits of the late empire; the hierarchical rigidity of ancient Egyptian figures with the abstract formalism of Oceanic and sub-Saharan masks; or the airy impressionism of Claude Monet with the neurotic surrealism of Salvador Dali. Because the physical needs of the body are unchanging over time, the applied arts remain relatively constant in form. An ancient Shang Dynasty vase, made in China in 1200 B.C., is immediately recognizable as a container, as are an ancient Inca bowl made in Peru in

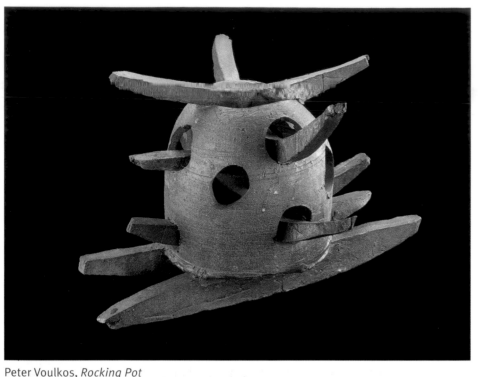

Peter Voulkos, *Rocking Pot*

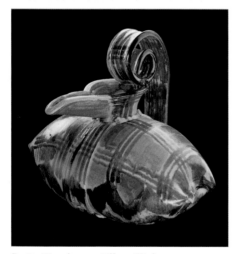

Betty Woodman, *Pillow Pitcher*

A.D. 1400 and a pot made in California in 1970. That they were made in very different cultures at different times and places matters very little; their form follows a basic pattern that is echoed again and again throughout history, as if the form derived from some kind of archetype embedded in our collective memory.

If this is an archetype, it is one that stems not from social conventions but from physical needs. To recognize this is to comprehend the fact that tradition derived from nature forms the basis of applied arts, while it is the cultural realm that forms the basis of fine art. This age-old dichotomy between nature and culture is extremely important to the crafts field and should not be abandoned without a great deal of thought. As anthropologist Claude Lévi-Strauss points out, we need to distinguish between the "universal and unchanging [that is nature] from what, being dependent on a system of norms, is capable of variation from one society to the next."[15] Since the crafts stem from nature, they rest on a structure that is universal and unchanging, offering the possibility of engaging issues that reach across social and cultural divides. This is something that crafts people need to recognize as they seek a structure upon which to create meaning in the postmodern world.

tradition and the laws of nature

Applied-art objects are easily identified because of their origin in nature, but there is another major reason why these objects constitute a kind of living memory, linking past and present, that is still a recognizable part of tradition. The applied arts are bound by the laws of physics, which pertain to both the materials used in their making and the substances and things to be contained, supported, and sheltered. These laws are universal in their application, regardless of cultural beliefs, superstitions, geography, or climate. There is no way around the fact that containers, shelters, and supports must be functional. If a pot has no bottom or has large openings in its sides, it could hardly be considered a container in any traditional sense. Peter Voulkos's *Rocking Pot*, for example, with its inverted form and openings, is more like a ritual object of sculptural proportions that is derived from a pot form than it is a traditional stoneware pot. On the other hand, Betty Woodman's *Pillow Pitcher* of glazed earthenware is perfectly functional as a container.

Since the laws of physics, not some arbitrary decision, have determined the general form of applied-art objects, they follow basic patterns, so much so that functional forms can vary only within certain limits. Buildings without roofs, for example, are unusual because they depart from the norm. However, not all functional objects are exactly alike; that is why we recognize a Shang Dynasty vase as being different from an Inca vase. What varies is not the basic

Judy Kensley McKie, *Monkey Settee*

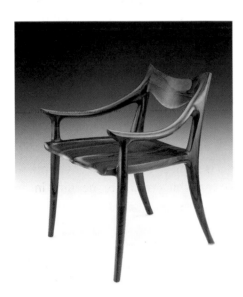

Sam Maloof, *Michael W. Monroe Low-back Side Chair*

form but the incidental details that do not obstruct the object's primary function. Judy Kensley McKie's *Monkey Settee* and Sam Maloof's *Michael W. Monroe Low-back Side Chair* are both basically made of wood. McKie's is walnut with bronze armrests in the form of monkeys, showing the influence of tribal art, particularly Ashanti stools; Maloof's chair is all zircote wood, streamlined with the look of functional efficiency. Despite these differences, the two objects closely echo each other and are readily recognized as chairs. Even McKie's animal armrests are similar in form to those of Maloof, although his are abstract. In the same way, even though John Prip's *Coffeepot* and Ralph Bacerra's *Teapot* are made of completely different materials—Prip's is of silver and ebony, Bacerra's of glazed porcelain—both have the same basic function and are subject to the same physical laws. Their spouts rise above the lid to prevent the liquid from spilling out when the pot is being filled; the finials on the lids are tall so they will stay cool, and, both pots have handles opposite the spout for better leverage and balance. As a result, they closely resemble each other, even though Prip's form reflects the clean lines of modern industrial design, while Bacerra's displays the influence of pop art, popular culture, and kitsch.

Sensitivity to physical laws is an important consideration for the maker of applied-art objects. It is often taken for granted that this is also true for the maker of fine-art objects. To do so misses a significant difference between the two disciplines. Fine-art objects are not constrained by the laws of physics in the same way that applied-art objects are. Sculptures must, of course, be stable, which requires an understanding of the properties of mass, weight distribution, and stress. Paintings must have rigid stretchers so that the canvas will be taut, and the paint must not deteriorate, crack, or discolor. These are problems that must be overcome by the artist because they tend to intrude upon his or her conception of the work. For example, in the early Italian Renaissance, bronze statues of horses with a raised foreleg usually had a cannonball under that hoof. This was done because the cannonball was needed to support the weight of the leg. In other words, the demands of the laws of physics, not the sculptor's aesthetic intentions, placed the ball there. That this device was a necessary structural compromise is clear from the fact that the

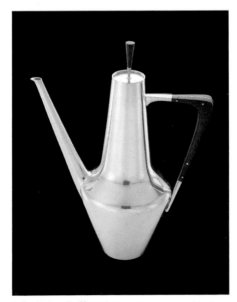

John Prip, *Coffeepot*

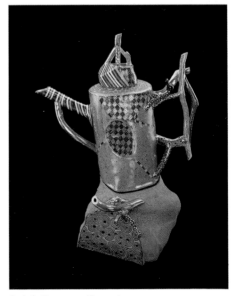

Ralph Bacerra, *Teapot*

cannonball quickly disappeared when sculptors learned how to strengthen the structural armature within a statue with iron braces (iron being much stronger than bronze). Thus the long-desired pose of a rearing horse became a reality.

Painters also had problems to overcome. When they created frescoes in the fourteenth century, it was difficult to attain certain colors, especially those made from heavy metals such as white lead and vermilion (mercuric sulfide). Fresco technique involves painting on wet plaster with a water-based paint. In principle, the paint seeps into the wet plaster, staining it so that when the plaster dries, it becomes a permanent image. Heavy metal colors were a problem because they turned black when exposed to the oxygen in the air. Fresco painters were forced to find substitutes for these colors or paint *a secco*, that is, they waited until the plaster had dried and then painted on top of it. The result was not nearly so permanent as true fresco, but it was a practical solution. In a similar effort to overcome the limitations of a medium, oil paint replaced tempera in the mid-1400s because the luminosity desired by painters could not be achieved in tempera.[16]

Even though the fine arts in the twentieth century, especially the process art and anti-formalism of the late 1960s, treat materials in new ways, the basic difference in attitude toward materials between fine art and applied art remains relatively constant.[17] It would therefore not be too great an exaggeration to say that practitioners of the fine arts work to *overcome* the limitations of their materials, whereas those engaged in the applied arts work *in concert with* their materials.

materiality and opticality

Another important feature of applied art makes it different from fine art, a difference that is betrayed by the terms used in these fields. When we refer to the fine arts, the most frequently used terms are "painting" and "sculpture." Technically these are descriptive terms that refer to the processes used in creating the artwork, that is, painting and sculpting. However, the terms only loosely retain this technical sense because they are commonly used for works created by means of a wide variety of processes. For example, not all sculptures are sculpted; many are modeled in clay, cast in bronze, or carved in wood. Modern sculptures are often welded or even assembled from various materials, using many different techniques in the same piece. As for the term "painting," it includes many works that are not painted. Some are done in oil stick or with a palette knife, not a brush; some combine painted areas with collage, as seen in the work of Georges Braque and Pablo Picasso dating from the years just before World War I. Thus when the term "sculpture" is used, it refers to a vast array of three-dimensional works. Similarly, when the term "painting" is used, it refers to the general category of pictures. This would include a variety of two-dimensional works, even photographs.

We tend to be more precise when discussing aspects of applied art, making subtle distinctions between materials and processes. We not only identify an object as made of ceramic, glass, wood, fiber, or metal but also distinguish between types of ceramics by identifying specific processes and materials (stoneware, earthenware, porcelain, raku, low or high fire), types of glass (plate, crystal, blown, mold-made), and types of fiber work (silk, wool, cotton, felt, woven, gauze, embroidery). When it comes to woodworking, we are sensitive not only to different types of wood (such as oak, ash, mahogany, rosewood, ebony), but also to process (turning, joining, bending, laminating).

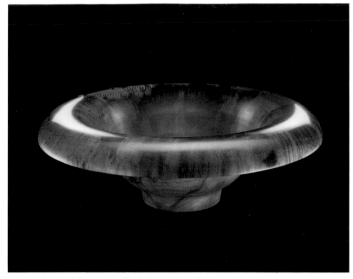

Edward Moulthrop, *Rolled-Edge Bowl*

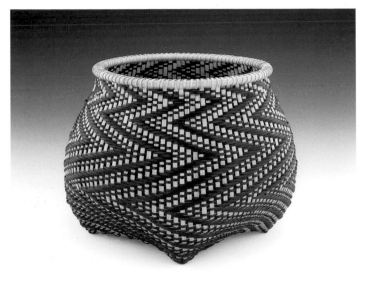

Billie Ruth Sudduth, *Fibonacci 5*

Why should this sensitivity to material in applied art not have a close parallel in fine art? This question leads us back to an earlier observation that the maker of fine art works to *overcome* material, whereas the maker of applied art works *in concert with* material. The latter idea evolved from a series of intricately connected factors. First, as previously noted, applied-art objects must be functional, so attention must be given to form. This is not an arbitrary consideration because the laws of physics determine how well a form will function. In this regard, Edward Moulthrop's *Rolled-Edge Bowl* is a wonderful container for something like fruit, but its flat, broad shape makes it ill suited for pouring liquids. Second, both form and function are intricately related to material. It is easier to make ceramic bowls or baskets round rather than square, and, conversely, it is easier to make wood boxes square rather than round. By the same token, tightly woven baskets are less efficient for holding liquids than ceramic or glass containers; baskets are much better than ceramic or glass for carrying grains and foodstuffs because they are not as fragile, heavy, or airtight. Foodstuffs tend to mildew or rot if kept in containers that don't "breathe." Thus, Billie Ruth Sudduth's *Fibonacci 5* basket functions extremely well for the storage of foodstuffs.

It is for reasons such as these that the maker of traditional applied-art objects develops a keen interest in materials. To make a properly functional object, one must know and understand the physical properties of materials in order to choose which will be most appropriate for a specific object. The maker must also know the properties of the materials (liquids, grains, solids, even the human body) that the object is to contain, support, or shelter. Otherwise, it would be impossible to make objects that carry out their functional purpose to any reasonable degree.

While the maker of applied-art objects has developed a keen interest in materials, this is not the case for the fine artist, whose principal concern is usually how the object looks. Whether a sculpture is made of painted aluminum or painted lead is not important. It makes a significant difference, however, to the maker of functional objects, whether these be lawn chairs, furniture, or baskets. The laminated mahogany and steel *Rocking Chaise* by Michael Hurwitz is a case in point; lead would be an unacceptable substitute even if it looked the same as laminated wood. However, the use of acrylics or oils matters less to a

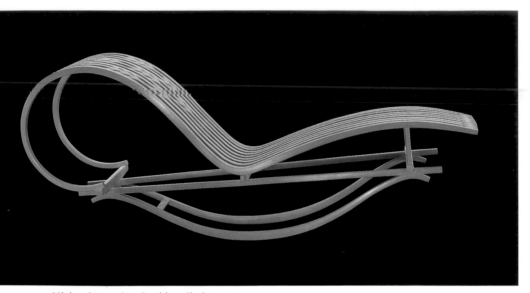

Michael Hurwitz, *Rocking Chaise*

painter than how the work ultimately looks. Granted, the desired effect may be more easily achieved with one rather than the other. It is still the effect, the look, that the painter desires above all else.

If we can say that in the realm of fine art the maker is first concerned with the optical properties of objects, by the same token, it is true that the maker of applied art is above all concerned with the material properties of objects. If the fine artist works to overcome the material, it is in order to create optical effects; if the applied artist works in concert with material, it is because the properties of materials are essential to form and function. In short, it is a matter of the difference between an optical basis in fine art and a tactile basis in applied art. The fine artist is an "image" maker, whereas the applied artist is an "object" maker.

technique and the expressivity of material

Someone once remarked that "fine artists give lectures, while crafts people give demonstrations."[18] Whether or not this was meant to belittle crafts is unknown. It is, however, a very astute observation because it goes to the heart of the differences between the two practices. In the typical lecture by fine artists, they may discuss how their work is made, but it is almost never demonstrated. Instead, they show slides of their work arranged in chronological order, give dates, media, and a general impression of their artistic interests at the time the work was made. By contrast, people working in the craft tradition go to great trouble to organize live demonstrations. They assemble materials, arrange equipment, and then execute works, explaining procedures while an audience watches.

In his well-known book *The Shape of Time: Remarks on the History of Things*, George Kubler obliquely commented on this when he noted that "a great difference separates traditional craft education from the work of artistic invention." He writes, "The former requires only repetitious actions, but the latter depends upon departures from all routine. Craft education is the activity of groups of learners performing identical actions, but artistic invention requires the solitary efforts of individual persons."[19] This distinction between what Kubler calls "artistic invention" and craft is emphasized as he argues that the practitioners of individual crafts cannot communicate with one another "in technical matters but only in matters of design."[20]

Kubler's observation about "artistic invention" is debatable, but he is quite correct in asserting the importance of technique for traditional craft. In fact, he does not emphasize technique enough. It is not some fetishistic obsession on the part of the applied artist, but an essential feature inherent in traditional craft practice. Technique, after all, is directly related to material, and material is directly related to function. To know which materials to use for a specific object requires a keen knowledge of their physical properties—which materials

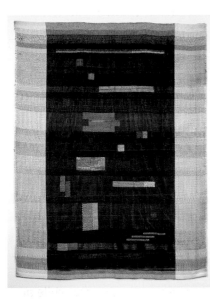

Richard DeVore, *Untitled (#403) Vase*

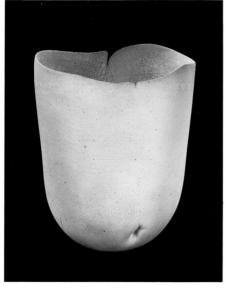

Anni Albers, *Ancient Writing*

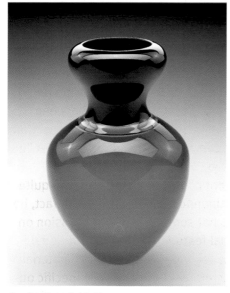

Sonja Blomdahl, *B 1095*

will withstand prolonged use, which are impermeable or pliable, what is their tensile strength, and so forth.

But this is not all; the maker of traditional craft must also know how to work the material into the desired object. This is seldom a simple process of going from raw material to finished product. Quite the contrary. One must first select the proper material, then work the material through several stages before beginning to form the object. Going from raw fiber such as wool, cotton, or linen to fabric involves sheering or picking, then carding or separating, spinning, and finally weaving on the loom. For ceramics, one has to select the proper clay, then mix and wedge it before beginning the process of forming the object. After it has been formed comes the delicate process of controlling the temperature while firing the object in the kiln. The working of glass and of metal is equally complex.

Today many of these stages have been taken over by commercial specialists, but the working of material is still a very difficult and sensitive procedure, requiring a great deal of intellectual and practical knowledge as well as motor skill. This is not to say that physical control—what is often referred to as eye–hand coordination—is not also necessary in the practice of fine art, but here one is engaged with the material only to the extent needed to overcome it. In traditional oil painting, for example, the artist's intention is to make the image come alive, not to have the viewer distracted by the material used to create the image. Whether the painting is done in oil or tempera is not a major concern of the artist, nor is it intended to be for the viewer. The painting is first and foremost a picture, and what is pictured is important. Historically, the same can be said of sculpture; what is "sculpted" is the central focus of the piece, not the material of which it is made.

In traditional crafts, however, it is difficult to separate the making from what is made. That is why the physical action of making, the technique involved, is never far from the description of the object. We commonly speak of weaving cloth, of blowing glass, of throwing pots, of smithing metals, of turning, bending, or joining wood. In traditional craft practice material is something to work with in the effort to create meaning. To do this, the maker must learn how to handle material. This "handling" is learned, as Kubler points out, by repeating the same action over and over until it has become second nature to the hand. Only in this way is it possible to achieve the technical proficiency seen in Richard DeVore's *Untitled (#403) Vase* of multiglazed stoneware, or Anni Albers's cotton and rayon weaving *Ancient Writing*, or Sonja Blomdahl's blown-glass vase *B 1095*.

By contrast, the fine arts traditionally focus on the way a work looks, certainly not on how it feels to the touch (one is seldom encouraged to touch paintings or sculptures). Granted, in many cases the "look" sought by the artist is that of material things, for example, the look of rough clay tiles, a satin gown, polished wood furniture. But this is always an optical sensation that has no tangible relationship to the actual object; the sensation gained from touching a passage in an oil painting depicting satin has no physical connection to the touching of real satin. For this reason, fine-art students hone their abilities to capture optical sensations by looking at things—the model, the still life, the landscape. Their chief concern is with "seeing" the thing to be rendered. Although many students may use the same model, each produces a different image because each sees the model from a different position in space. This would not be the case if the same model was used to make a piece of furni-

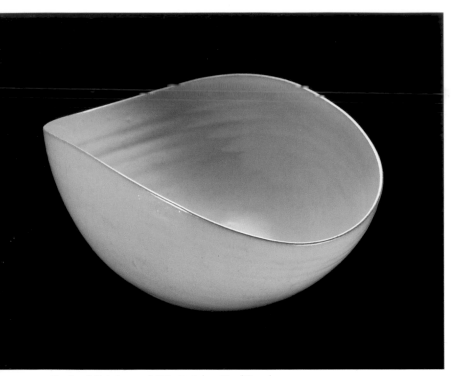

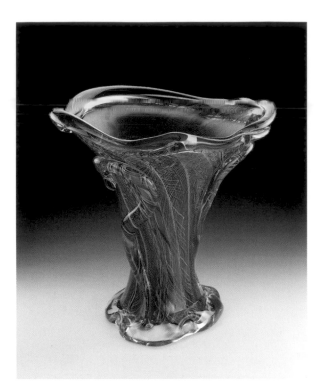

Gertrud Natzler and Otto Natzler, *Oval Bowl*

Fritz Dreisbach, *Ruby Wet Foot Mongo*

ture. It is also revealing that works of fine art traditionally focus on titles, whereas applied-art objects traditionally focus on materials and processes.

The connection between material and technique goes far beyond the functional physicality of the object. Technique has developed in ways that exploit the natural properties of material as an expressive vehicle. For example, Otto and Gertrud Natzler's *Oval Bowl* leaves visible the throw marks left by the fingers when the wet clay was being shaped on the wheel. By squeezing the rim of the bowl while the clay was still soft, an oval was formed, capturing the fluid property of the clay and creating a wavelike form that seems to ripple through the throw marks into the body of the vessel. In Fritz Dreisbach's glass vase *Ruby Wet Foot Mongo*, the technique of working molten glass is readily apparent in the fluidity of the form and the way the glass puddles at the foot and melds at the rim. These formal features enhance the properties of glass, notably its transparency, allowing light to pass through the piece as well as reflecting off its surface to create a "wet" look.

The subtly beaten surface of Alma Eikerman's sterling silver and red brass *Balanced Bowl* also reveals a communion of technique and material. The technique of hammering silver exploits the deep, richly reflective quality of the metal to create a softly focused shimmering of light and shadow across its surface. A similar effect is seen in John Paul Miller's gold and enamel *Pendant/ Brooch*. Its fleshy, organic shape is enhanced by the warm, soft color of gold as well as the fact that gold can be granulated to simulate delicate floral stamen; such an object made of wood, ceramic, or lead would not have the same feel. This harmony between technique and material is also evident in Lia Cook's *Crazy Too Quilt* of dyed rayon and acrylic. The physical properties of the fibers in Cook's work give it a luminescence that enhances her intricately woven undulating patterns, just as the luxuriousness of the Honduran rosewood, Australian lacewood, and other woods used by Jere Osgood in his *Cylinder-Front Desk* or the tropical woods used by Stephen Paulsen in his *Scent Bottles* heightens the quality of their work.

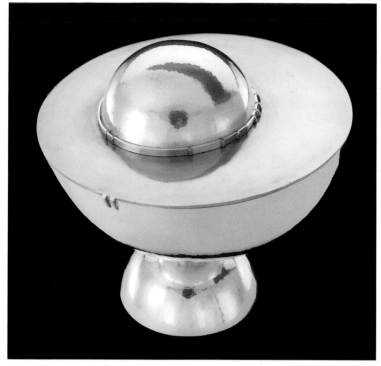

Alma Eikerman, *Balanced Bowl*

John Paul Miller, *Pendant/Brooch*

Lia Cook, *Crazy Too Quilt*

In all of these objects, materials are treated in ways that coax out the intrinsic properties of the material. In a sense, this is a dialogue with nature conducted through technique and material. The figuration and grain of wood, the transparency and molten quality of glass, the reflectivity of silver and the warmth of gold, the glossy sheen and luminosity of rayon, and the wetness of clay are all special properties of these materials, not simulated effects. And when exploited by a person who is skilled and knowledgeable, they become expressive vehicles, making applied-art objects come to life by the way they enhance form.

applied-art objects and the body

The importance of technique may explain in part the connection between applied-art objects and the human body. When we speak of mastering technique, this, of course, refers to training the hand through repetitive actions to create the object by using a certain method. This is analogous to practicing scales on the piano. But there is more involved than this, for it is in the process of the hand executing the technique that the object comes to be formed. In this sense, the object actually has its origin in the hand of the maker (not in the brush, chisel, burin, or pencil). And the various parts that are formed by the hand during construction—the neck of the vase, the handle of the pitcher, the circumference of the glass, the girth of the basket between hip and hand—all retain the shape and scale of the hand in their final form. Thus it is not surprising that well-made containers of all kinds fit the hand in the most gentle and natural ways.

All of these properties spring directly from the execution of technique. The special relationship of these objects to the hand is also connected to their origins and purpose, that is, the serving of bodily needs. When one holds a ceramic pot or pitcher, it fits the palm so that the fingers can grasp it, but the weight and balance must make it easy to use. Similarly, the total construction of glass vases or woven baskets must be geared to the hand. Handles must be neither too thick for the hand to grasp nor too thin to cause cuts on the palm; the surface should not be too rough on the skin nor so smooth that the object would slip from one's grasp. To be useful, it must also be portable—light enough to be lifted and moved, and shaped so that it can be grasped firmly. For large objects, this is most often done by using forms such as ovals, which allow the hand and arm to reach around the object at its narrowest point, or by constructing "hand holds" such as protruding lips or simply adding handles.

This principle is not a feature of objects in general, which soon becomes apparent when one attempts to move things designed without consideration for the human body. Many shipping packages, for example, are almost impossible for one person to handle, even though they are relatively light in weight, because their design ignores the human body in favor of the contents. They are awkward, unbalanced, too smooth to keep hold of, if a grasp can even be established. This is not so with the well-made applied-art object.

Small objects, especially items like clothing and jewelry, have an even more direct relationship to the body. The choice of material and technique is extremely important for clothing, so that warmth can be provided and the sun or rain kept off the body. Jewelry must fit properly, and the materials from which it is made must not be too heavy nor harm the skin or prevent movement. Ronald Hayes Pearson's *Neckpiece* exemplifies jewelry crafted with a concern for the wearer's body. Made of sterling silver that has been flattened in order to take advantage of the metal's natural flexibility, the neckpiece is contoured so that it rests comfortably on the shoulders.

This special relationship to the body is also important in semiportable and even more or less permanent objects such as supports and shelters. Tables and desks must be the correct height, allowing the hands and elbows to be above the top plane. The underside and legs must accommodate a person's lower torso and legs. All of these requirements are evident in Garry Knox Bennett's *Boston Kneehole Desk*, made of Honduran rosewood, maple, aluminum, brick, and bronze; even his title speaks to these concerns. Chairs must conform to the human body and not be so high that the sitter's legs cannot

Ronald Hayes Pearson, *Neckpiece*

Garry Knox Bennett, *Boston Kneehole Desk*

rest comfortably on the floor. It is not by chance that many applied-art objects are described in terms of the parts of the body they serve: containers have handles; chairs have seats, backs, and arm and foot rests; beds have head and foot boards. ("Brace," the root of the word "bracelet," comes from the Latin word for arm.)

fine art and the body

Turning our attention to the fine arts, we observe that these objects do not relate to the body in the same way that applied-art objects do. Indeed, the two fields relate to the body in diametrically opposite ways.

In 1962 the sculptor Tony Smith made a work that he titled *Die*. A six-foot cube painted black, it is considered a classic minimalist sculpture. When Smith was asked, "Why didn't you make it larger so that it would loom over the observer?" he replied, "I was not making a monument." When asked, "Then why didn't you make it smaller so that the observer could see over the top?" he replied, "I was not making an object."[21] What Smith was making was a sculpture. The size, six feet high, is very significant; it is the size of the ideal human body. Leonardo da Vinci's universal man, a standing figure with outstretched arms circumscribed within both a circle and a square, would fit in this cube.[22] This was Smith's reason for insisting on a height of six feet. However, the important point for our discussion is that the body relates to this sculpture, even though it is abstract, as to another body in space; it is not a relationship between the body and something that extends or adorns it, something that can be held like an applied-art object. This body-to-body relationship also occurs with figurative sculpture. A statue of a human figure is conceptually engaged by the viewer as one would engage another human being, not as one would an object.[23]

The difference between the two disciplines is not a question of the generally smaller size of applied-art objects compared with the generally larger size of sculptures. Certainly a small version of Smith's *Die* could be held in the

hand, making it object-like. However, it would still not fit the hand in the way that an applied-art object would; the corners would jab at the palm, so that the cube would have to be held very gingerly. The same can be said of figurines; despite their small size, they do not fit the hand, and the protruding body parts would cause the same problems as the corners of Smith's cube. If the figurine had a rigid, Egyptian-like pose without protruding appendages, it could be hand-held but would lose its identity, becoming more like a stick or club. The point is that grasped in the hand, the work loses all sense of being a human figure. Consequently, any relationship between the human body and its figurative reproduction is lost. This does not happen to the applied-art object. Quite the contrary; it is in the using, the holding that pots, bowls, and baskets come alive. It is on the human body that clothing and jewelry complete their function. And supports such as furniture establish a relationship to the body, using it by fitting its contours, thereby serving the body's needs; in a very real sense, these objects physically embrace the body and protect it.

function in late modern industrial society

Serving the body's needs, as previously noted, is one of the essential and originating aspects of applied art, allowing us to say that these objects derive from nature and, unlike fine art, are not a purely social or cultural construction. This remains one of the most contentious issues in the field, in part because in the twentieth century fine artists have insisted that their work is not functional, that it is done with no practical purpose in mind. It is obvious that applied artists would be sensitive to this viewpoint because their concern for function denies them the prestige of fine art. The question, then, is why should fine artists be so insistent on separating themselves from function?

One reason is that the industrialized world has witnessed such a proliferation of machine-made, use-oriented products—from three-dimensional objects to advertisements and billboards—that fine artists have had to insist upon the nonfunctionality of their work to differentiate it from commercially oriented objects. Otherwise, the fine arts would be in danger of being swallowed up by them.[24] And here lies the crux of the matter for applied art. Because these objects are useful, it seems logical to identify them with or even compare them to machine-made commercial products. Even though this is not the way the applied arts are intended to be perceived, when this happens, it becomes apparent that these objects cannot possibly compete on the same terms with industrially produced items. Applied-art objects are lacking, not only on the basis of cost and replicability but also in terms of the aesthetic qualities associated with machine production.

This leads to a second reason why function is such a sensitive issue for both applied art and fine art. We have accepted the idea that industrially produced objects should be purely functional. However erroneous this belief, it is widely held, which helps explain why the issue of function versus nonfunction has become so highly charged in the twentieth century rather than, say, in the Renaissance, when all objects were handmade.[25] This is not just a matter of the machine-made versus the handmade. Rather, it is the twentieth-century belief in purely functional efficiency as a near absolute value for judging utilitarian objects.

The problem arising from this viewpoint is that an object can be consid-

ered 100 percent functionally efficient only if both form and material are dictated solely by the laws of physics as related to efficiency and cost. There will be no possibility of the maker's imagination entering the equation. He or she will have little or nothing to say about the object's appearance. Purely functional efficiency vis-à-vis cost will be not just the overriding factors; they will be the only factors. In short, the making of such objects will be an act of engineering, not of artistry or craftsmanship. Unfortunately, this attitude has done much to shape the way we think about applied-art objects today. Their making is often perceived as a quaint historical curiosity, an anachronism, while "real" functional objects are engineered by designers in a cold and calculated way for mass production.

This is one of the legacies to the arts of twentieth-century industrial culture; it has shaped our views to the extent that the value of all objects tends to be based on their perceived efficiency. The unfortunate result is to equate applied-art objects with those industrially produced, even though the origins of their functional shapes are vastly different.[26] The functional shape of applied-art objects derives, as previously noted, from the hand. Industrially produced objects, in contrast, often begin with traditional applied-art shapes that are then altered so that they can be produced by machines. As a result, we often get metal pitchers with thin strap handles that hurt the hand and are difficult to hold. Such inconveniences are supposedly compensated for by the "look" of modern efficiency evident in the sleek design or by the attractive price.

In self-defense, fine art has generally disavowed any connection with function, creating a rift between fine art and applied art that has deepened since the pluralist decade of the 1970s. The disaffection is needless because both fields face similar problems of identity and value stemming from late modern industrial production and postmodern electronic-media technology. But more importantly, both are linked by their expressive intentions, which make each of them a form of art. Even though the maker of applied art is confronted by the demands of function, these have never deprived him or her of expressive choice, as seems to be the case with industrial production. Far from it! Like the magical and religious rituals that were the origin of fine art, function is a constraint that does not hinder applied art. On the contrary, it gives purpose, identity, and meaning to these objects, serving as the vehicle through which a unique and meaningful expression emerges. Thus applied art is very much like fine art and very different from a piece of industrial equipment, possessing a constancy of purpose that is real and necessary. For an applied-art object—a container, support, or shelter—is not a cultural construction, a representation, or a substitute for something else; it is the real thing.

Since very early times, the applied arts have been recognized as expressive vehicles, which explains why the term "applied arts" has been employed rather than simply "useful objects." Woodworker and writer David Pye hints at this in his book *The Nature and Aesthetics of Design*. As he notes, "Anyone can verify by simple observation two important facts. The first is, that whenever humans design and make a useful thing they invariably expend a good deal of unnecessary and easily avoidable work on it which contributes nothing to its usefulness."[27] This "unnecessary and easily avoidable work" is done solely for expressive purposes and is apparent in the earliest manmade objects known to us. Almost without exception, to

Edith Bondie, *Porkypine Basket*

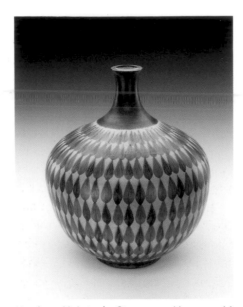

Harrison McIntosh, *Stoneware Vase no. 661*

some degree, such objects are more than purely functional, better made than they need to be and often embellished in some way. In making ceramics, for example, time is spent smoothing the surfaces; attention is given to the shapes of vessels, the rims of openings, and the edges of spouts. In making cloth, care is taken in carding and spinning fibers in order to maintain a consistent diameter of thread and a regularity of weave. In glass, clarity and consistency of material and symmetry of form are sought. Great care is taken in the making of baskets, beginning with the cutting of reeds or splitting of wood, so that form is symmetrical and logically consistent.

What we encounter in applied-art objects is nothing less than the urge for self-expression, an urge unique to human beings. It is so ubiquitous across cultures, both in terms of time and space, that its origins must lie somewhere deep within the human psyche, perhaps even at the genetic level. This urge accounts not only for the great amounts of time and energy spent making things better but also for the desire to enhance their aesthetic quality through the addition of decorative elements. Objects are colored with paint or dyed; clay is incised with designs and shapes; patterns are woven into fabrics and baskets, all in order to make them pleasing to both touch and sight.

This urge to "make better" has been the tradition of applied art since prehistoric times. It is apparent today in Edith Bondie's *Porkypine Basket* of woven black ash. Rather than employing the easiest method possible, Bondie has carefully twisted her material at regular intervals to create sharp, pointed protrusions, producing a basket that suggests a piece of exotic fruit. The way Edward Moulthrop centers the wood in his turned *Rolled-Edge Bowl* causes the grain to accentuate the overflowing/turned-under rim. Even more complex is the process used by Dan Kvitka in his vase of vero wood. He has shaped it from a carefully chosen and centered piece of crotch wood so that the knots create four symmetrical circular patterns on the shoulder and four star shapes near the neck. In a similar way, Harrison McIntosh enlivens his *Stoneware Vase no. 661* with rows of repeated teardrop shapes. Covering the vase, they seem to expand and stretch across the body and then rush with greater speed toward the neck.

These works, like those of all good applied artists, continue a long tradition of making objects in ways that do not necessarily increase their functional efficiency. Priority is not given to cost-effectiveness or speed of production, but to enhancing the appearance of the object. This is evident in the way it is formed, the choice of material used, the manner/technique in which the material is worked, and the way it is embellished.

aesthetic quality: revivals and metaphors

The urge to expression, so basic that it is tantamount to being primal, would mean little if it were not connected to an innate and deeply felt aesthetic sen-

sibility. In traditional applied arts, this is expressed by making useful objects better than they need to be and enhancing them through the exploitation of material, design, and pattern. The result is beauty for the eye to behold and the body to touch during use. This kind of aesthetic quality cannot be found in other kinds of objects, not even in the fine arts.

The uniqueness of this sensibility is not the justification for the inordinate amounts of time, energy, and resources—sometimes very precious resources—that traditionally have been expended on otherwise simple objects for every-day use. These efforts are justified by the way beauty transforms the ordinary into the special, the way it changes the necessary into the edifying.

The term "shelter" means not only protection from the elements but also providing a space sensitive to the well-being of the body, both physically and psychically. It cannot be the kind of space whose scale diminishes the body by dominating it, nor one whose materials and shape are inhospitable. To this end, ceilings cannot be so low as to force one to stoop, nor so high as to make one feel unprotected. A proper shelter, in other words, should be a place that welcomes us, providing relief from the difficulties and exigencies of the outside world.

In this sense, the traditional home or shelter stands in contrast to the natural world, the profane, by providing a place of respite, security, comfort, even sanctuary. (It is not by chance that buildings used for religious services are referred to as "houses of worship.") For the home to fulfill its role, the objects in it must provide a sense of delight, harmony, even wonder. So important has this been since the earliest times that even the simplest applied-art objects have been carefully built and decorated to make them special. Eventually, as the needs they served were elevated, they were transformed into precious instruments for social and religious rituals relating to the life cycle, to planting, harvesting, fertility, and regeneration. The communal eating that marks our celebration of important events—birthdays, weddings, holi-days, holy days, funerals—and the custom of drinking a toast to someone's health can be traced to those early rituals.

In this age of doubt and confusion that began with the pluralist decade of the 1970s, the aesthetic quality of traditional applied-art objects remains one of the few vestiges of the ancient impulse to transform basic physical necessities into shared rituals. Today this is more important than ever, for, as Jacques Ellul points out, the situation in our society is that "of the 'lonely crowd,' or of isolation in the mass." In such a society, Ellul contends, the essential man is the "lonely man," and "the larger the crowd in which he lives, the more isolated he is."[28] According to critic Donald Kuspit, this is pluralism in action; it is "ingeniously nondisruptive for all its discontinuities" because one has difficulty articulating one's loneliness in the face of "the overwhelming evidence of togetherness with all others in the crowd."[29] The aesthetic quality of applied-art objects can help break through this unarticulated loneliness. It can do this by elevating basic human interaction to a level at which it becomes a metaphor for deeper shared experiences that must exist at the core of a society if it is to survive, for such shared experiences are the basis of civilized life.

Recognizing this fact, many applied artists have sought to imbue their objects with the aura of shared ritualistic experiences. Flora Mace and Joey Kirkpatrick do this by imitating food, one of life's necessities. Their *Fruit Still Life* consists of two apples, a pear, and a plum, all of blown glass. Their large

Flora Mace and Joey Kirkpatrick, *Fruit Still Life*

Richard Mawdsley, *Feast Bracelet*

Richard Marquis, *Teapot Goblets*

size (the pear is over twenty-five inches high) makes them symbols of necessity and the hope for abundance. Richard Mawdsley's large *Feast Bracelet,* made of sterling silver, pearl, and jade, features a miniature table, set and silently awaiting guests to partake of its fruit-filled delights. More directly ritualistic are the works of Albert Paley, Abrasha, and Howard Ben Tré. Paley's forged steel, brass, copper, and bronze *Portal Gates*, with their organic, undulating form, establish a ceremonial entrance that recalls nature as it "sanctifies" the space it encloses. The stainless-steel *Hanukkah Menorah* by Abrasha transforms a simple system of cone-shaped oil lamps into a deeply meaningful religious object. Ben Tré's *First Vase* achieves much the same effect, but his means are somewhat different. He takes a simplified vessel shape, greatly enlarges it (to a height of more than forty-three inches), and casts it in glass so that it is translucent; he then gilds the interior so that when illuminated, a spiritual/magical light glows within the object.

In an effort to recapture something of the reverence of traditional religious objects, many applied artists have taken to appropriating their forms. The elaborate ritual objects of the Eastern Rite Catholic Church are reflected in Valerie Timofeev's *Chalice*, made of plique-à-jour, silver, gold, and various jewels. Renie Breskin Adams, in contrast, uses an embroidery technique and updated traditional designs to suggest an Oriental carpet/prayer rug. In the same vein but more tribally influenced is the primitivistic jewelry made of semi-precious stones and metals by William Harper and D. X. Ross. Harper's brooch, *Self-Portrait of the Artist as a Haruspek*, resembles a talismanic figure

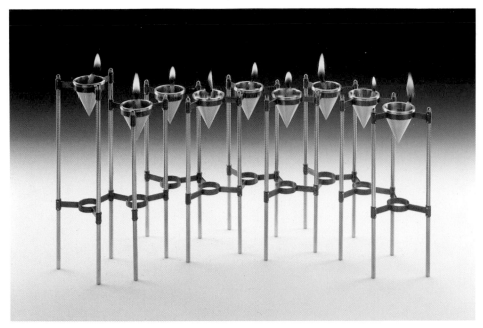

Abrasha, *Hanukkah Menorah*

of an ancient warrior, as does that of Ross. The objects by Bruce Metcalf and Graham Marks also have an anthropological look, evoking the mysteries of long-forgotten rituals. Metcalf's *Wood Necklace #11* is composed of various unusual elements, including a hand, leaves, and beads all carved of wood, as well as a tagua nut and a pre-fossil horse tooth. Similarly evocative is Marks's *Untitled #2*, a sandblasted stoneware object that suggests a shaman's paraphernalia in the way it displays what seem to be ancient cryptic markings.

These evocations of traditions, both ancient and more recent, charge the objects with a solemnity and mystery that border on the liturgical. They are attempts to reinstill a sense of wonder into contemporary everyday life. They have a more conceptual counterpart in the works of artists who exploit the basic, functional aspects of applied art through the creation of metaphorical objects. Michelle Holzapfel's turned wooden *Vase* of cherry burl has no usable interior space, and its exterior is carved to look as though it were wrapped in a cloth, making the object more a metaphor for the preciousness of containing than a functional container. Related in conception is Sidney Hutter's *Vase #65–78*. A generic vase form, it is made of horizontally stacked planes of plate glass with no interior space; more a drawing in space than an actual vase, it, too, becomes a kind of metaphor for containing as well as for the category "vase." Echoing the metaphorical aspect of Hutter's vase, but with much humor, are Richard Marquis's delicate *Teapot Goblets* of blown glass. Like something encountered by Alice during her travels in Wonderland, they are goblets superimposed on teapots,

Howard Ben Tré, *First Vase*

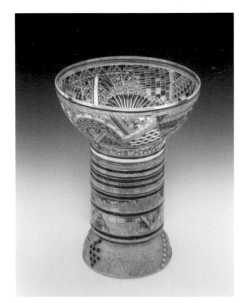

Valerie Timofeev, *Chalice*

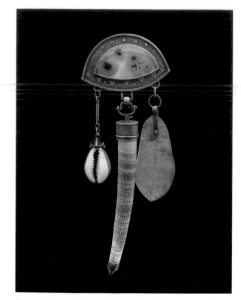

D. X. Ross, *Tides of the Centuries*

William Harper, *Self-Portrait of the Artist as a Haruspek*

Bruce Metcalf, *Wood Necklace #11*

so that filling them with liquid remains a delectably frustrating impossibility—an idea never to be realized but intriguing to contemplate.

The decidedly conceptual thrust of these works turns them into objects that explore the idea of function as metaphor. Other applied artists have done something similar by making objects that explore the concept of technique as metaphor. Separating technique from functional "objecthood," they have brought technique into the realm of the conceptual, making it operate as metaphor. In *Anatid*, Françoise Grossen creates an abstract object from natural manila and cotton rope, using a traditional weaving/braiding technique; the work suggests ceremonies and rituals by evoking elaborate courtly wigs as well as stately tiebacks for drapery. Joanne Segal Brandford does something similar in *Bundle*, a large abstract object made of wood, rattan, kozo, nylon, and paint. Its focus is also more conceptual, involved with the notion of bundling (bundling goods for storage or bodies for burial) rather than an actual bundled object.

James Makins and Wayne Higby look at the metaphorical idea of containing through illusionistic associations. In *Midtown*, Makins assembles a series of porcelain bottles with extremely exaggerated throw marks, so exaggerated that they seem precariously unbalanced, about to fall apart. Coupled with the title, this conjures up a hilarious yet disturbing illusion of New York skyscrapers in which people live. In contrast to this urban image, Higby's earthenware *Temple's Gate Pass* returns the idea of containing to its roots in the natural environment through a play of real and illusionistic landscape elements. Here containing becomes a metaphor reminding us of our continued dependence upon nature for survival.

All of these metaphorical objects are both conceptually and physically about the techniques and functions they engage. In this regard, they are like more traditional applied-art objects. They are not representations of reality but part of it, a stable and unchanging reality based in and upon nature. For the fine arts, as Sigmund Freud would say, there is no precultural real, no reality beyond representation.[30] But applied art is not based on representing something else, such as a figure, a cube, a landscape, or a person. Its origin and its traditions emanate from the precultural reality that is nature. Applied

Graham Marks, *Untitled #2*

Michelle Holzapfel, *Vase*

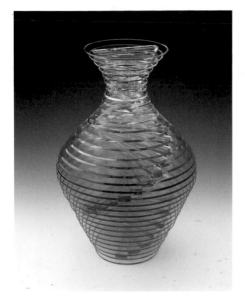

Sidney R. Hutter, *Vase #65–78*

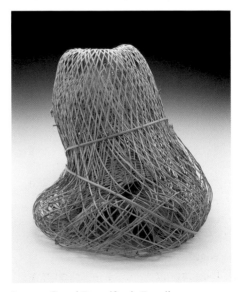

Françoise Grossen, *Anatid*

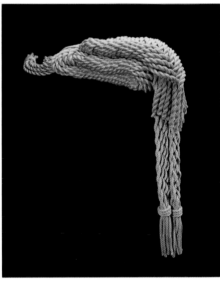

Joanne Segal Brandford, *Bundle*

art also contains a cultural component, as evidenced by its ritual uses and decorative qualities. Because of this, we can argue that applied art is nature brought into the reality of culture through its nonfunctional elements. But unlike fine art, it is never a purely cultural construction. It is a unique art form that straddles the boundary between pure nature and pure culture, keeping a foothold in each as a way of making meaning of necessity. It is this aspect of applied art that presents us with the possibility of returning to the real.

This is extremely important today, for we live in an age of spectacle, a coliseum culture epitomized by hyped-up media events and dazzling video displays. It is an age in which late modern industrial production has given us copies without originals, and postmodern electronic technology has given us images without presence or substance. The result has been a leveling down, an equalizing, of all experience. In stark contrast to this world of endless multiples and virtual realities is the aesthetic quality that comes from the tradition of applied-art objects; it is a beauty founded on tangible realities connected to genuine human needs. Because these needs are universal and real, they connect cultures across time and space, making applied art the perfect antidote to the contemporary culture of endless copies, spectacles, and simulations. The issue confronting us today is whether the shared, contemplative experiences made tangible by the aesthetics of applied art are capable of breaking this mesmerizing spell of the unreal. Can the applied arts once again focus our attention on a reality bounded by physical necessities that gives shape to our being? This reality, elevating the ordinary details of everyday life to rituals of living, can give a meaningful dimension to our wider ambitions and aspirations.

notes

1. See Calvin J. Goodman, *Art Marketing Handbook: Marketing Art in the 90s,* 6th ed. (Los Angeles: G.T. B. Press, 1991), 3.

2. *The Art Sales Index 1987/88,* 20th ed., vol. I (Weybridge, Surrey, England: Art Sales Index Ltd., 1988), 720.

3. For more on Johns's *Out the Window* and the art market in general, see Christin J. Mamiya, *Pop Art and Consumer Culture: American Super Market* (Austin: University of Texas Press, 1992), 7–13. For the auction record of *False Start,* see *The Art Sales Index 1988/89,* 21st ed., vol. I, 1069.

4. Among the numberous features in *Vogue* magazine about the artist and his wife were "Portrait of the Artist's Wife" (March 1985), 510ff, and "Schnabel's Spanish Mission" (January 1995), 152ff.

5. Matthew Kangas suggested this when he, Rose Slivka, Alan Rosenbaum, and I were on the panel "Re-Evaluation: The New Ceramic Presence" at the National Council on Education for the Ceramic Arts conference in Cincinnati in 1990. As an example of why this was so, he pointed to the "gallery" vessel, whose existence was predicated not on function but on the concept of the gallery exhibition; its dependence upon the gallery space for meaning and identity made it not unlike late modern painting and sculpture.

6. Arthur C. Danto, "Art after the End of Art," *Artforum* (April 1993): 67.

7. Octavio Paz, *Children of the Mire: Modern Poetry from Romanticism to the Avant-Garde,* quoted in Thomas Lawson, "Last Exit: Painting," *Artforum* (October 1981): 40.

8. In response to this situation, as reflected in Danto's "End of Art" theory, literary theorist Terry Eagleton writes that "For Danto, history is not so much bunk as junk. Rather like junk, the baroque, the rococo and the rest lie around awaiting our contemporary recycling. It is hard to imagine a more blatant form of collective egoism." In Danto's view, according to Eagleton, "History is just raw material…to consume, pliable stuff for our arbitrary self-fashionings." See Eagleton, "But Is It Art?," a review of Danto's *After the End of Art: Contemporary Art and the Pale of History,* in the *New York Times Book Review,* 16 February 1997, 16.

9. Painting's return to prominence was heralded by the exhibition *American Painting: The Eighties,* organized by Barbara Rose and presented at the Grey Art Gallery in New York in 1979. In the exhibition catalogue Rose quoted Clement Greenberg in her defense of painting and answered "no" to the question "Is painting dead?"

10. Jürgen Habermas, "Modernity versus Postmodernity," *New German Critique* 22 (Winter 1981), reprinted in *Postmodern Perspectives: Issues in Contemporary Art,* edited by Howard Risatti (Englewood Cliffs, N.J.: Prentice Hall, 1990), 54. Habermas's essay was first delivered in German in September 1980 when he received the Theodor W. Adorno prize from the city of Frankfurt.

11. Eagleton, "But Is It Art?," 16.

12. Thomas Lawson, "Last Exit: Painting," *Artforum* (October 1981), reprinted in Risatti, *Postmodern Perspectives,* 151.

13. See Hal Foster, "Signs Taken for Wonders," *Art in America* (July 1986) and Jean Baudrillard, *Simulations* (New York: Semiotext(e), Inc., 1983).

14. Baudrillard, *Simulations,* 10–11.

15. Claude Lévi-Strauss, quoted in Kate Linker, "Eluding Definition," *Artforum* (December 1984), reprinted in Risatti, *Postmodern Perspectives,* 210.

16. One of the most dramatic examples of this problem is Leonardo da Vinci's *Last Supper;* in an effort to overcome the limitations of fresco, he concocted various kinds of paints, which unfortunately began to deteriorate soon after he completed the work.

17. Process art usually refers to work whose form is determined by the process applied to the material, such as cutting, pouring, throwing, or scattering. For such work, the material used must be appropriate to the process. Anti-form usually refers to work that uses material in such a way that it has a loose, pliable form, in contrast to the rigid, solid forms of minimalism; instead of rigid materials such as steel or plywood, rubber, string, and vinyl were often employed.

18. This remark was relayed to me by Kenneth Trapp in conversation about this essay.

19. George Kubler, *The Shape of Time: Remarks on the History of Things* (New Haven: Yale University Press, 1962), 15.

20. Ibid., 15.

21. Tony Smith, quoted in Robert Morris, "Note on Sculpture, Part II," *Artforum* (October 1966), reprinted in *Minimal Art: A Critical Anthology*, edited by Gregory Battcock (New York: E. P. Dutton, 1968), 228–30.

22. Leonardo's drawing of this figure, taken from the *Ten Books of Architecture* by the first-century A.D. Roman writer Vitruvius, is in the Galleria dell'Accademia, Venice.

23. The photorealist sculptures of Duane Hanson are an extreme case in point that proves the rule. They are so realistic that they appear to be live people; when we carefully look at them, we get the uneasy feeling of intruding upon the psychological and physical space of others.

24. In his essay "Avant-Garde and Kitsch,"published in the *Partisan Review* (Fall 1939), critic Clement Greenberg discussed the threat to the arts by kitsch, which he saw as a product of Western industrialized culture. In a later essay "Modernist Painting," published in *Art and Literature* 4 (Spring 1963), he argued that the arts can be saved from kitsch and entertainment only if they "demonstrate that the kind of experience they provide was valuable in its own right and not to be obtained from any other kind of activity."

25. As ceramist and writer Warren Frederick has noted, in recent years an effort has been made to use the term "vessel" instead of "pot" in order to suggest freedom from function in ceramics. See Frederick, "An Aesthetic of Function," *New Art Examiner* 13, no. 1 (September 1985): 42. As for the question of function, Erwin Panofsky points out how it became a style, a look, so that actual function was often sacrificed for the look of function. See Panofksy, *Meaning in the Visual Arts* (Garden City, N.Y.: Doubleday, 1955), 12–13, especially note 10.

26. It is also worth noting that when it comes to efficiency and function, there is a tendency to compare applied-art objects with machines—as if function in applied art can be equated with function in things like airplanes or helicopters. The demands of function are completely different. Not only is the airplane or helicopter designer making a machine, but the laws of flight are more exacting than the physical laws concerning containers, shelters, and supports.

27. Pye's second observation is that "all useful devices have got to do useless things which no one wants them to do," such as tires wearing out or engines making noise. David Pye, *The Nature and Aesthetics of Design* (Bethel, Conn.: Cambium Press, 1978), 13.

28. Jacques Ellul, *Propaganda: The Formation of Men's Attitudes* (New York: Alfred A. Knopf, 1972), 8–9, 147, quoted in Donald Kuspit, "Crowding the Picture: Notes on American Activist Art Today," *Artforum* (May 1988): 112.

29. Kuspit, "Crowding the Picture," 112.

30. For Freud's remarks, see Lisa Tickner, "Eluding Definition," in Risatti, *Postmodern Perspectives*, 211.

acknowledgment

The research for this essay was supported in part by the Grant-In-Aid Program for Faculty of Virginia Commonwealth University.

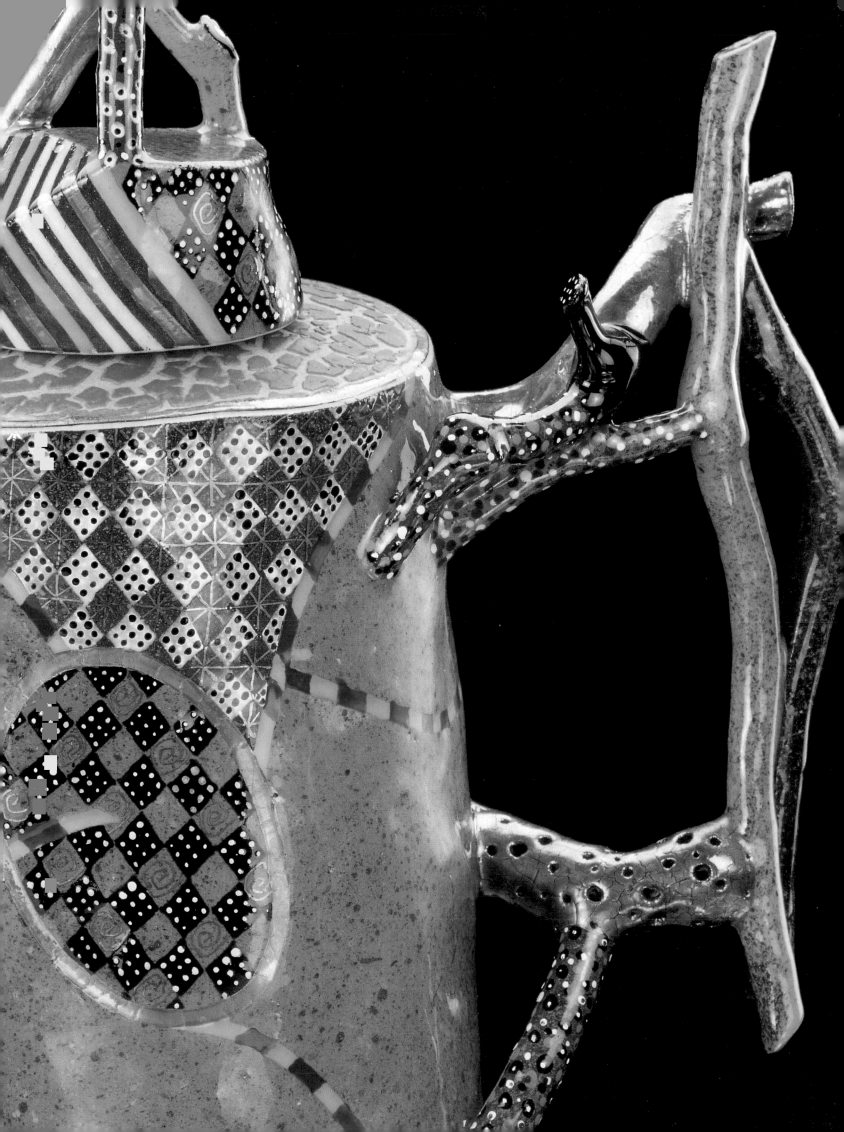

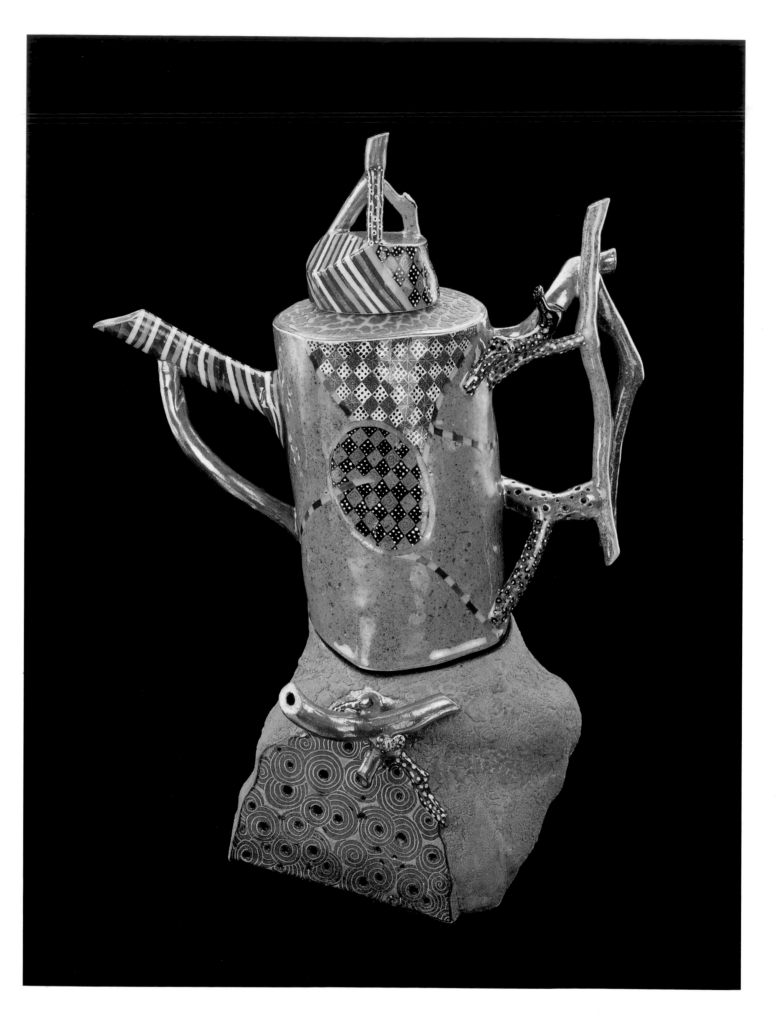

Ralph Bacerra

(opposite) *Teapot,* 1989, glazed porcelain, 41.3 x 31.5 x 24.5 cm (16 1/4 x 12 3/8 x 9 5/8 in.). Gift of the James Renwick Alliance and museum purchase through the Director's Discretionary Fund

Betty Woodman

(below) *Pillow Pitcher,* 1983, glazed earthenware, 48.3 x 40.7 x 58.4 cm (19 x 16 x 23 in.). Gift of Jocelyn and Charles Woodman

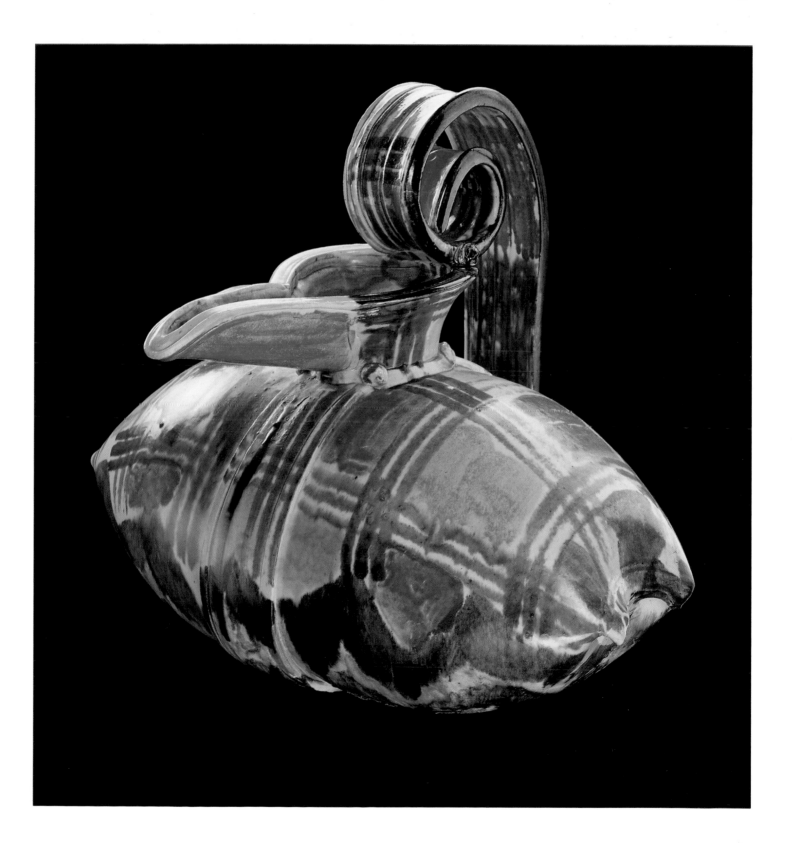

Richard DeVore

(below) *Untitled (#403) Vase,* 1983, multiglazed stoneware, 40.6 x 37.1 x 22.8 cm (16 x 12 1/2 x 9 in.). Museum purchase

Harrison McIntosh

(opposite) *Stoneware Vase no. 661,* 1966, glazed stoneware, 38.7 x 33 cm (15 1/4 x 13 in.). Gift of Catherine McIntosh

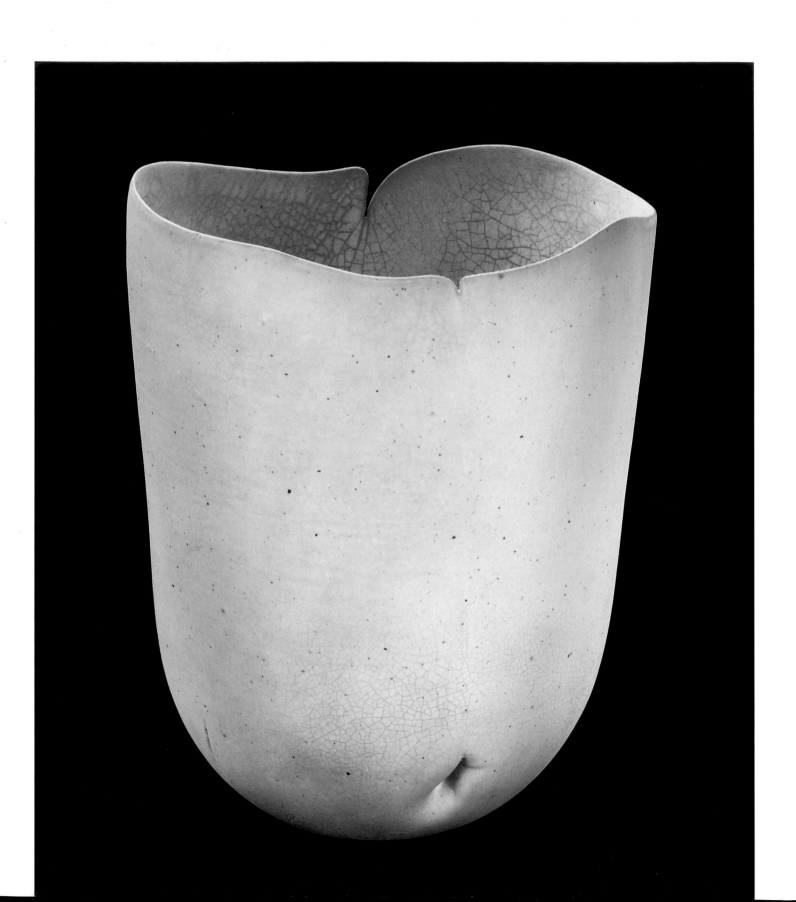

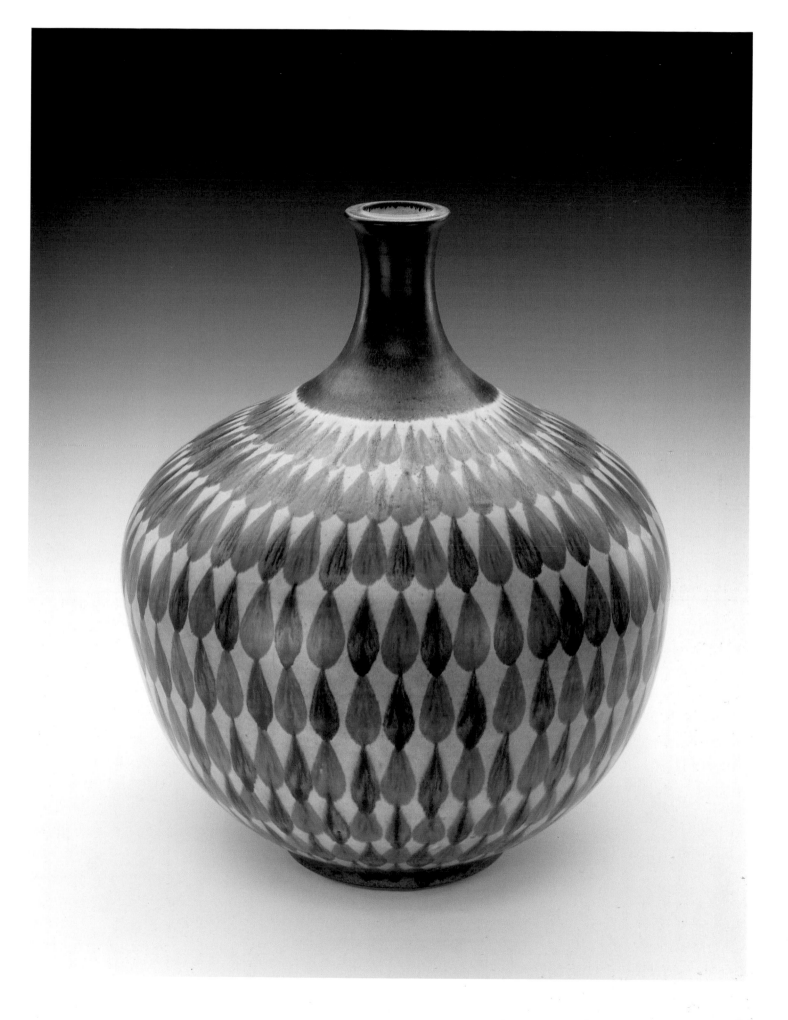

James Makins

(opposite) *Midtown*, 1991, thrown porcelain, tray: 4.8 x 67.3 cm (1 7/8 x 26 1/2 in.); bottles: 32.4 x 10.2 cm (12 3/4 x 4 in.); 44.5 x 10.2 cm (17 1/2 x 4 in.); 34.6 x 9.3 cm (13 5/8 x 3 5/8 in.); 45.1 x 9.9 cm (17 3/4 x 3 7/8 in.); 39.1 x 9.9 cm (15 3/8 x 3 7/8 in.); 49.6 x 10.2 cm (19 1/2 x 4 in.); 48.6 x 9.9 cm (19 1/8 x 3 7/8 in.); 53.4 x 9 cm (21 x 3 1/2 in.). Gift of the James Renwick Alliance and museum purchase through the Smithsonian Institution Collections Acquisition Program

Rick Dillingham

(below) *Gas Can*, 1981, glazed earthenware, 48.3 x 43.8 x 8.7 cm (19 x 17 1/4 x 3 7/16 in.). Gift of Mr. and Mrs. Joseph Luria and Trudy Luria Fleisher from the collection of and in memory of Michael Stephen Luria

Gertrud Natzler and **Otto Natzler**

Oval Bowl, 1942, glazed clay, 12.1 x 26.7 x 17.1 cm (4 3/4 x 10 1/2 x 6 3/4 in.). Gift of Mary Peterson Hartzler and James Hartzler

John Glick

Plate, 1976, glazed stoneware, 7.7 x 48.7
cm (3 x 19 1/4 in.). Gift of Susumu Hada in
memory of his wife, Martha

Robert Sperry
Plate #753, 1986, glazed stoneware, 10.3
x 70.2 cm (4 x 27 5/8 in.). Gift of the James
Renwick Alliance

Wayne Higby

Temple's Gate Pass, 1988, glazed earthen-
ware, 36.2 x 15.3 x 15.3 cm (14 1/4 x 6 x 6
in.). Gift of KPMG Peat Marwick

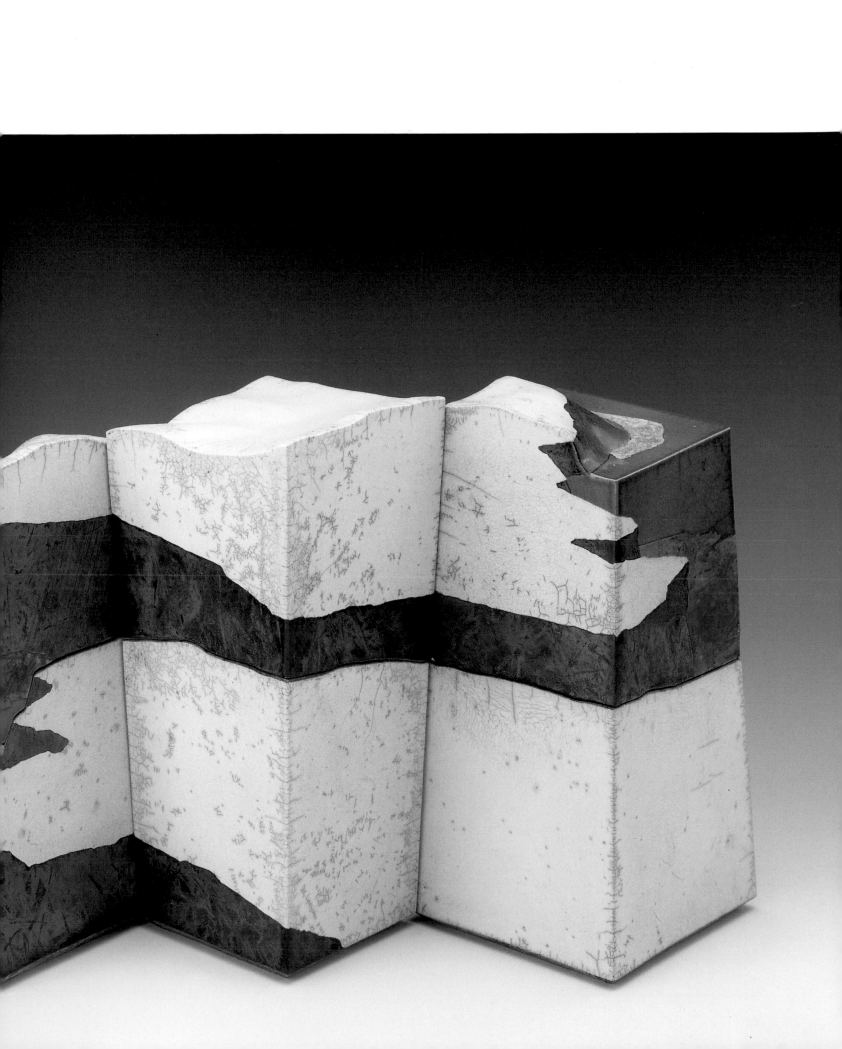

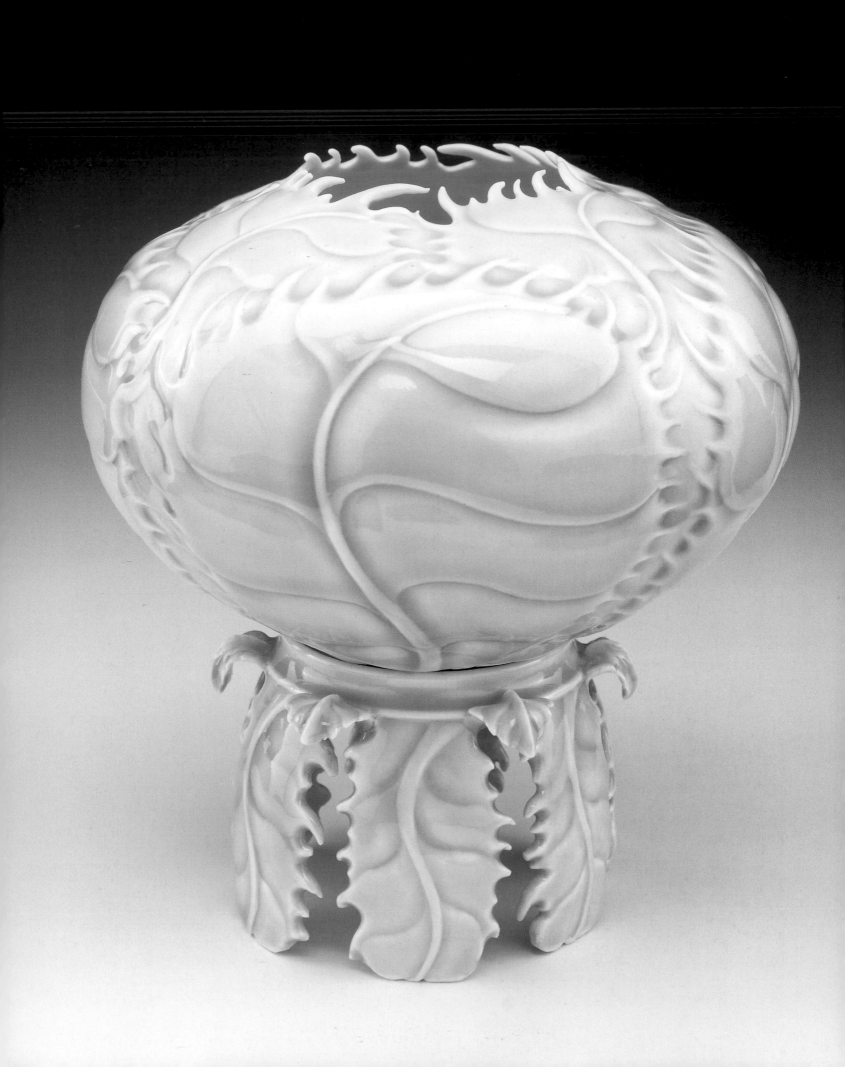

Cliff Lee

(opposite) *Cabbage Vase on a Pedestal*, 1993, glazed porcelain, 21.6 x 20.3 cm (8 1/2 x 8 in.). Gift of Rebecca Klemm

Adrian Saxe

(below) *Untitled Covered Jar*, 1980, thrown, slab-built and glazed porcelain, raku, and stoneware, 47 x 27.3 x 24.8 cm (18 1/2 x 10 3/4 x 9 3/4 in.). Gift of Paul and Elmerina Parkman

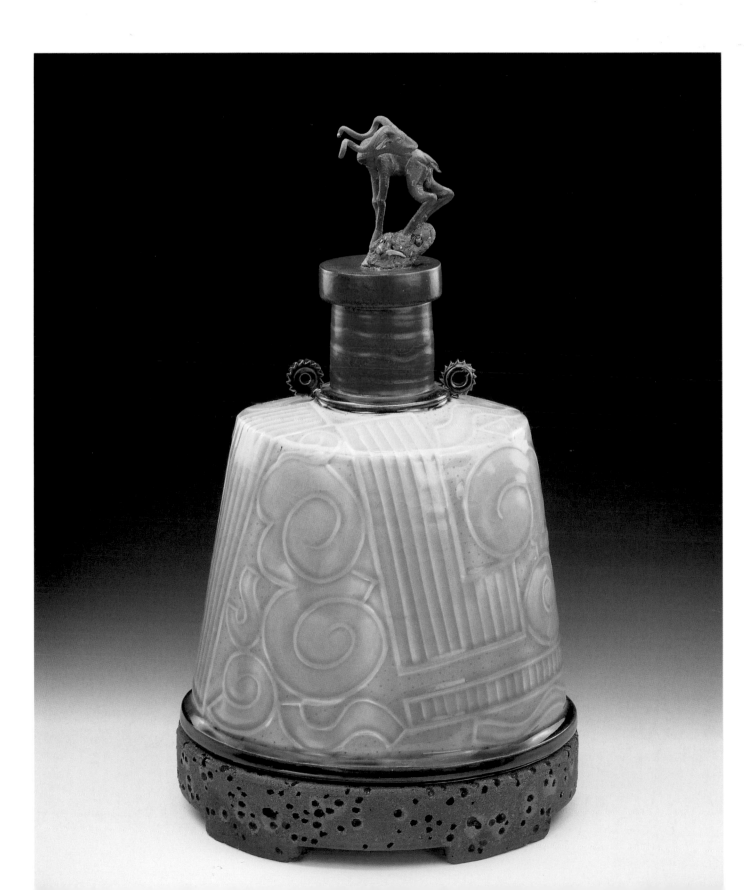

Graham Marks
(below) *Untitled #2,* 1985, sandblasted stoneware, 71.1 x 77.5 cm (28 x 30 1/2 in.). Gift of the James Renwick Alliance

Toshiko Takaezu
(opposite) *Full Moon,* 1978, glazed stoneware with interior pebbles, 70.5 x 74.9 cm (27 3/4 x 29 1/2 in.). Museum purchase and gift of the James Renwick Alliance

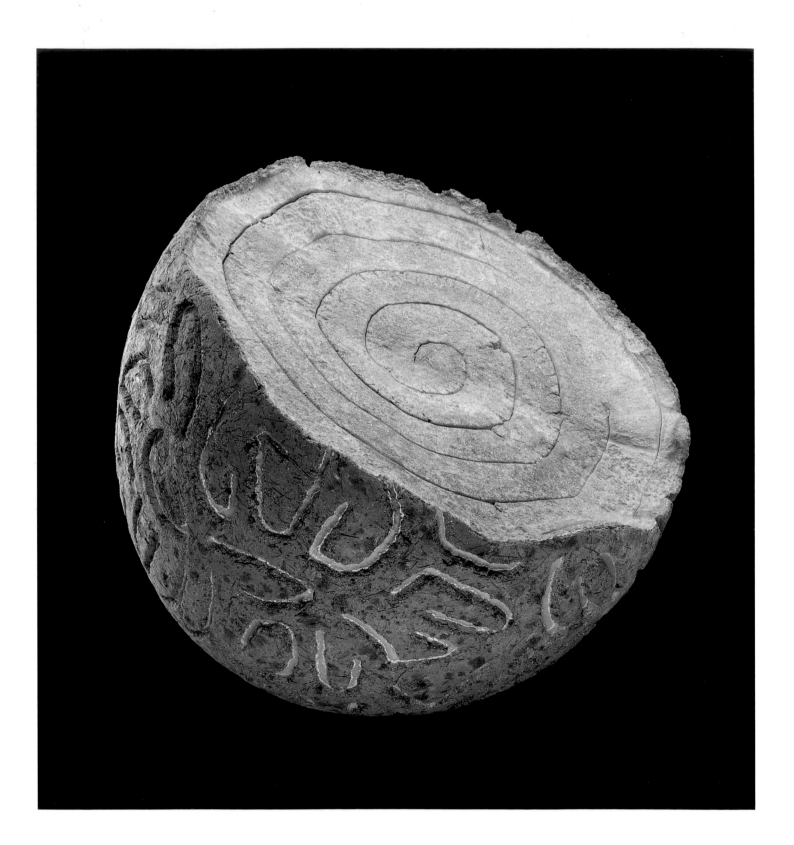

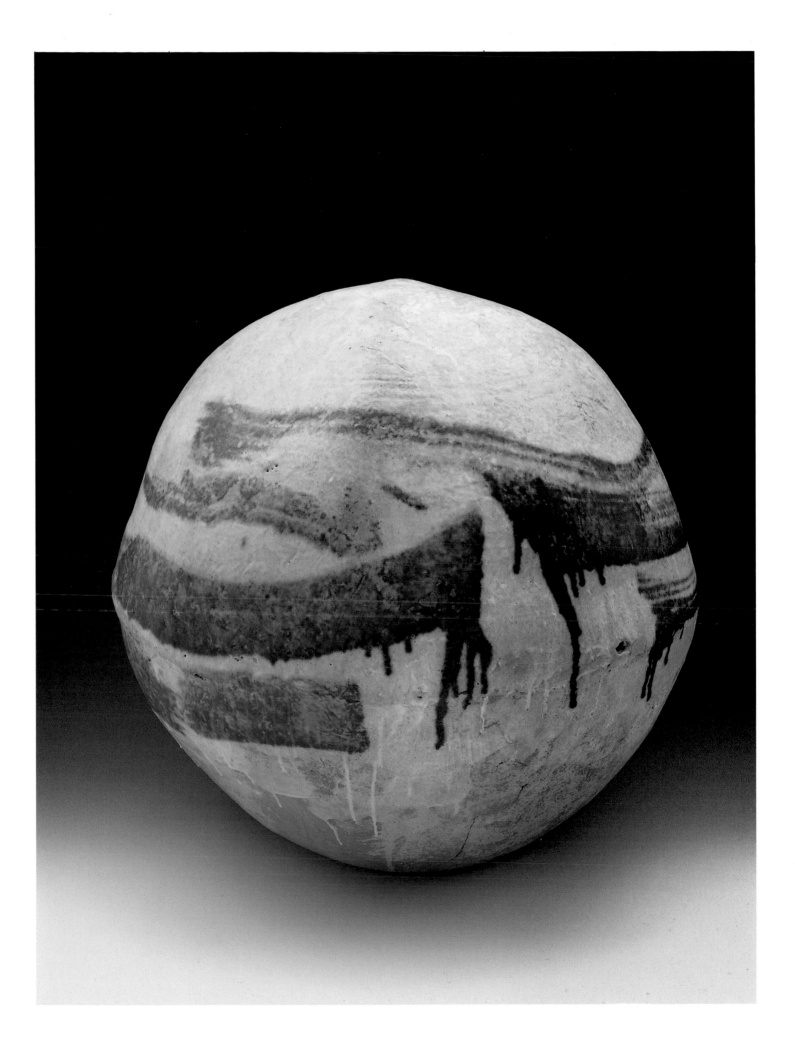

Howard Kottler

(below) *Waiting for Master*, 1986, earthenware, paint, simulated gold leaf, and decals, 95.9 x 40.6 x 66 cm (37 3/4 x 16 x 26 in.). Bequest of the artist

Richard Shaw

(opposite) *Carrie*, 1992, glazed porcelain, 92.1 x 49.6 x 28 cm (36 1/4 x 19 1/2 x 11 in.). Gift of the James Renwick Alliance

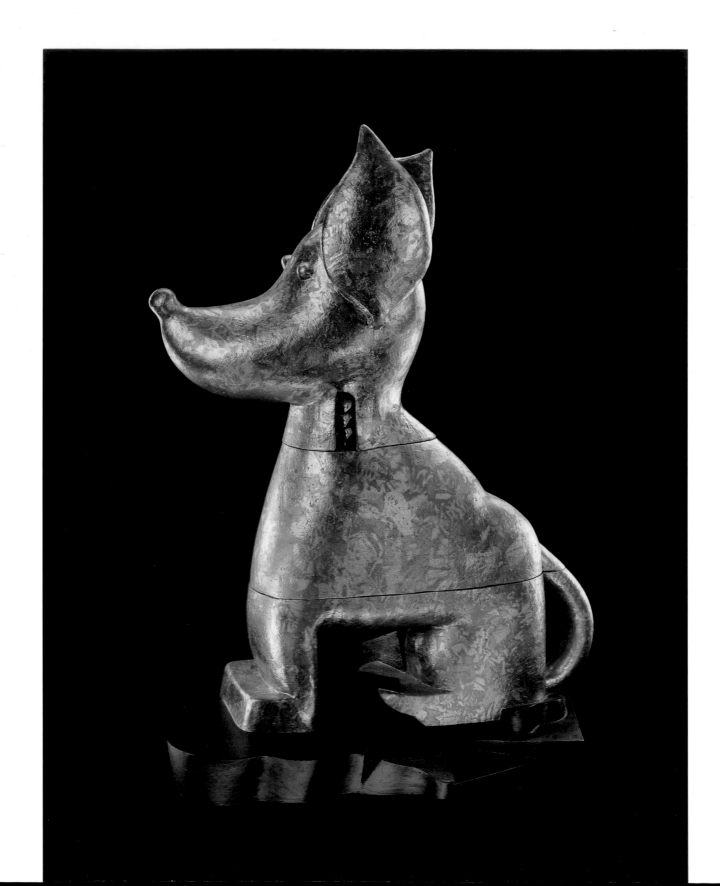

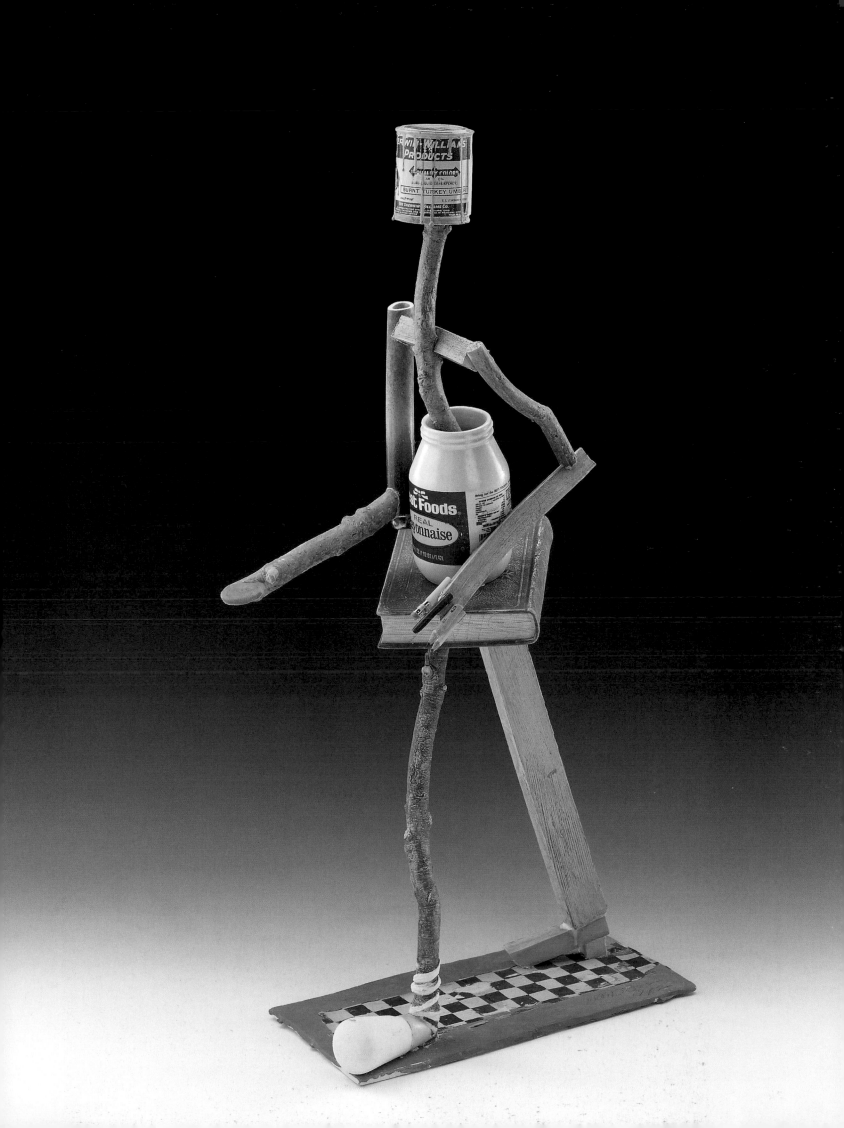

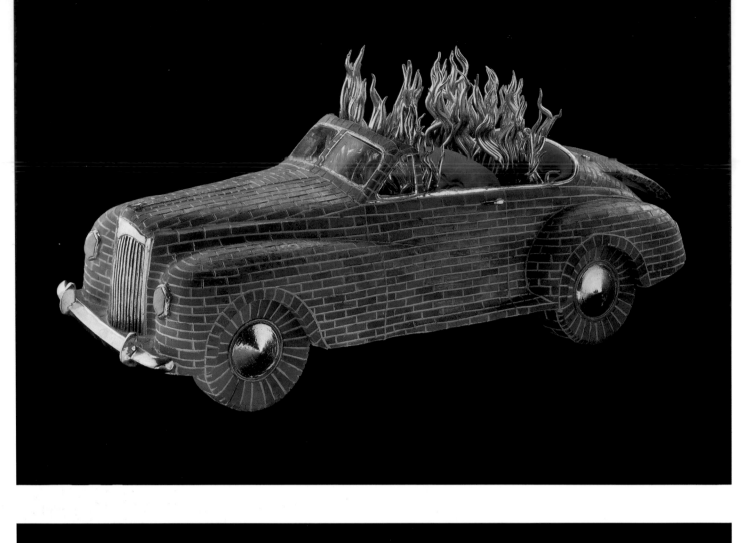

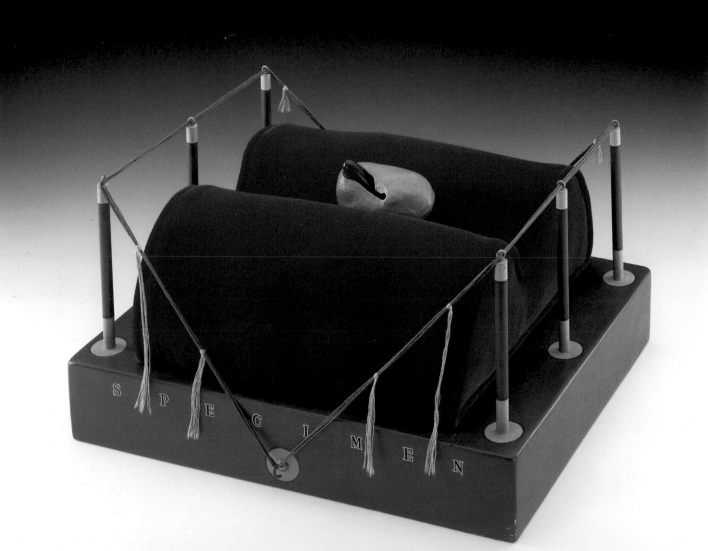

Patti Warashina

(left, top) *Convertible Car Kiln,* ca. 1971, glazed clay and plastic, 36.9 x 90.2 x 36.9 cm (14 1/2 x 35 1/2 x 14 1/2 in.). Gift of the James Renwick Alliance

Ken Price

(left, bottom) *Specimen,* 1964, glazed and painted clay, fabric, wood, and string, 20.3 x 34.9 x 26.7 cm (8 x 13 3/4 x 10 1/2 in.). Museum purchase

Paul Anthony Dresang

(right) *Untitled,* 1995, glazed porcelain, 48.3 x 26.7 x 24.2 cm (19 x 10 1/2 x 9 1/2 in.). Gift of the James Renwick Alliance

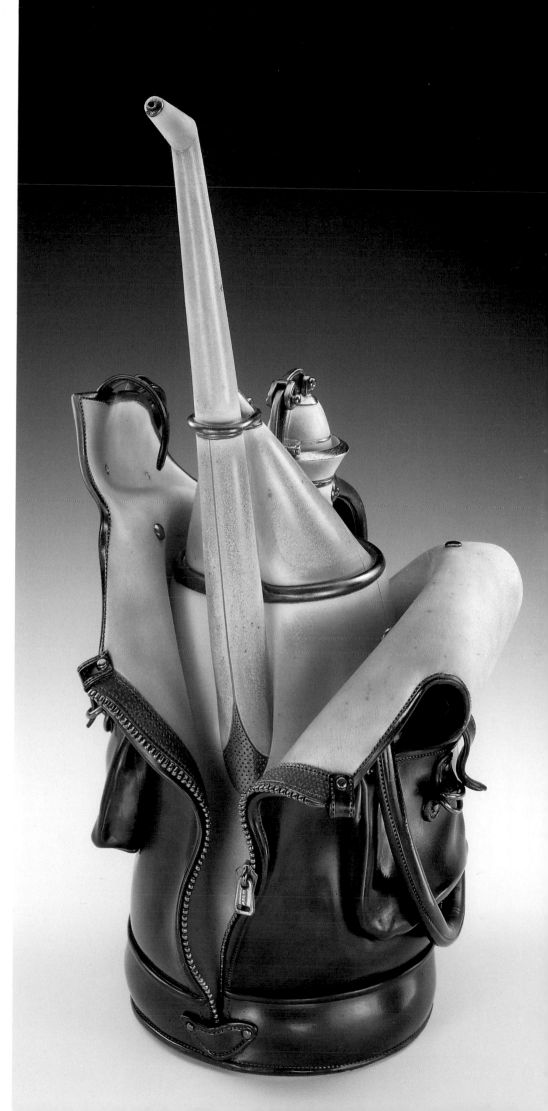

Robert Turner

(below) *Akan*, 1984, stoneware, 44.2 x 31.5 x 28.6 cm (17 3/8 x 12 3/8 x 11 1/4 in.). Gift of KPMG Peat Marwick.

William Daley

(opposite) *Oval Chamber*, 1986, stoneware, 102.6 x 59.4 x 52.1 cm (40 3/8 x 23 3/8 x 20 1/2 in.). Gift of the James Renwick Alliance and museum purchase through the Smithsonian Institution Collections Acquisition Program

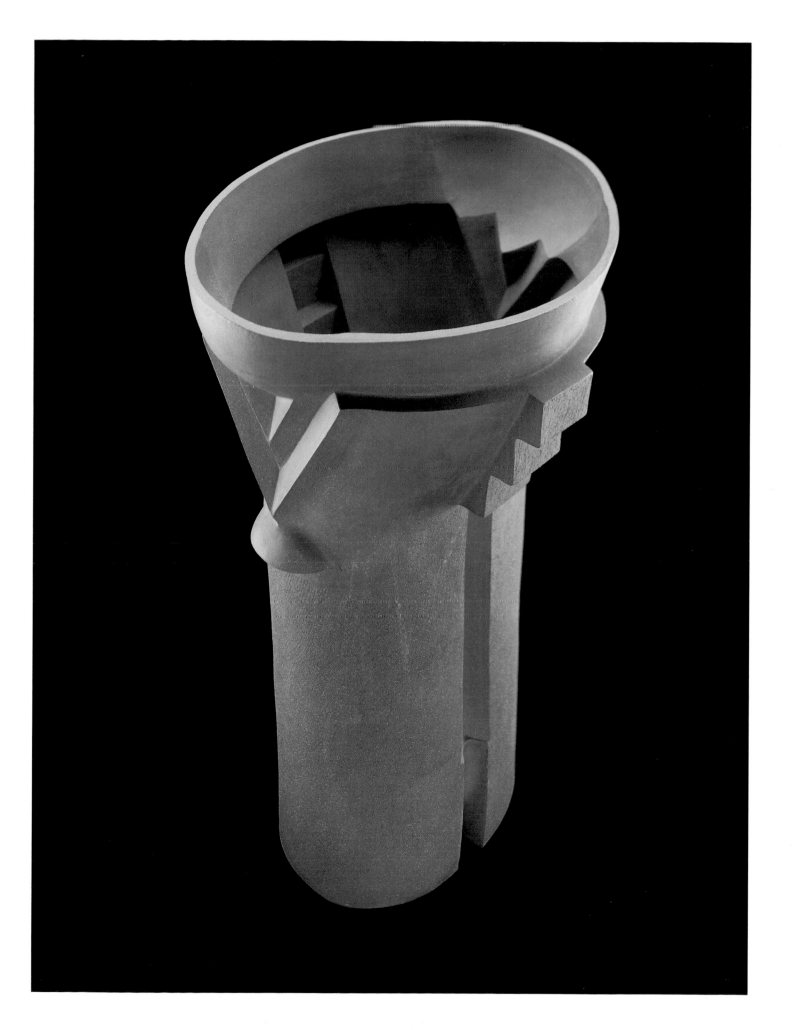

Peter Voulkos

Rocking Pot, 1956, stoneware, 34.6 x 53.3
x 44.6 cm (13 3/4 x 21 x 17 1/2 in.). Gift of
the James Renwick Alliance and various
donors and museum purchase

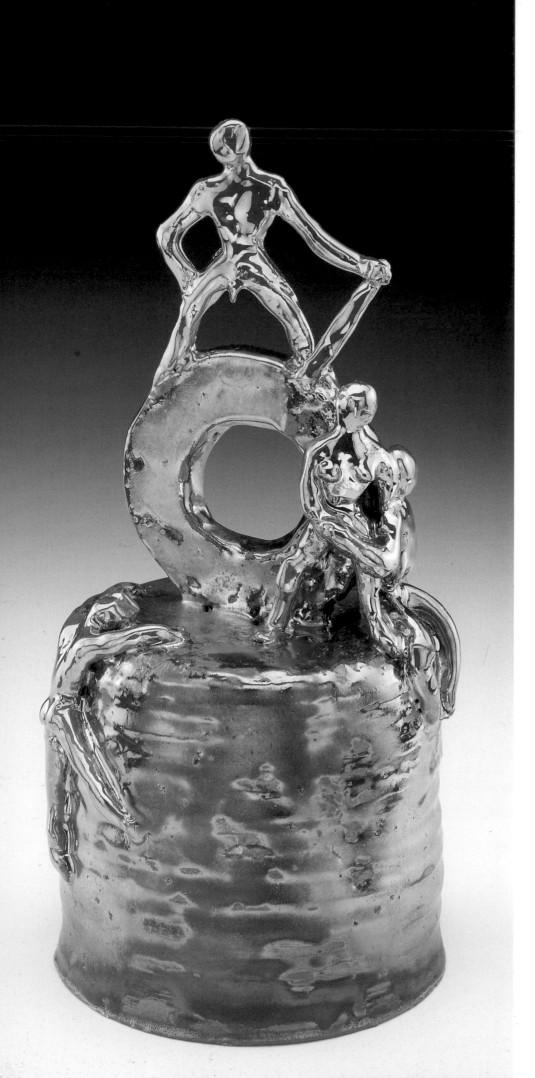

Beatrice Wood

Tides in a Man's Life, ca. 1988, gold luster-glazed ceramic, 29.3 x 14 cm (11 1/2 x 5 1/2 in.). Gift of Kenneth R. Trapp in honor of Shelby M. Gans on the occasion of her appointment to the Board of Commissioners of the National Museum of American Art

Rudy Autio

(opposite) *Listening to the East Wind*, 1986, glazed stoneware, 100.4 x 73.6 x 53.3 cm (39 1/2 x 29 x 21 in.). Gift of the James Renwick Alliance and museum purchase through the Director's Discretionary Fund

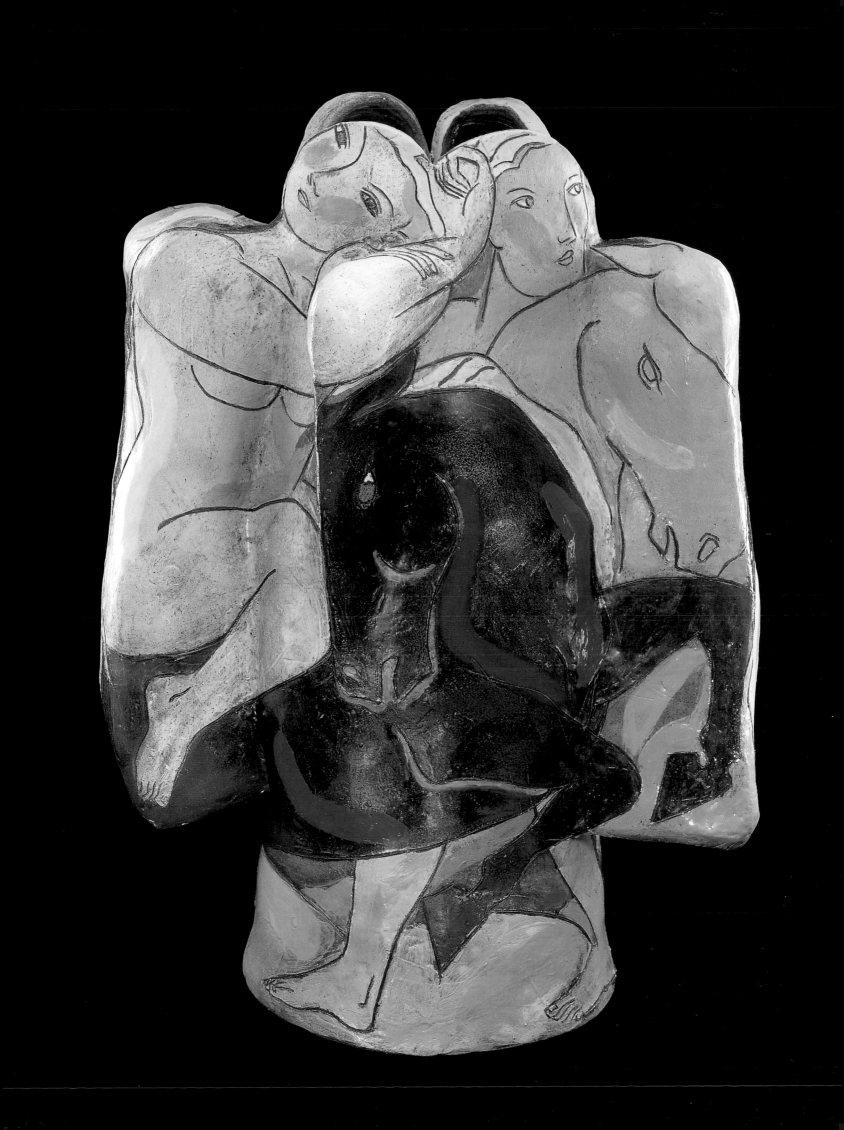

John McQueen
(below) *Untitled #192,* 1989, burdock
(burrs) and applewood, 56.6 x 45.8 x 52.8
cm (22 1/4 x 18 x 20 in.). Gift of the James
Renwick Alliance

Joanne Segal Brandford
(opposite) *Bundle,* 1992, wood, rattan,
kozo, nylon, and paint, 61 x 71.1 x 59.7 cm
(24 x 28 x 23 1/2 in.). Museum purchase
through the Renwick Acquisitions Fund

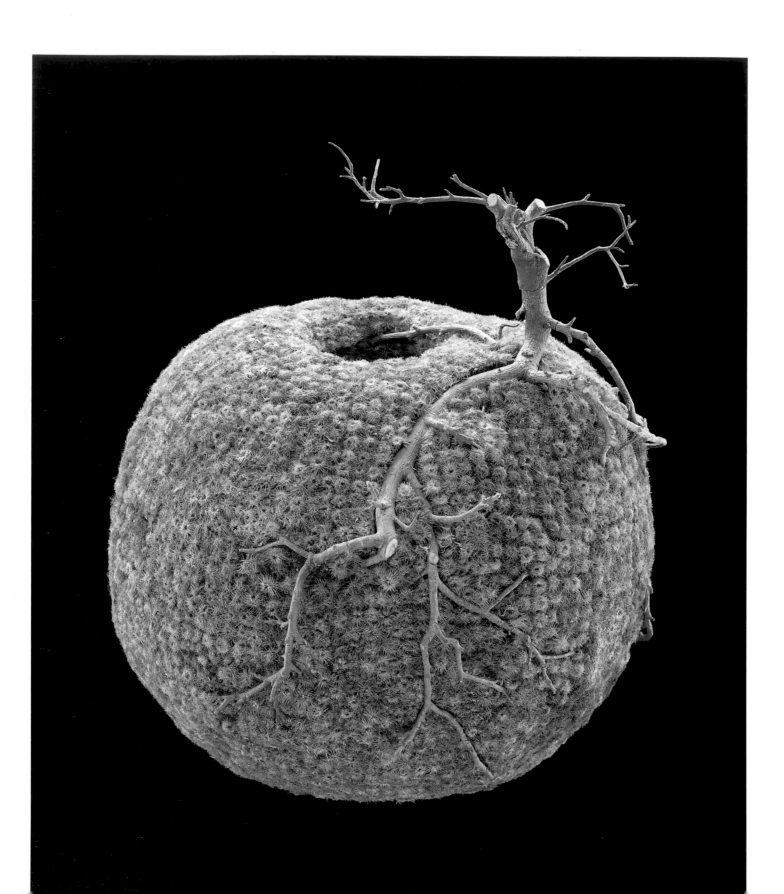

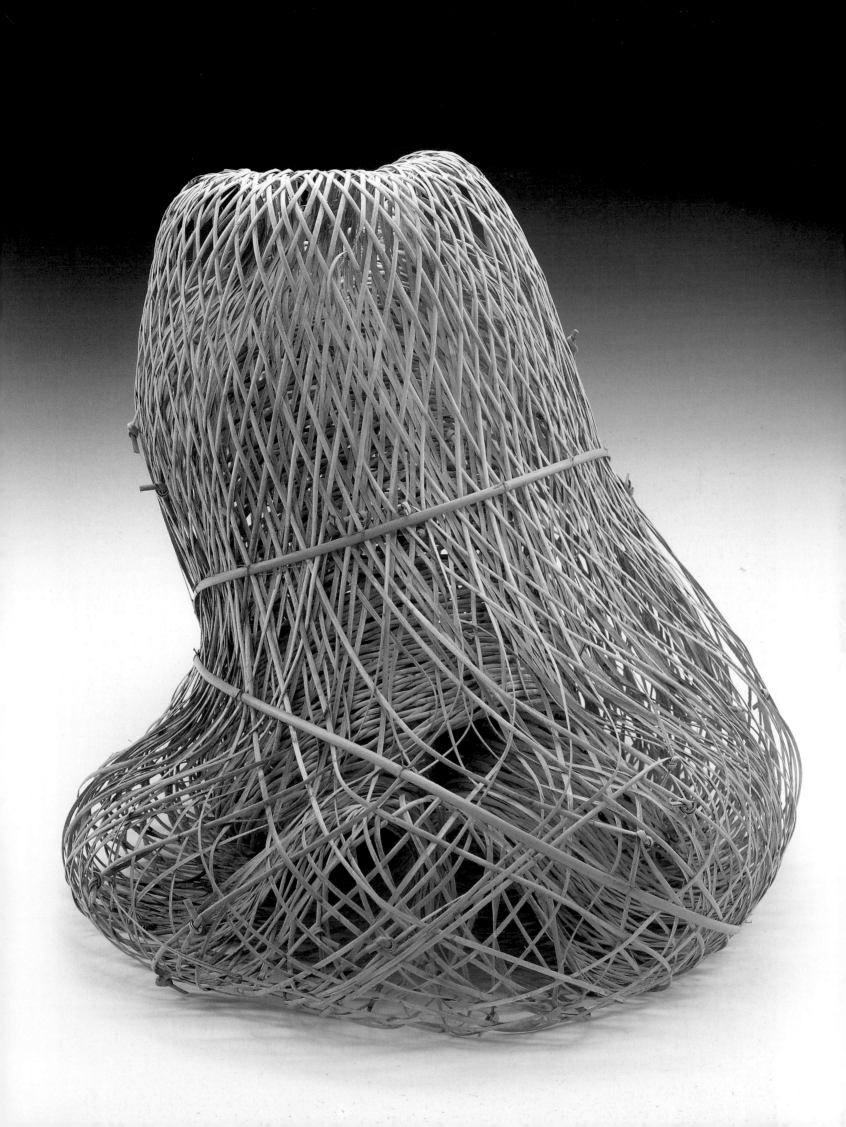

Françoise Grossen

(below) *Anatid,* 1981, natural manila and cotton rope, 35.5 x 236.2 x 48.2 cm (14 1/2 x 93 x 19 in.). Museum purchase

Kay Sekimachi

(opposite, left) *Nagare VII,* 1970, woven monofilament, 203.2 x 22.8 x 22.8 cm (80 x 9 x 9 in.). Museum purchase

Dominic Di Mare

(opposite, right) *Mourning Station #11,* 1988, wood, horsehair, and feathers, 111.8 x 49.3 x 40.7 cm (44 x 19 3/8 x 16 in.). Gift of the James Renwick Alliance, Patrick and Darle Maveety and museum purchase through the Smithsonian Institution Collections Acquisition Program

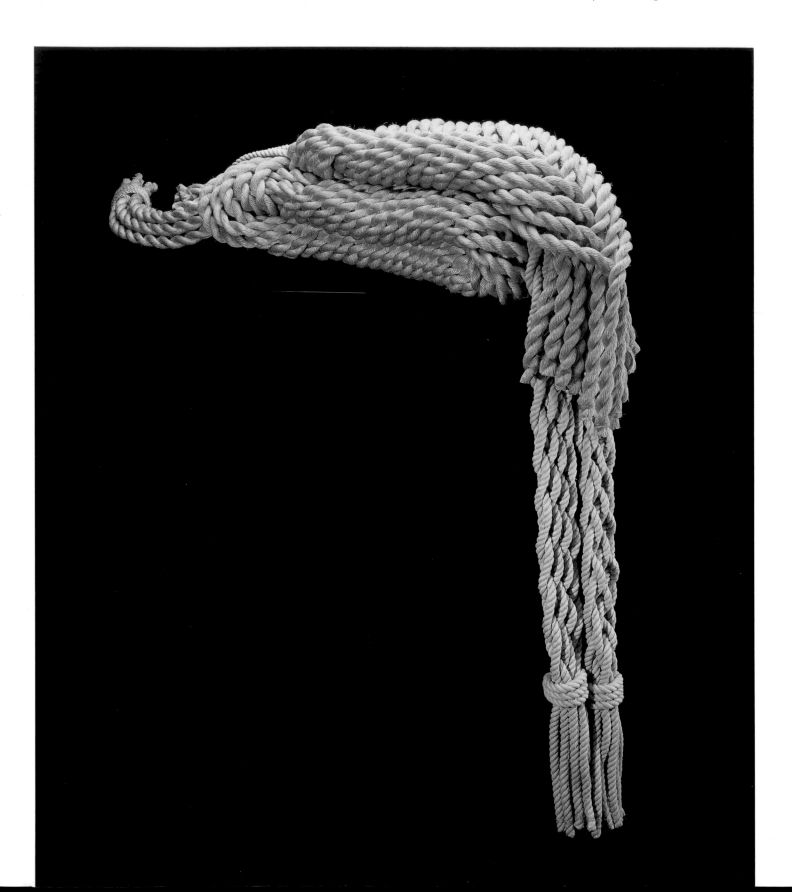

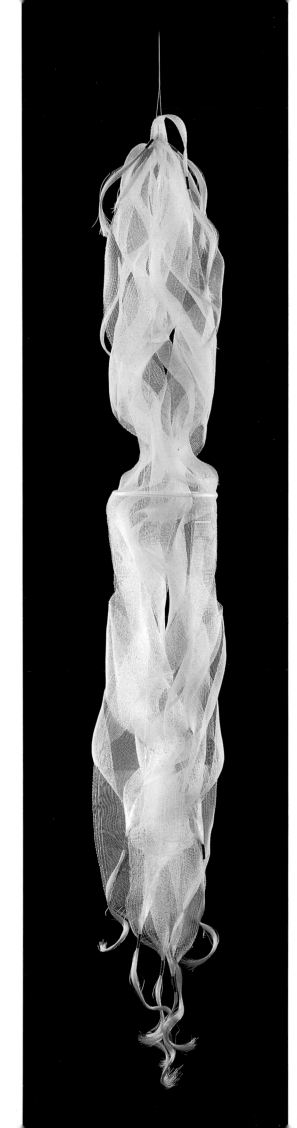

Claire Zeisler

(opposite) *Coil Series III—A Celebration,* 1978, natural hemp and wool, 169 x 86.3 cm (66 1/2 x 34 in.). Museum purchase

Pat Hickman and **Lillian Elliott**

(below) *Nomad,* 1983, reeds, waxed linen, paint, India ink, and gut, 21.7 x 38.2 x 31.2 cm (8 1/2 x 15 x 12 1/4 in.). Gift of the artists

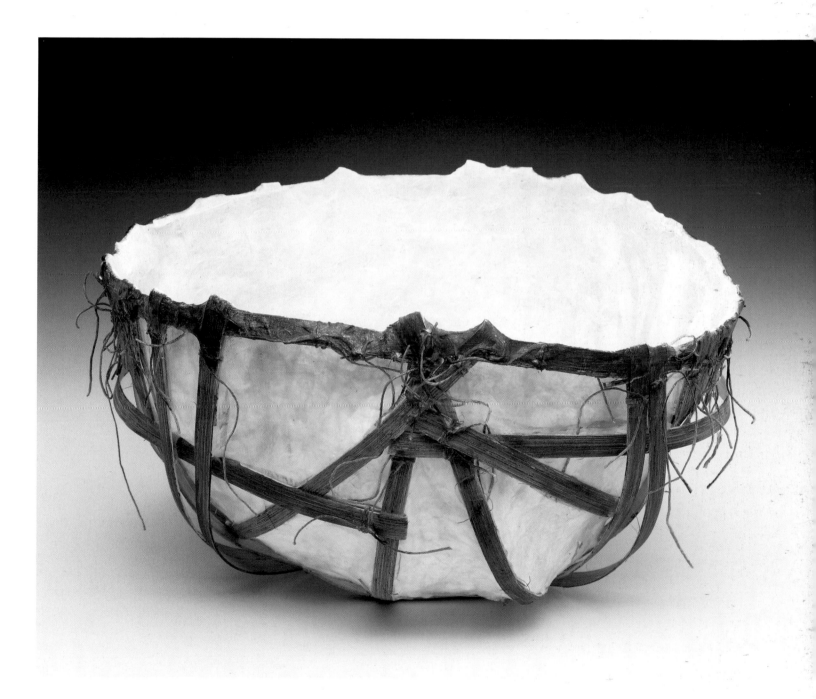

Billie Ruth Sudduth

(below) *Fibonacci 5*, 1996, woven cut reed splints, 33 x 41.9 cm (13 x 16 1/2 in.). Gift of Kay Sekimachi and Bob Stocksdale and Susan Stewart

Edith Bondie

(opposite) *Porkypine Basket*, ca. 1975, woven black ash, 20 x 21.5 cm (7 7/8 x 8 1/2 in.). Museum purchase

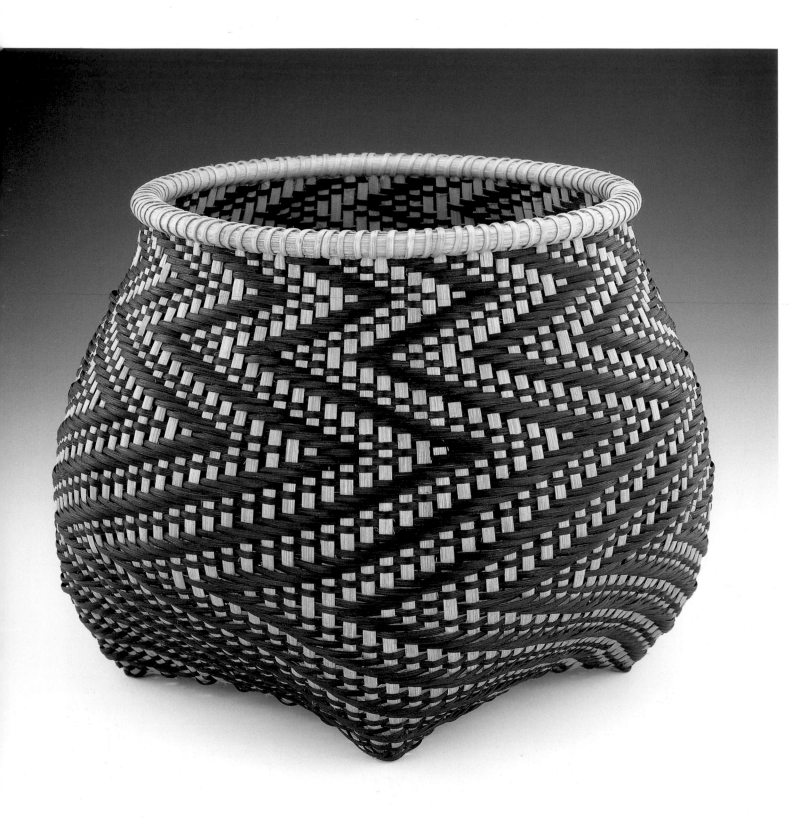

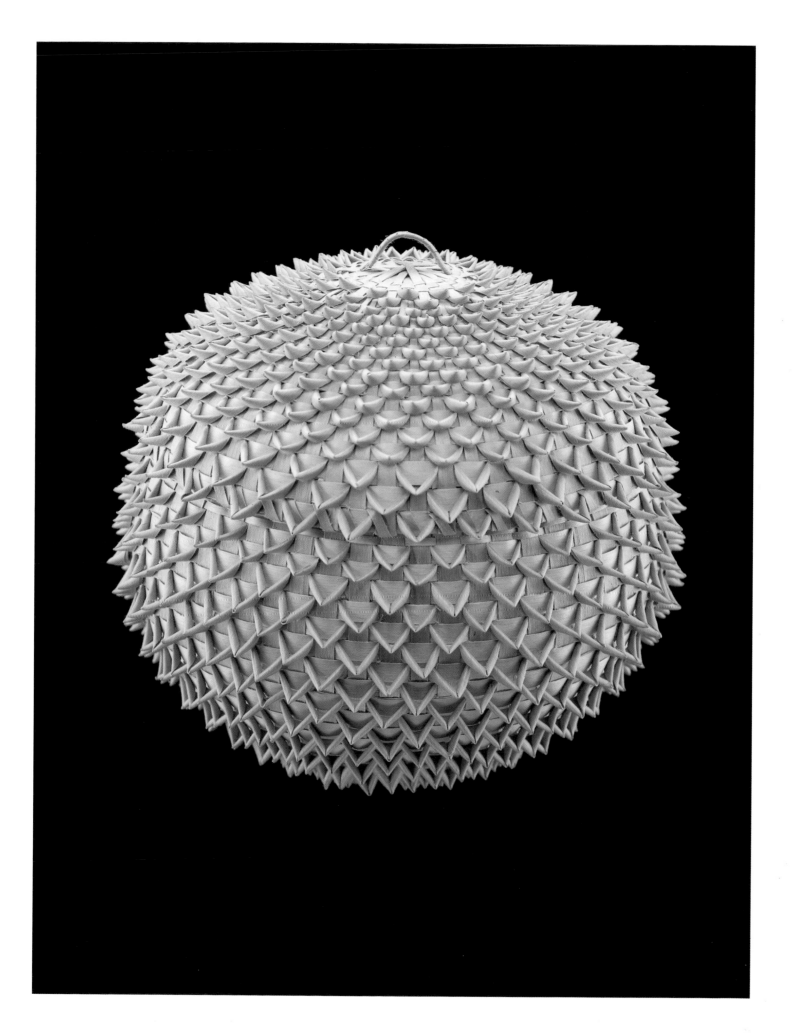

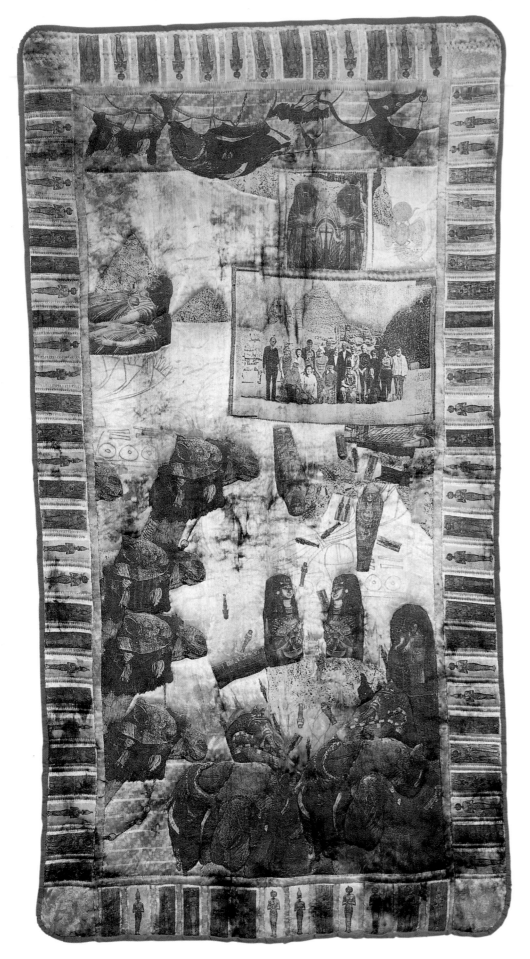

Katherine Westphal
(left) *Seven Camels Find Buried Treasure*,
1972, printed and dyed fabric and color
photocopy, 227.3 x 121.3 cm
(89 1/2 x 47 3/4 in.). Gift of the artist

Consuelo Jimenez Underwood
(opposite) *Virgen de los Caminos*, 1994,
drawn, embroidered, and quilted cotton
and silk, 147.3 x 91.4 cm (58 x 36 in.).
Museum purchase

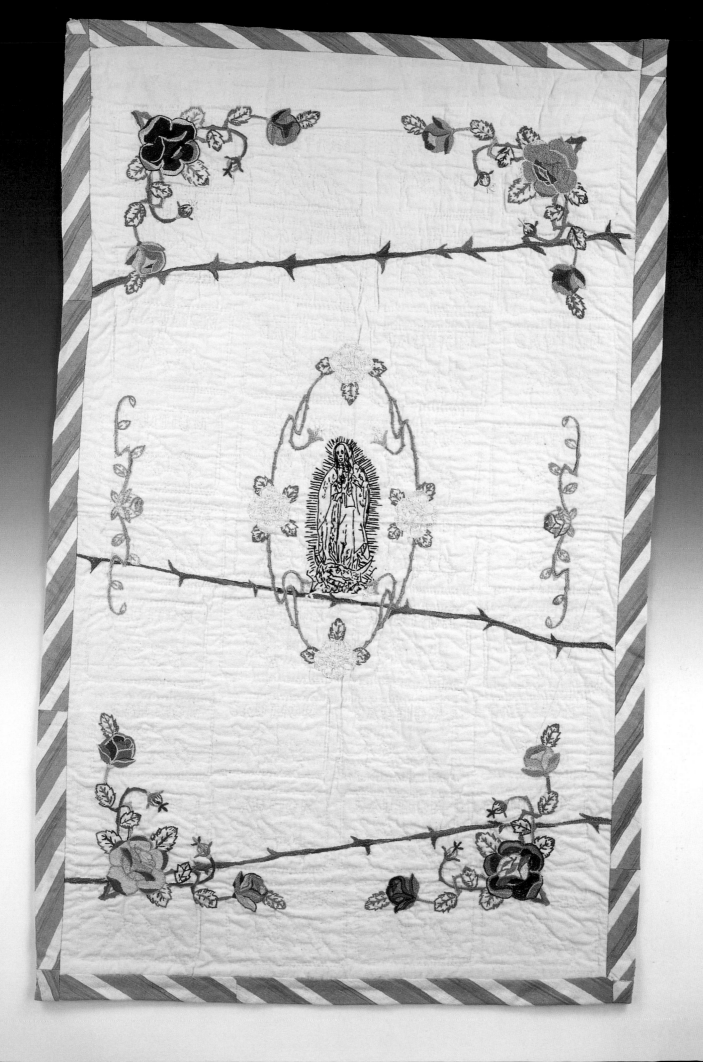

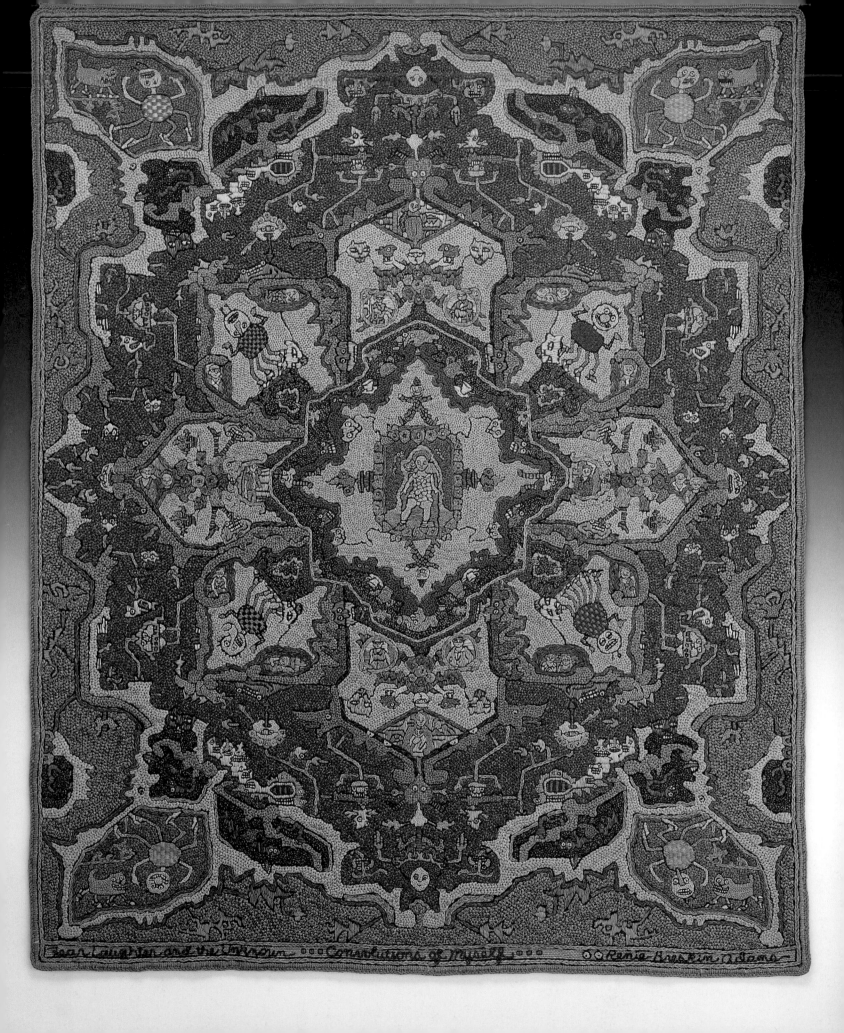

Renie Breskin Adams

(opposite) *Fear, Laughter, and the Un-
known,* 1978, embroidered cotton and
linen, 76.2 x 60.3 cm (30 x 23 3/4 in.). Gift
of the Council of American Embroiderers
on the Occasion of the 25th Anniversary of
the Renwick Gallery

Pamela Studstill

(below) *Quilt #17,* 1982, painted cotton,
161.9 x 154.3 cm (63 3/4 x 60 3/4 in.). Gift
of KPMG Peat Warwick

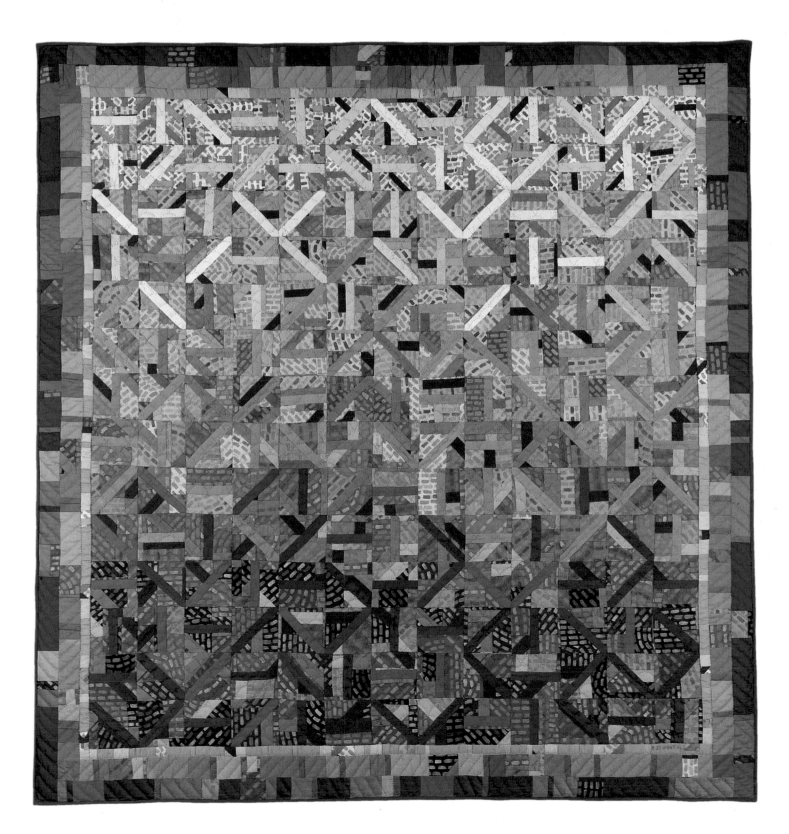

Lia Cook

(below) *Crazy Too Quilt,* 1989, dyed rayon and acrylic on woven and pressed abaca paper, 160.7 x 220.6 cm (63 1/4 x 87 7/8 in.). Gift of the James Renwick Alliance and Bernard and Sherley Koteen and museum purchase through the Smithsonian Institution Collections Acquisition Program

Mariska Karasz

(opposite) *Skeins,* ca. 1950, cotton and wool, 135.9 x 127.6 cm (53 1/2 x 50 1/4 in.). Gift of the James Renwick Alliance and museum purchase through the Smithsonian Institution Collections Acquisition Program

Yvonne Porcella

(below) *Takoage,* 1980, cotton, 207 x 181.6 cm (82 1/2 x 71 1/2 in.). Museum purchase through the Smithsonian Institution Collections Acquisition Program

Michael James

(opposite) *Rehoboth Meander: Quilt #150,* 1993, cotton and silk, 134.6 x 133.4 cm (53 x 52 1/2 in,), Gift of the James Renwick Alliance

Ed Rossbach

(below) *Linen Doublecloth Wallhanging,*
1966, linen, 158.1 x 164.1 cm
(62 1/4 x 64 5/8 in.). Gift of the artist

(opposite) *San Blas,* 1967, cotton and
linen, 182.9 x 177.8 cm (72 x 70 in.).
Gift of Lisa and Dudley Anderson

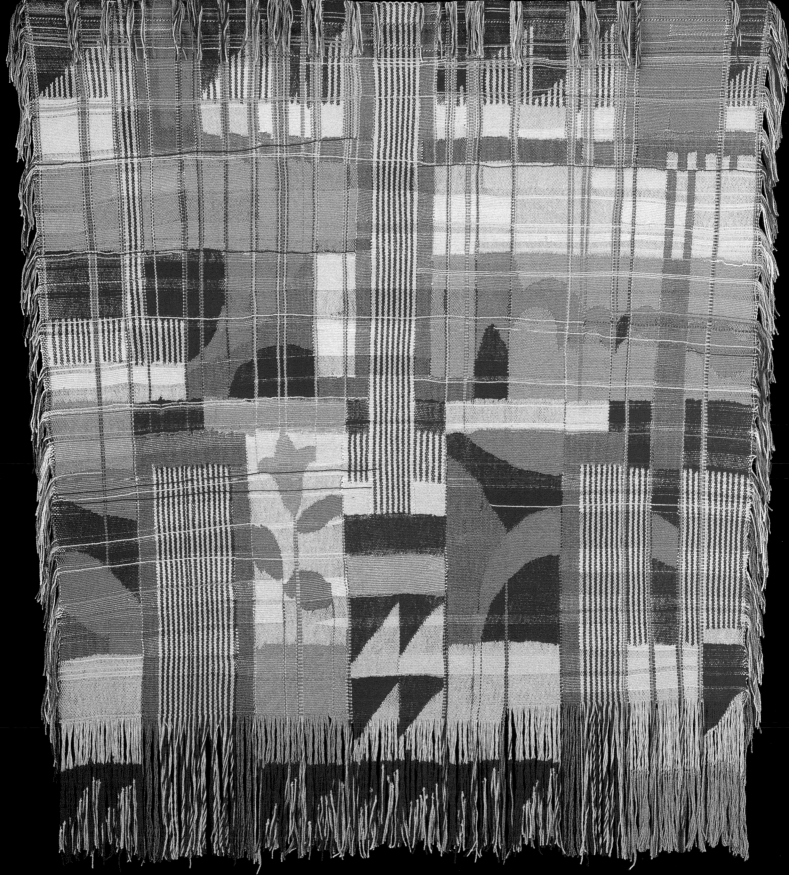

Cynthia Schira

(below) *Reflections,* 1982, cotton, linen, and rayon, 241.3 x 383.5 cm (95 x 151 in.). Museum purchase made possible in part by the James Renwick Alliance and Roberta Golding

Anni Albers

(opposite) *Ancient Writing,* 1936, woven cotton and rayon, 150.5 x 111.8 cm (59 1/4 x 44 in.). Gift of John Young

Sonja Blomdahl

(below) *B 1095*, 1995, blown glass,
47 x 30.5 cm (18 1/2 x 12 in.). Museum
purchase

Howard Ben Tré

(opposite) *First Vase*, 1989, cast glass,
gold leaf, and lead, 111.4 x 141.6 cm
(43 7/8 x 55 3/4 in.). Gift of the James
Renwick Alliance and museum purchase
through the Smithsonian Institution
Collections Acquisition Program

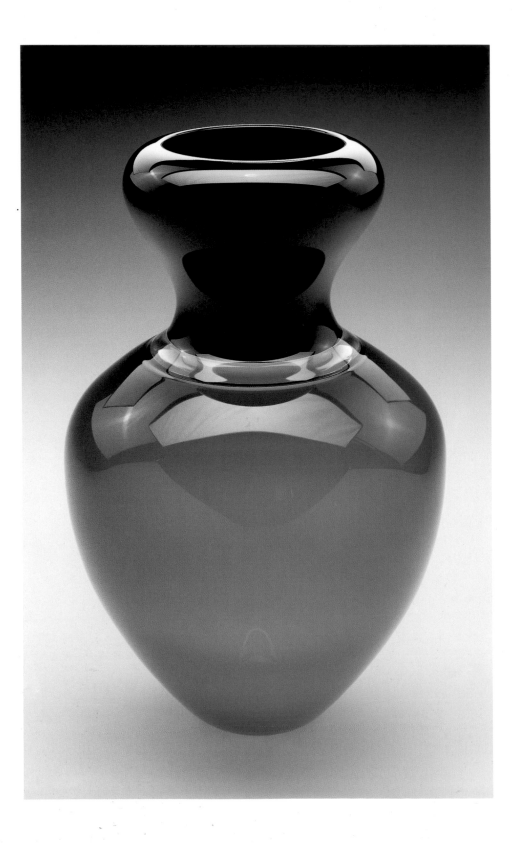

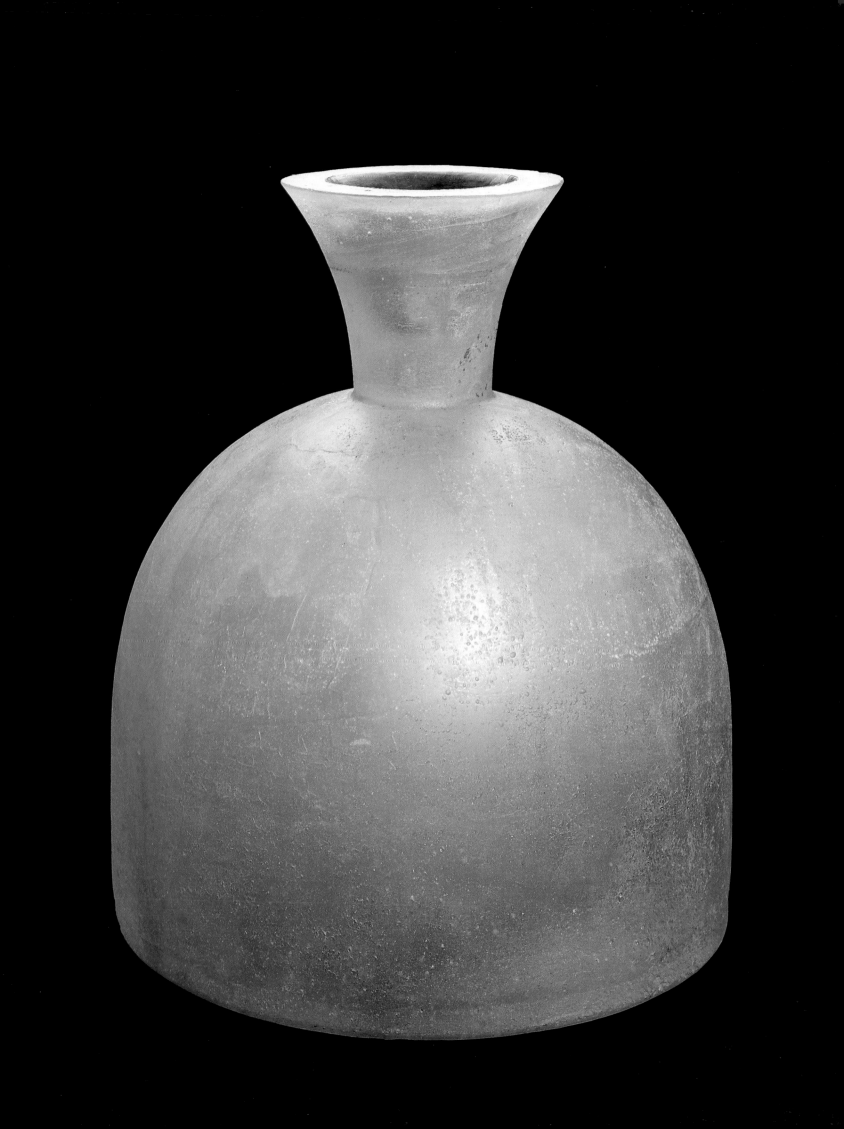

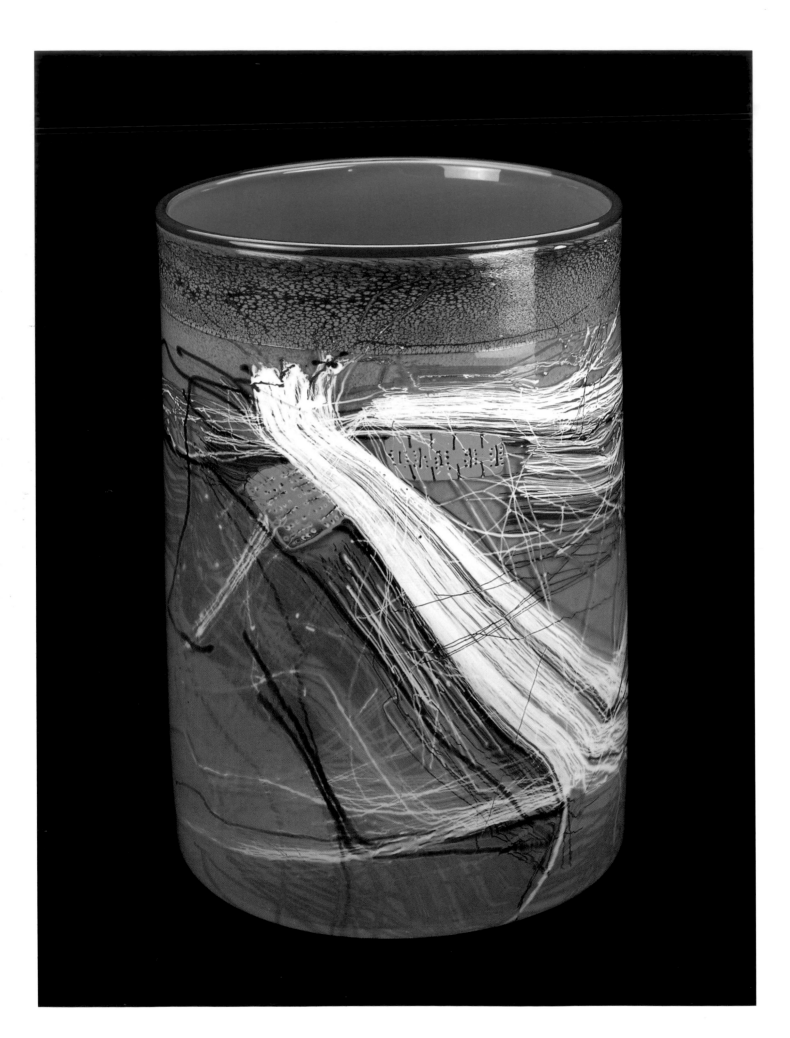

Dale Chihuly

(opposite) *Emerald Green Blanket Cylinder with Cerulean Blue Drawing,* 1984, blown glass, 31.8 x 20.3 x 21.6 cm (12 1/2 x 8 x 8 1/2 in.). Gift of the James Renwick Alliance and museum purchase through the Smithsonian Institution Collections Acquisition Program

(below) *Niijima Floats: Garnet Black and Mint Green Float with Dimple,* 1991, blown glass, 49.7 x 57.8 x 49.6 cm (18 3/4 x 22 3/4 x 19 1/2 in.); *Snow White and Gold Leaf,* 1991, blown glass, 54.9 x 63.5 x 61 cm (21 5/8 x 25 x 24 in.); *Mottled Blue Black Float with Silver Leaf,* 1992, blown glass, 63.5 x 66.7 x 65.4 cm (25 x 26 1/4 x 24 3/4 in.). Gift of Dale and Doug Anderson

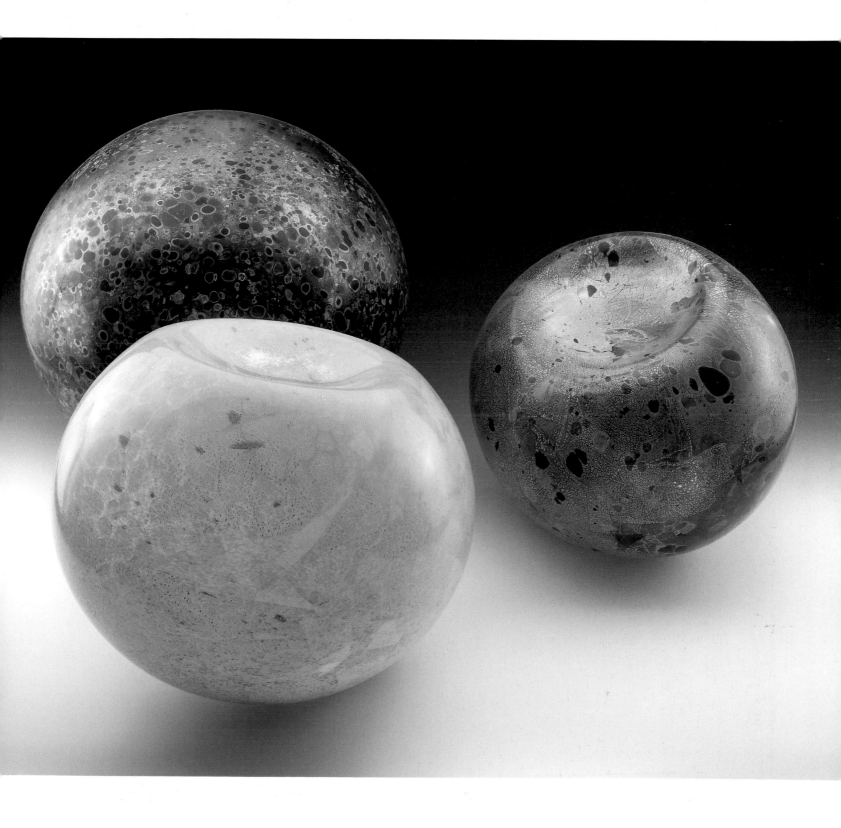

Richard Marquis

Teapot Goblets, 1991–94, blown glass (left
to right): 19.8 x 12.8 x 12.8 cm (7 3/4 x 5 x 5
in.); 26.1 x 10.3 x 9.3 cm (10 1/4 x 4 x 3 5/8
in.); 26.7 x 10.9 x 9 cm (10 1/2 x 4 1/2 x 3 1/2
in.); 28 x 9.3 x 9.3 cm (11 x 3 5/8 x 3 5/8 in.);
19.5 x 14.7 x 14.7 cm (7 5/8 x 5 3/4 x 5 3/4
in.). Gift of the James Renwick Alliance

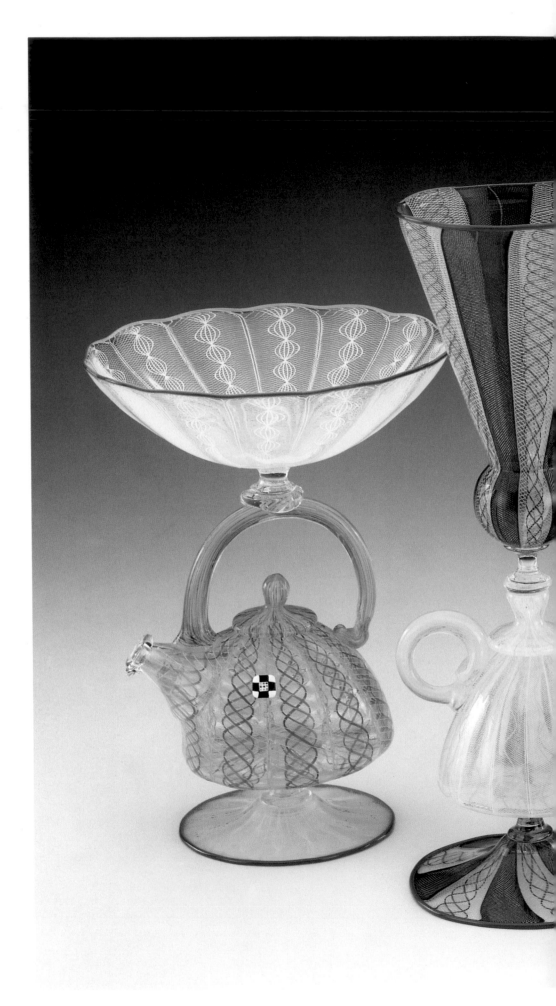

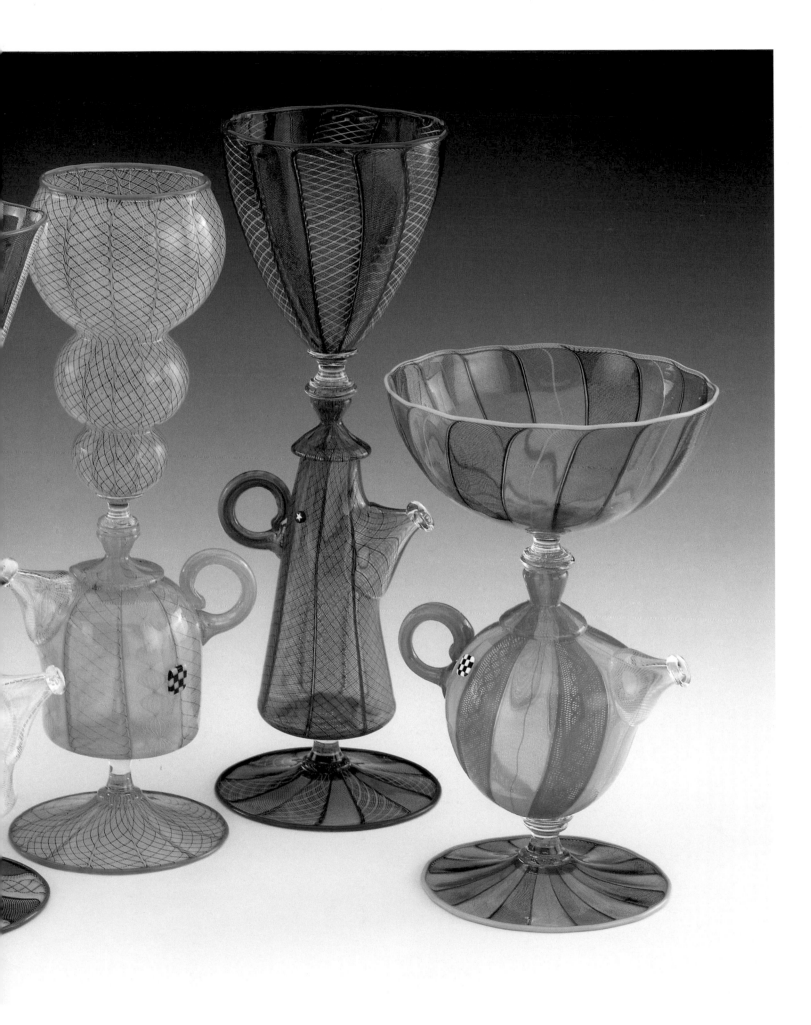

Fritz Dreisbach

(below) *Ruby Wet Foot Mongo*, 1990, blown glass, 48.9 x 48.3 x 39.4 cm (19 1/4 x 19 x 15 1/2 in.). Gift of the James Renwick Alliance and museum purchase through the Smithsonian Institution Collections Acquisition Program

Sidney R. Hutter

(opposite) *Vase #65-78*, 1990, constructed plate glass, 58.4 x 38.1 cm (23 x 15 in.). Gift of the James Renwick Alliance, Anne and Ronald Abramson, Sarah and Edwin Hansen, and museum purchase through the Smithsonian Institution Collections Acquisition Program

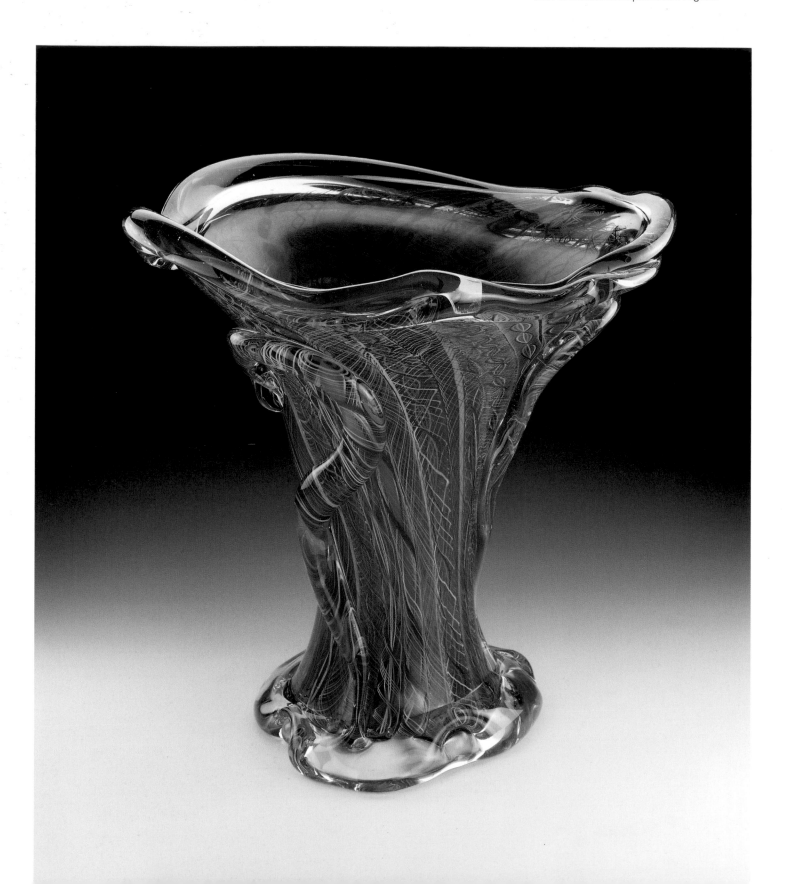

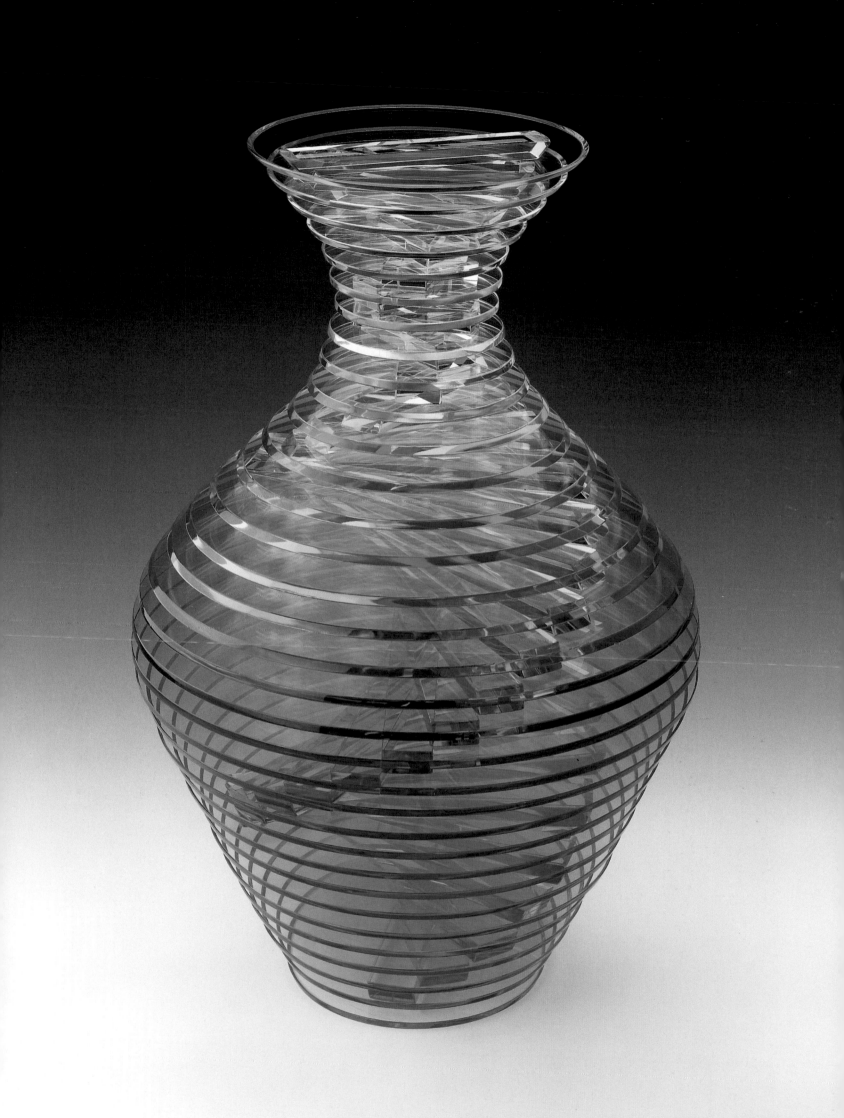

Daniel Clayman

(below) *Cascade,* 1996, cast glass and bronze, 21.6 x 50.8 x 30 cm (8 1/2 x 20 x 12 in.). Gift of the James Renwick Alliance on the Occasion of the 25th Anniversary of the Renwick Gallery

William Carlson

(opposite) *Pragnanz,* 1988, cast and laminated glass and granite, 69.5 x 45.7 x 17.2 cm (27 3/8 x 18 x 6 3/4 in.). Gift of Annie and Mike Belkin

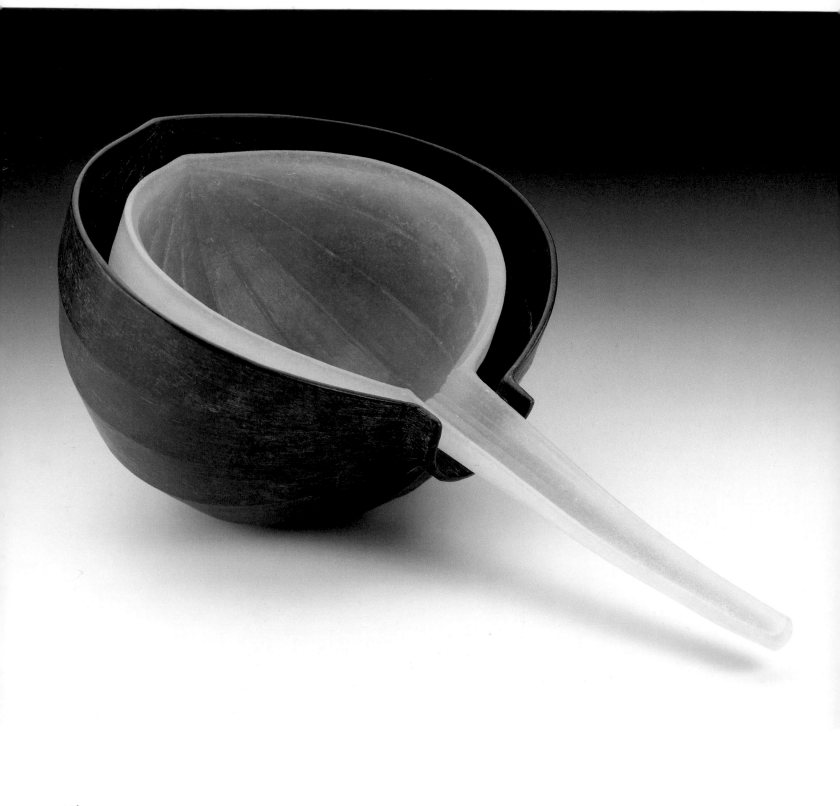

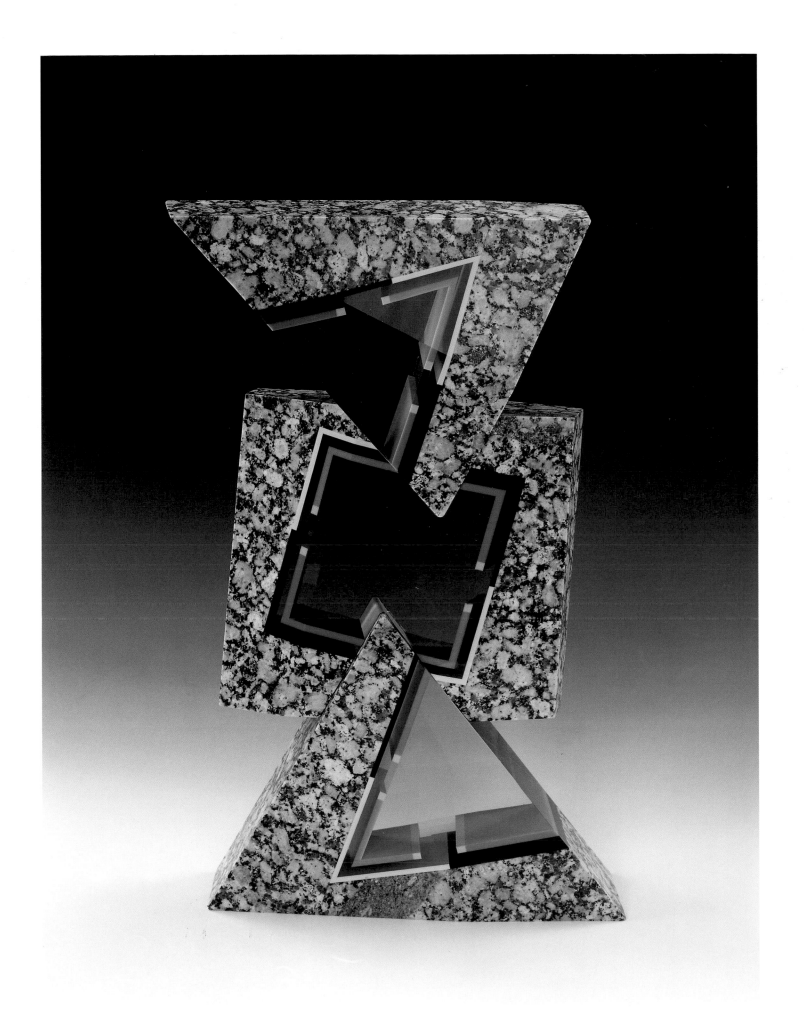

Harvey Littleton

Four Seasons, 1977, blown glass,
14 x 35.5 x 30.5 cm (5 1/2 x 14 x 12 in.).
Gift of Paul and Elmerina Parkman

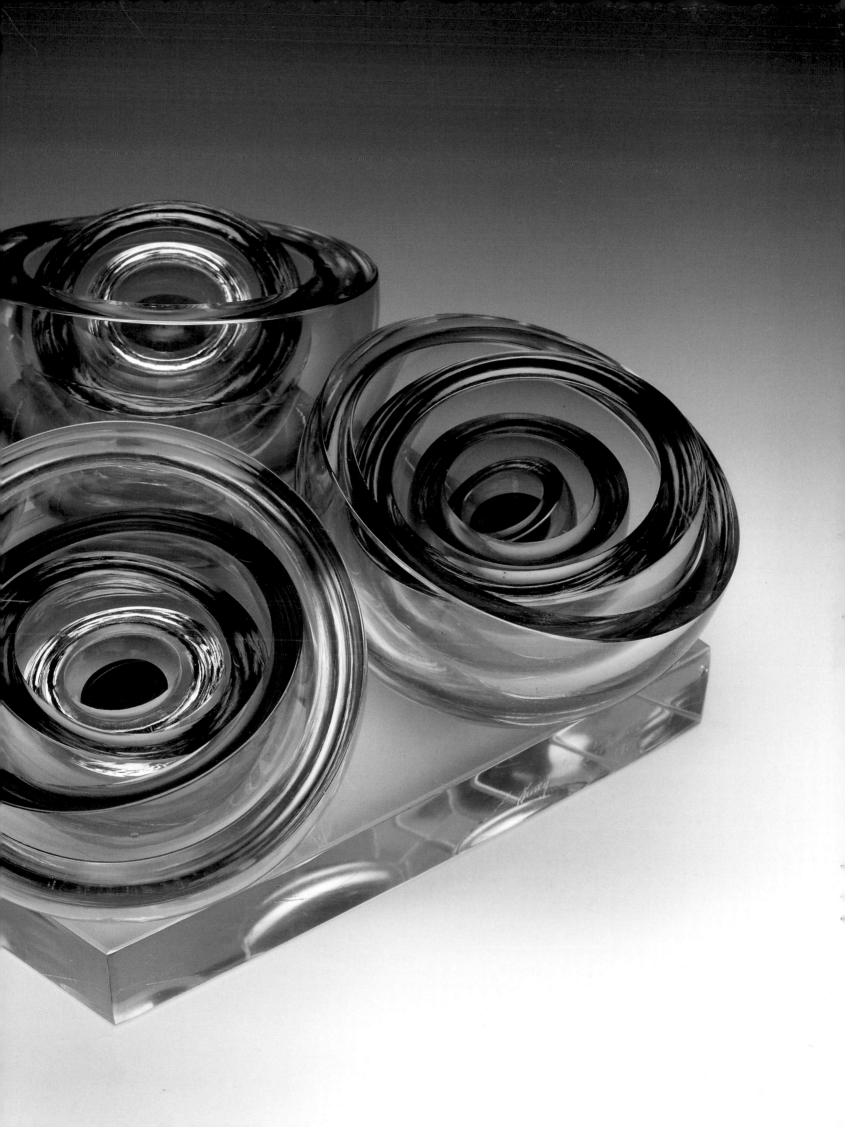

Flora Mace and **Joey Kirkpatrick**
(below) *Fruit Still Life,* 1994, blown glass
(left to right) Opaque Pear: 64.2 x 40.7
x 39.7 cm (25 1/4 x 16 x 15 5/8 in.); Zanfirico
Apple: 32.4 x 32.4 x 30.5 cm (12 3/4 x 12 3/4
x 12 in.); Opaque Apple: 41.3 x 38.2 x 37.5
cm (16 1/4 x 15 x 14 3/4 in.); Zanfirico Plum:
20.3 x 28 x 21.9 cm (8 x 11 x 8 5/8 in.). Gift of
the James Renwick Alliance

Marvin Lipofsky
(opposite) *Untitled Glass Sculpture
(Leerdam Series),* 1970, blown glass,
20.3 x 42.9 x 28 cm (8 x 16 7/8 x 11 in.).
Gift of Mack L. Graham

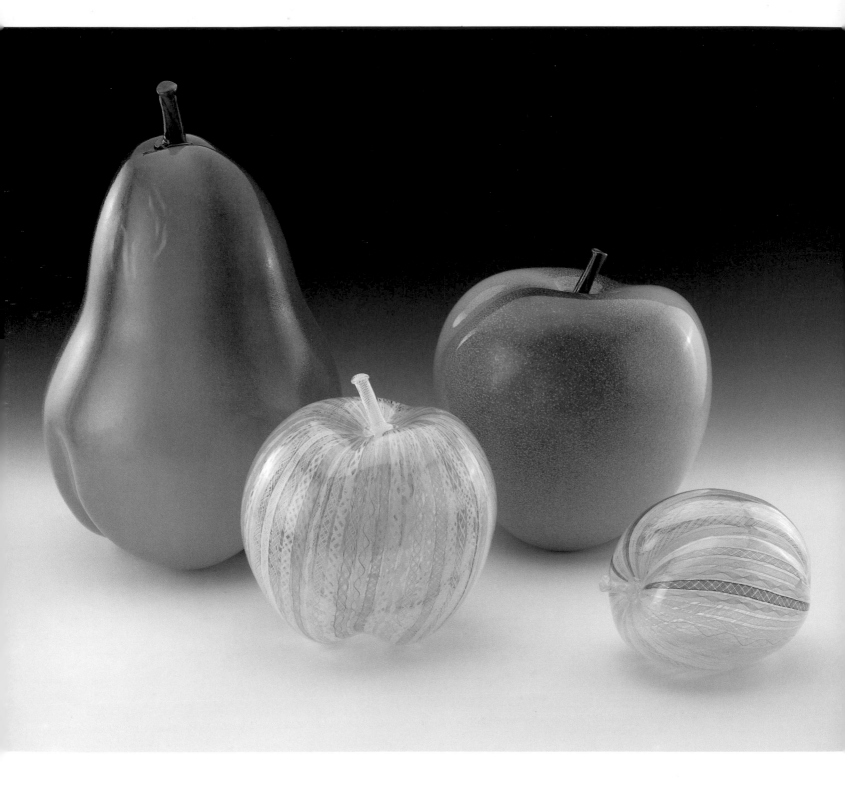

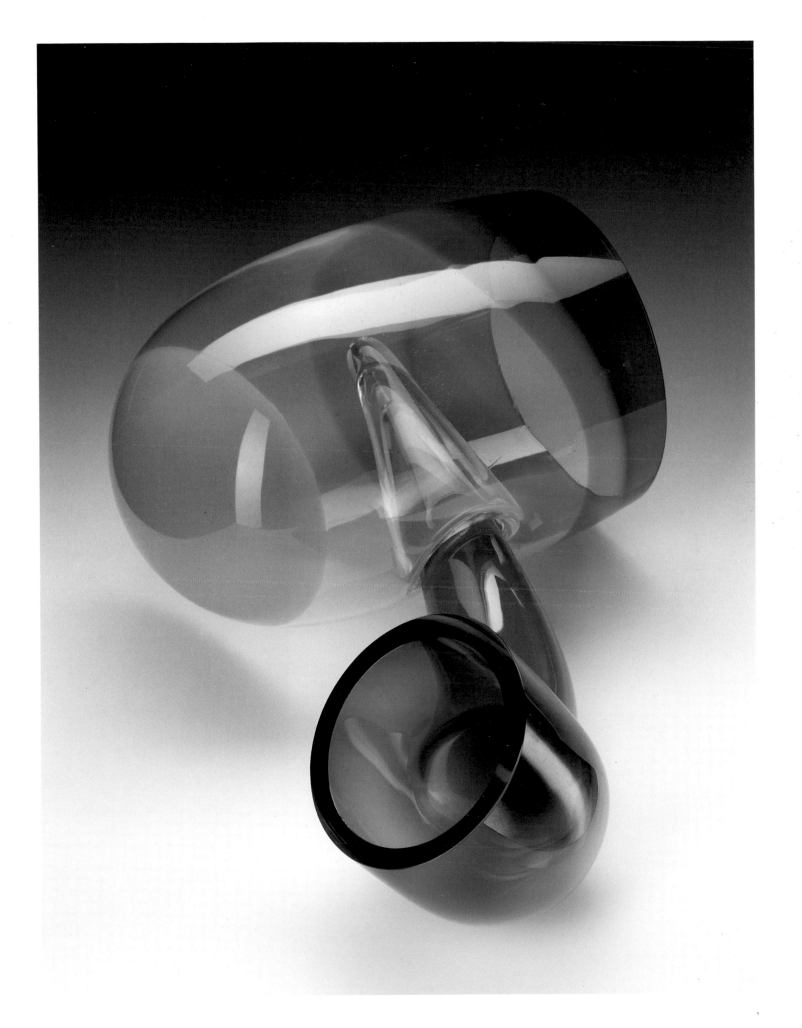

Steven Weinberg
(below) *Untitled,* 1989, cast glass,
21 x 20.3 x 20.3 cm (8 1/4 x 8 x 8 in.).
Gift of Annie and Mike Belkin

Tom Patti
(opposite) *Bi-Axial Tubated Green Riser,*
1985, blown glass, 16.2 x 15.9 x 11.5 cm
(6 3/8 x 6 1/4 x 4 1/2 in.). Gift of Anne and
Ronald Abramson, Edward Lenkin, Arlene
R. and Robert P. Kogod, and the James
Renwick Alliance

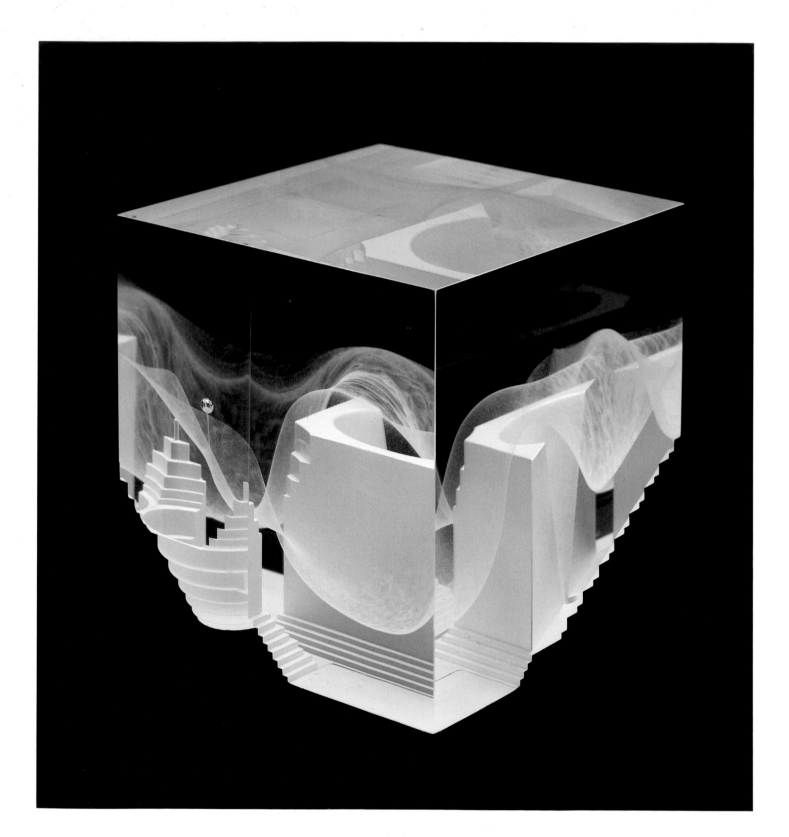

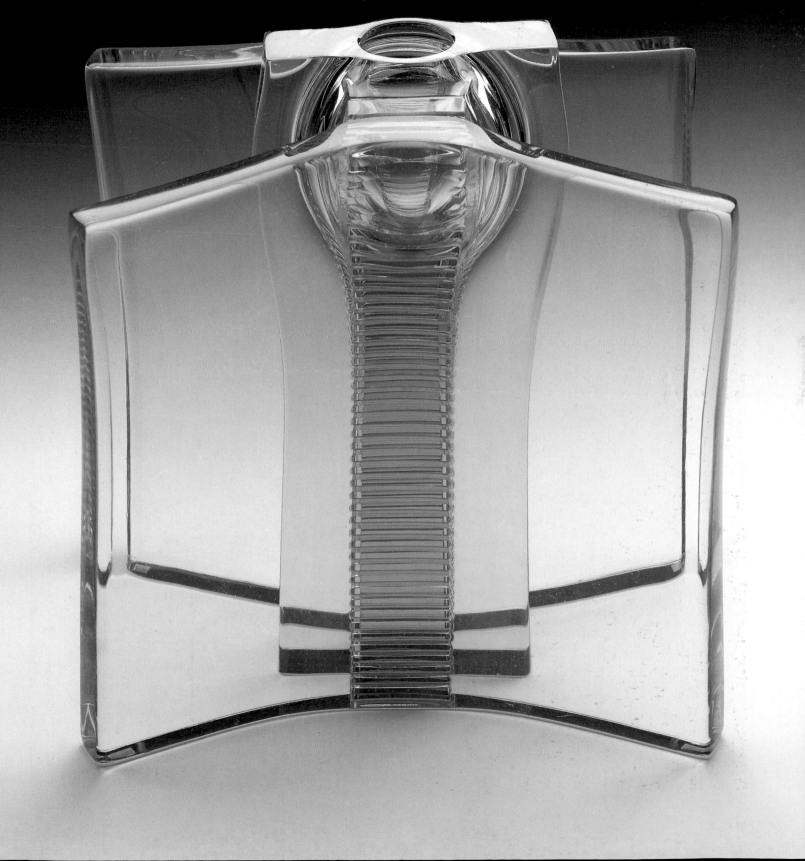

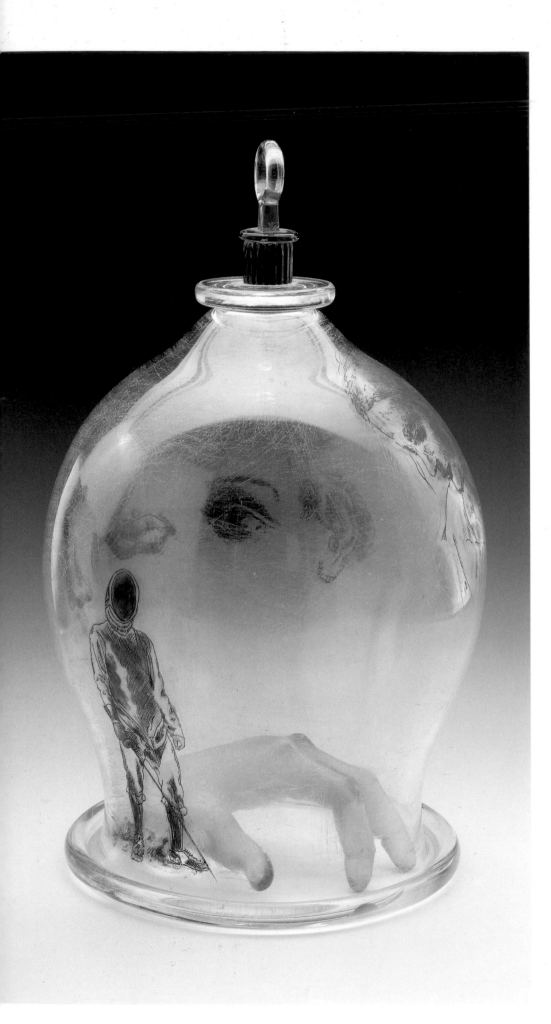

Susan Stinsmuehlen-Amend
(left) *The Memory of Touch,* 1994, blown, cast, engraved, and painted glass, 43.2 x 25.4 x 25.4 cm (17 x 10 x 10 in.). Gift of the James Renwick Alliance

Therman Statom
(opposite) *Arabian Seasons,* 1994, painted glass and plastic, 106.7 x 91.4 x 11.8 cm (42 1/2 x 36 x 4 5/8 in.). Gift of the James Renwick Alliance and museum purchase through the Smithsonian Institution Collections Acquisition Program

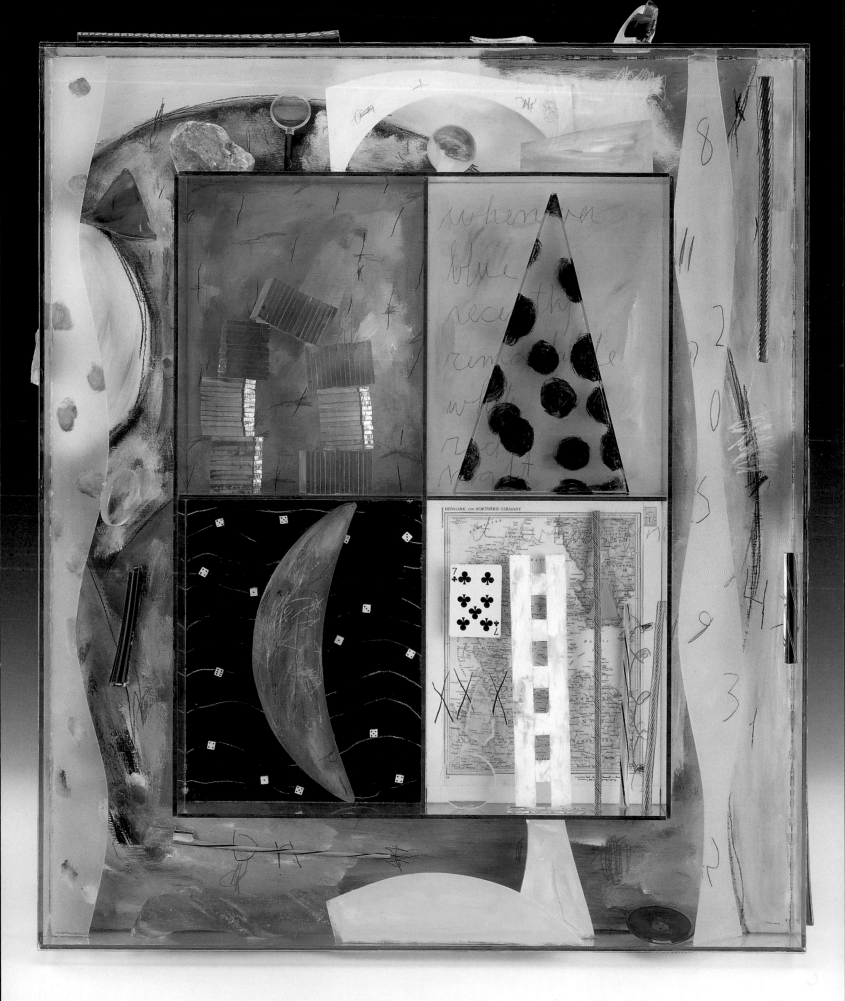

Valerie Timofeev

(below) *Chalice,* 1995, silver, gold, gold foil, garnets, pearls, turquoise, hematite, tiger's eye, filigree wire, and plique-à-jour Thompson and Blythe enamels, 19.4 x 15.3 cm (7 5/8 x 6 in.). Gift of the James Renwick Alliance

Evelyn Ackerman

(opposite) *Stories from the Bible,* 1984–85. First row (left to right): The Archangel Michael, Creation, Adam and Eve in the Garden of Eden, Eve Takes the Forbidden Fruit, Cherubim. Second row (left to right): Cain and Abel, The Flood and Noah's Ark, Sodom and Gomorrah, Abraham and Isaac, Rebecca at the Well. Third row (left to right): Jacob Dreams, Jacob's Ladder, Joseph's Coat of Many Colors, Joseph and Potiphar's Wife, Joseph in Pharaoh's Chariot. Fourth row (left to right): Moses in the Bulrushes, Moses and the Burning Bush, Moses Parts the Red Sea, Moses and the Ten Commandments, The Walls of Jericho. Fifth row (left to right):Samson Slays the Lion, Samson and Delilah, Samson Destroys the Philistines' Temple, Ruth and Boaz, Samuel and Saul. Sixth row (left to right): David Plays the Lyre, David and Goliath, David and Bathsheba, Absalom, King Solomon Enthroned. Seventh row (left to right): Solomon's Judgment, The Temple and the Ark, Elijah Cures the Widow's Son, Ahasuerus Crowns Esther Queen, Haman Leading Mordecai. Bottom row (left to right): The Hanging of Haman, Shadrach, Meshach, Abednego, Daniel in the Lion's Den, Jonah and the Whale, The Angel Gabriel, cloisonné enamel with silver wire on copper, each enamel 8 x 8 x .3 cm (3 1/8 x 3 1/8 x 1/8 in.). Gift of Laura Ackerman-Shaw in honor of her mother, Evelyn Ackerman

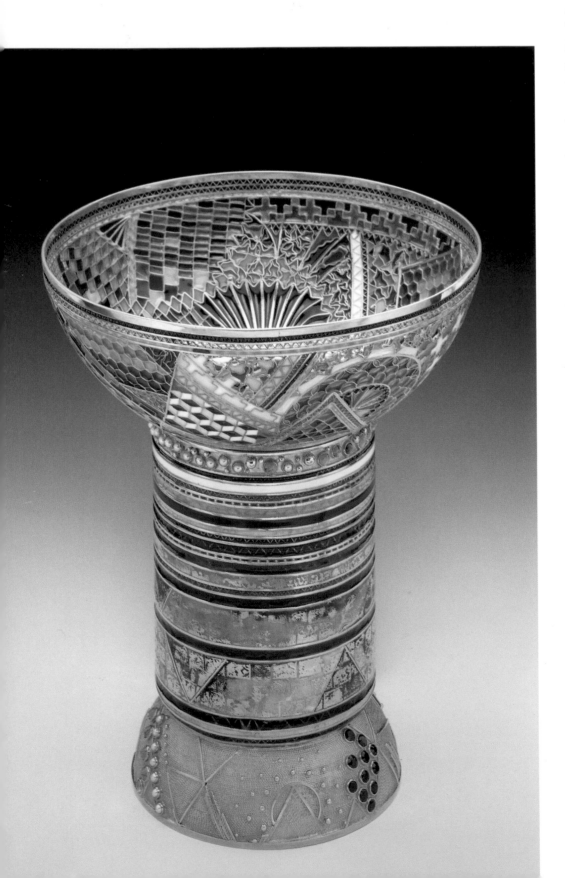

Abrasha

Hanukkah Menorah, 1995, fabricated stainless steel, silver, and gold, 17.5 x 43.8 x 9.8 cm (6 7/8 x 17 1/4 x 3 7/8 in.). Gift of the James Renwick Alliance, and In memory of the artist's father, Solomon David Staszewski

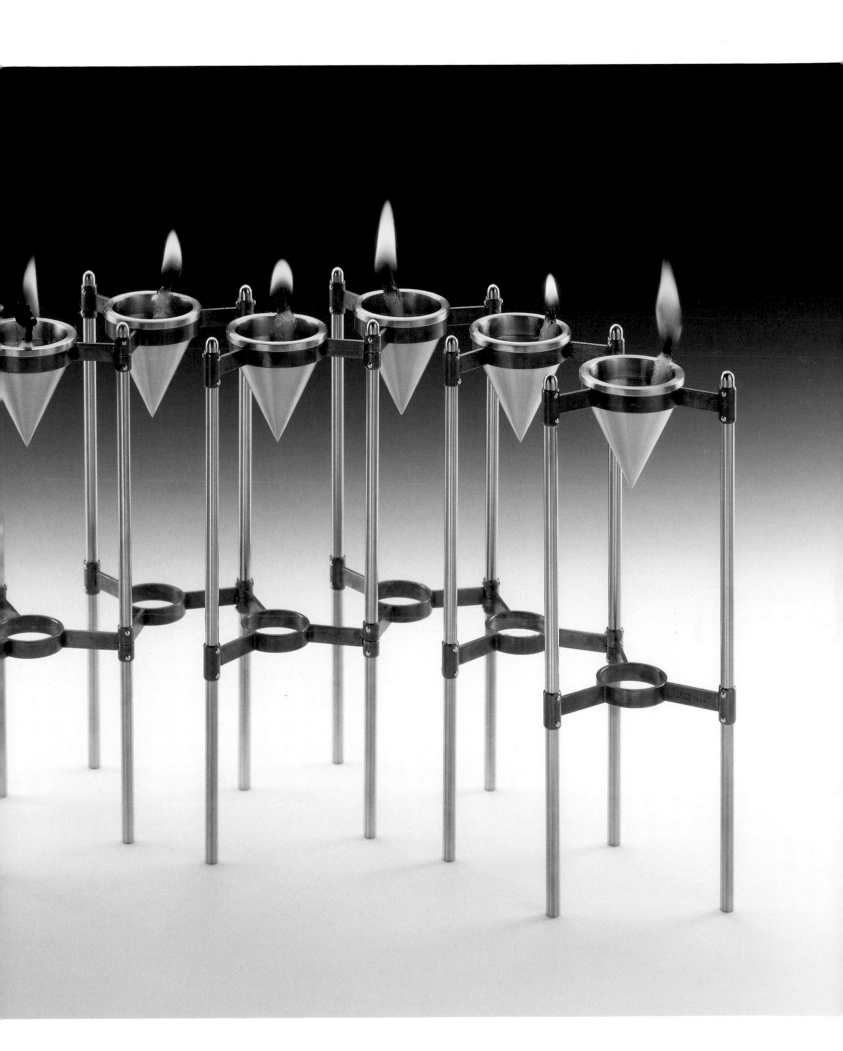

Margret Craver

Muffineer, 1946, sterling silver,
9.6 x 7.7 x 7.7 cm (3 3/4 x 3 x 3 in.).
Gift of the James Renwick Alliance

Alma Eikerman

Balanced Bowl, 1974, sterling
silver and red brass, 17.8 x 18.5 cm
(7 x 7 1/4 in.). Gift of the James Renwick
Alliance and museum purchase through
the Smithsonian Institution Collections
Acquisition Program

John Prip

(below) *Coffeepot*, 1958, silver and ebony, 29.8 x 23.5 x 11.5 cm (11 3/4 x 9 1/4 x 4 1/2 in.). Gift of the James Renwick Alliance and museum purchase through the Smithsonian Institution Collections Acquisition Program

Fred Fenster

(opposite) *Teapot and Cup*, 1994, constructed pewter; teapot: 29.3 x 21.7 x 11.5 cm (11 1/2 x 8 1/2 x 4 1/2 in.); lid: 5 .? x 5 .? x 5.2 cm (2 x 2 x 2 in.); cup: 6.4 x 5.2 x 5.2 cm (2 1/2 x 2 x 2 in.). Gift of Ruth Neubauer

Myra Mimlitsch Gray

(below) *Sugar Bowl and Creamer III,* 1996, raised, formed, and constructed copper; bowl: 28 x 17.8 x 12.7 cm (11 x 7 x 5 in.); creamer: 28 x 24.2 x 10.2 cm (11 x 9 1/2 x 4 in.). Gift of the James Renwick Alliance on the Occasion of the 25th Anniversary of the Renwick Gallery

John Prip

(opposite) *Box,* silver and gold, 1971–72, 19.4 x 6.7 x 6.7 cm (7 5/8 x 2 5/8 x 2 5/8 in.). Gift of the James Renwick Alliance and museum purchase through the Smithsonian Institution Collections Acquisition Program

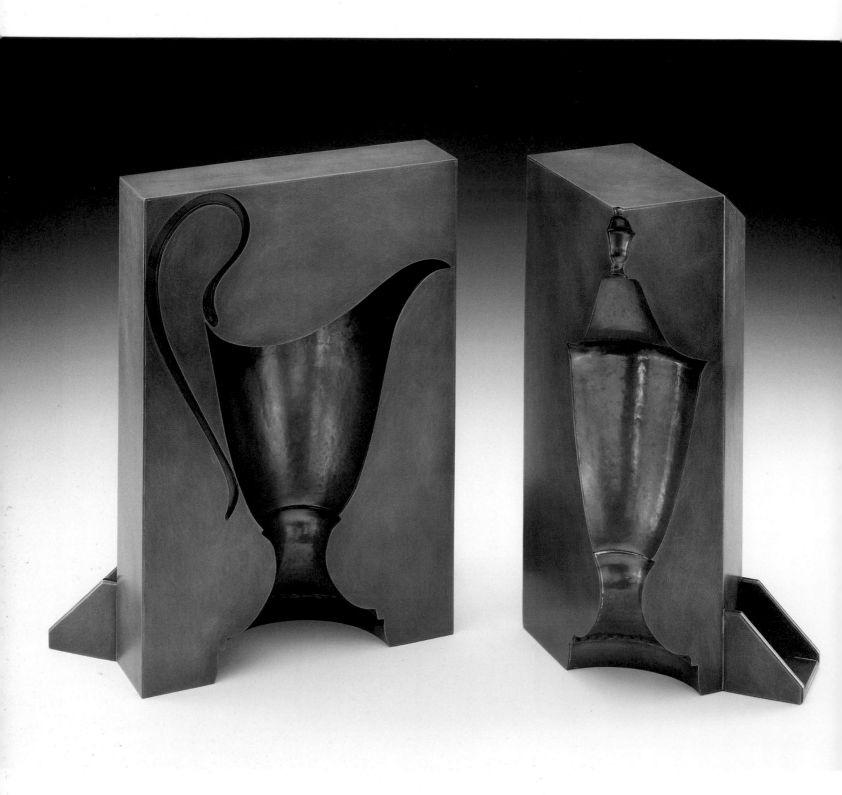

Arline Fisch

(top) *Spirit Box Brooch,* 1989, sterling silver, gold, gold leaf, onyx, and mother-of-pearl, 11.5 x 8.7 x 1.3 cm (4 1/2 x 3 3/8 x 1/2 in.). Gift of the James Renwick Alliance and the Joanne Rapp Gallery, The Hand and the Spirit

John Paul Miller

(bottom) *Pendant/Brooch,* 1975, gold and enamel, 6.4 x 5.2 x 2.5 cm (2 1/2 x 2 x 1 in.). Anonymous gift in memory of Dorothy S. Payer in honor of John Paul Miller

Robert Ebendorf

(opposite) *Necklace,* 1972, sterling silver, 14k gold, ebony, amber, wood, ivory, bone, and copper, 82.9 x 5.4 cm (32 5/8 x 2 1/8 in.). Museum purchase

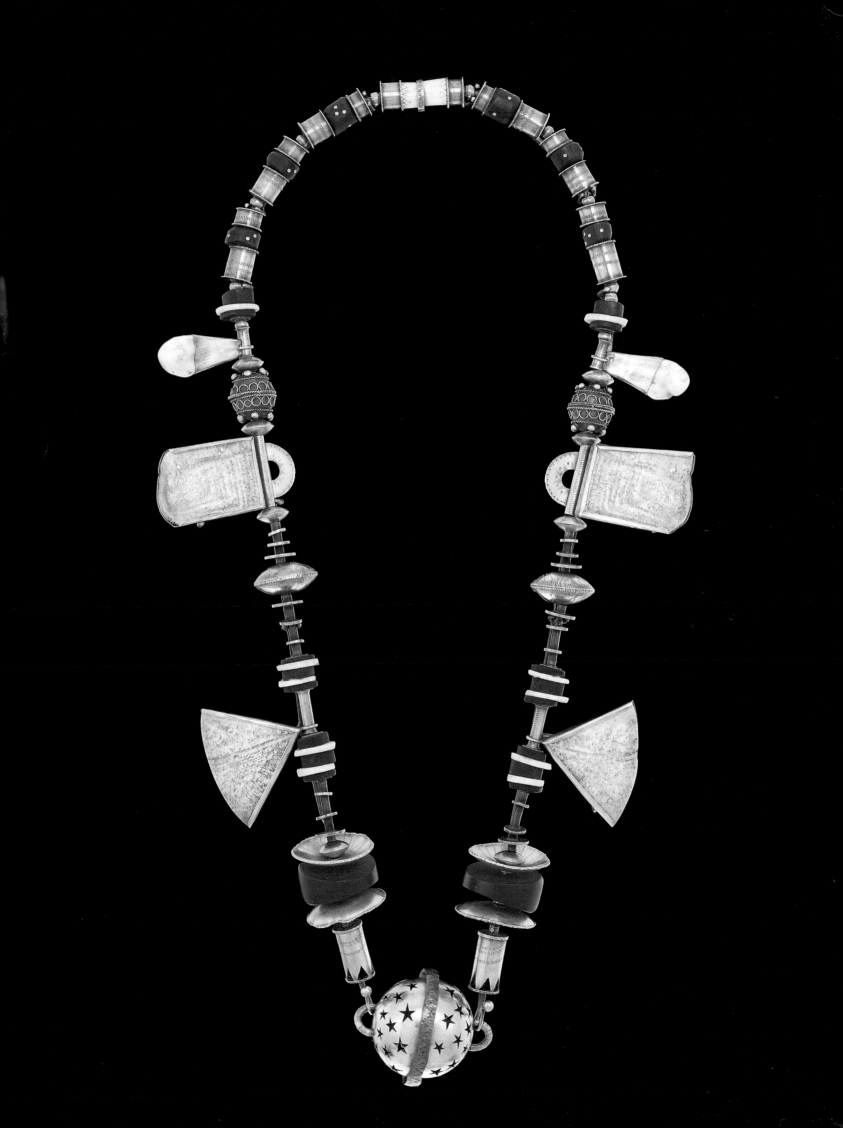

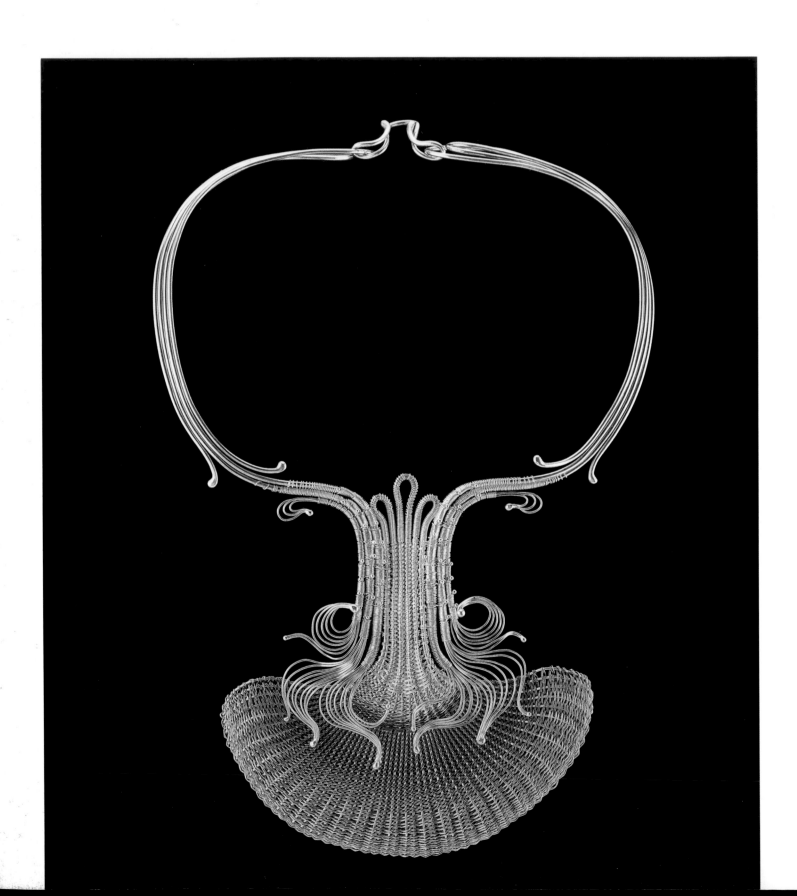

D. X. Ross

(below) *Tides of the Centuries,* 1991,
agate, carved jade, silver, gold, and dentalia,
16.9 x 6.4 x 1.7 cm (6 5/8 x 2 1/2 x 5/8 in.).
Gift of Kenneth R. Trapp in honor of Donald
Freeman Mahan

William Harper

(right) *Self-Portrait of the Artist as a
Haruspek,* 1990, gold, sterling silver,
cloisonné enamel, opal, pearl, coral,
shell and carapace, 29.2 x 6.4 x 5.8 cm
(11 1/2 x 2 1/2 x 2 1/4 in.). Gift of the James
Renwick Alliance and museum purchase
through the Smithsonian Institution Col-
lections Acquisition Program

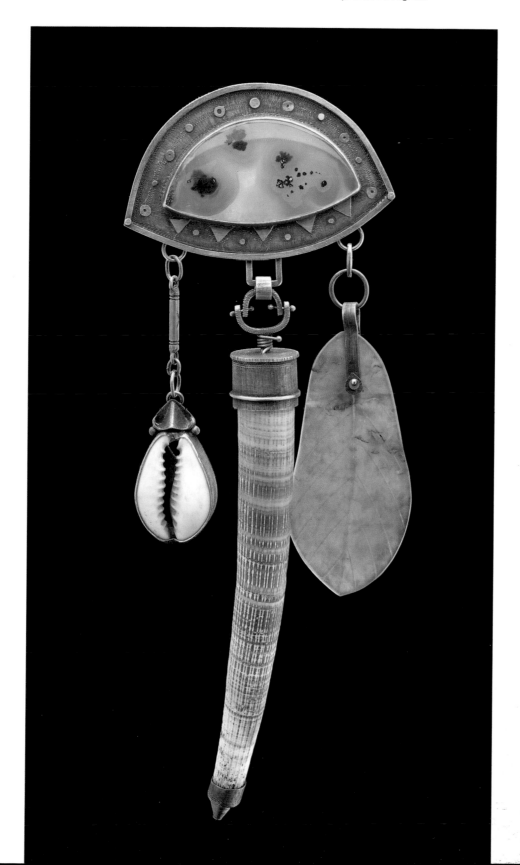

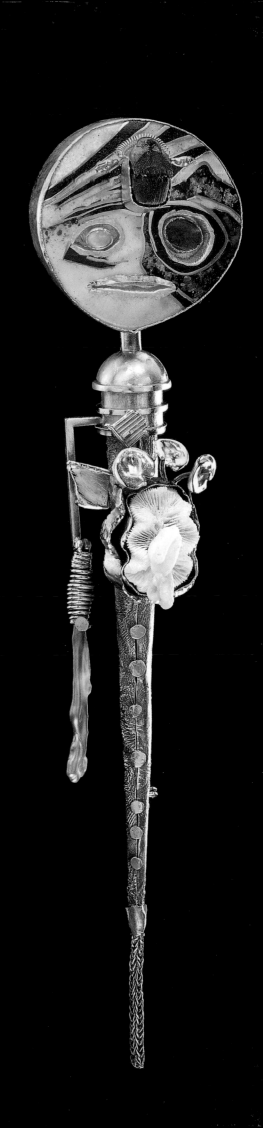

Richard Mawdsley

(below) *Feast Bracelet,* 1974, sterling silver, jade, and pearls, 9.6 x 7 x 11.5 cm (3 1/2 x 2 3/4 x 4 1/2 in.). Gift of the James Renwick Alliance in honor of Lloyd E. Herman, Director Emeritus, Renwick Gallery

Earl Pardon

(opposite) *Necklace #1057,* 1988, sterling silver, 14k gold, ebony, ivory, enamel, shell, ruby, garnet, blue topaz, amethyst, spinel, and rhodolite, 43.8 x 2.9 x .3 cm (17 1/4 x 1 1/8 x 1/8 in.). Gift of the James Renwick Alliance and museum purchase through the Smithsonian Institution Collections Acquisition Program

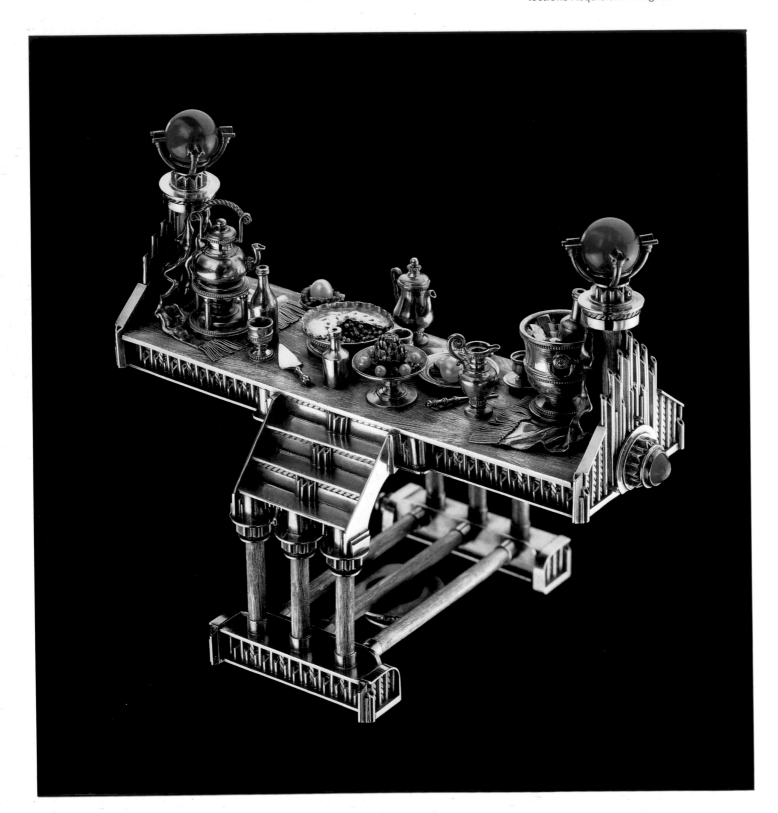

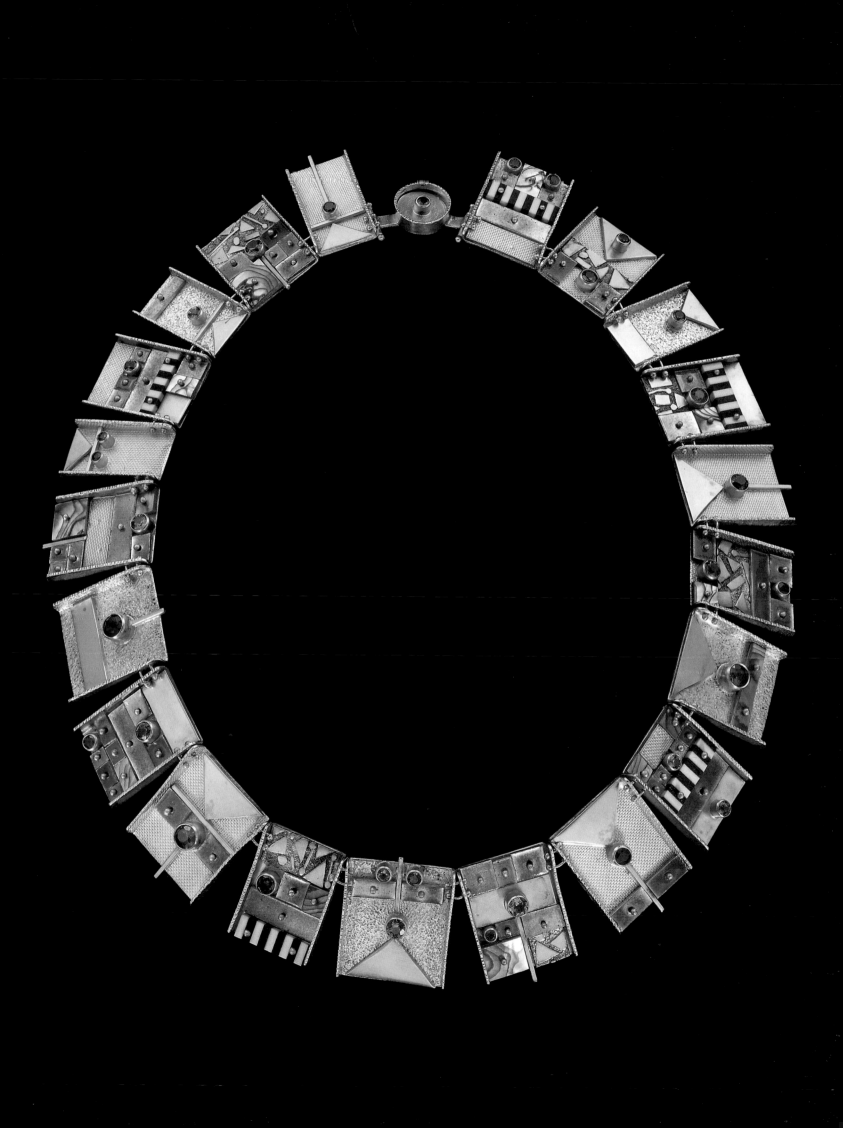

Albert Paley

Pendant, 1973, gold, silver, copper, labradorite, moonstone, jade, glass, and ivory, 55.9 x 21.6 x 3.9 cm (22 x 8 1/2 x 1 1/2 in.). Gift of the James Renwick Alliance and museum purchase through the Smithsonian Institution Collections Acquisition Program

(opposite) *Portal Gates,* 1974, forged steel, brass, copper, and bronze, 230.5 x 182.9 x 10.2 cm (90 3/4 x 72 x 4 in.). Commissioned for the Renwick Gallery

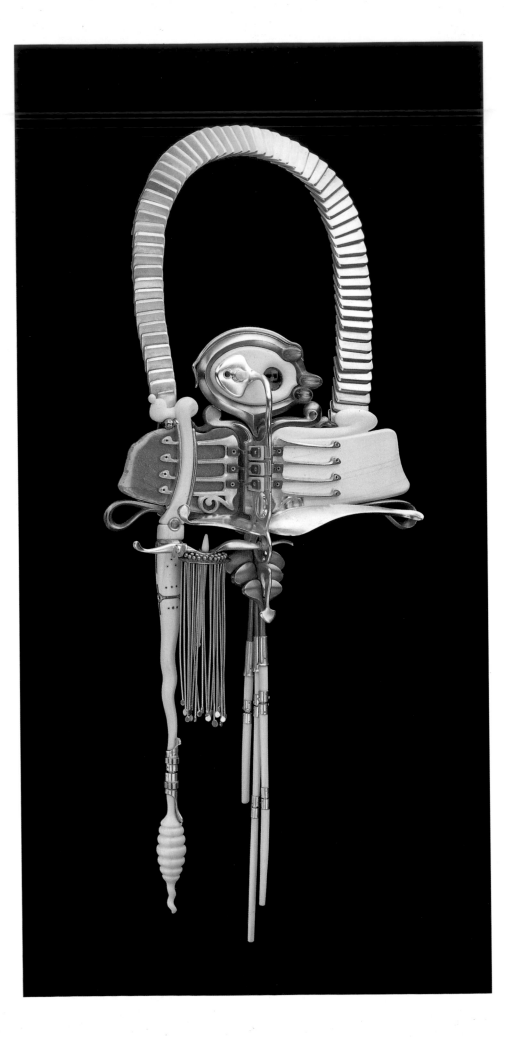

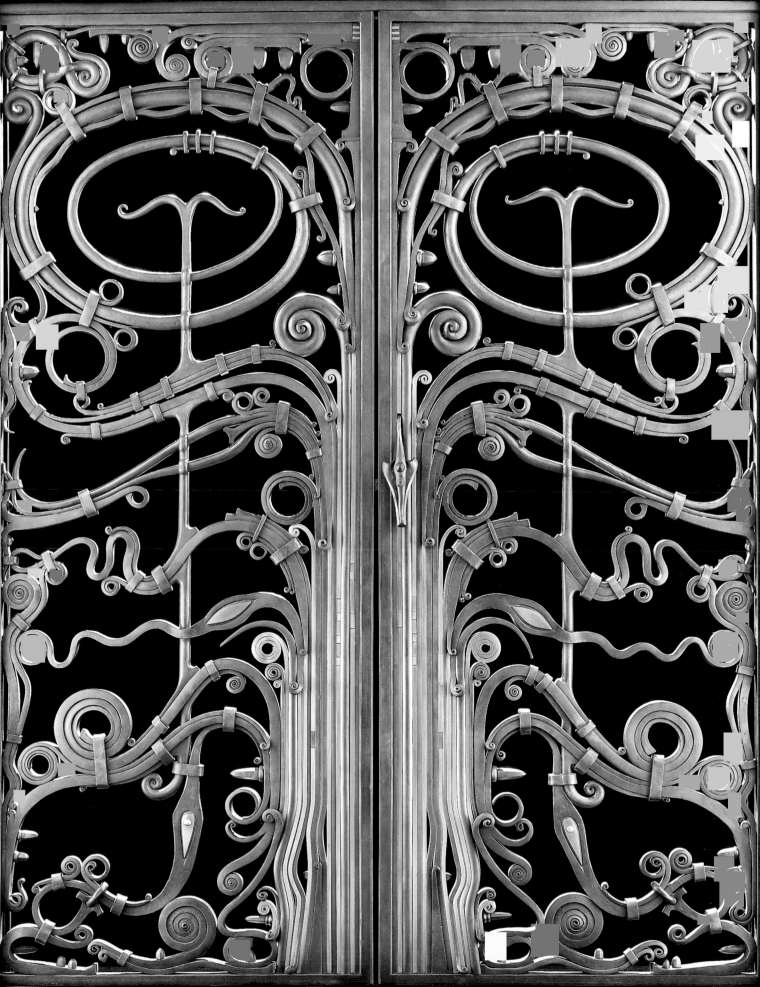

Ronald Hayes Pearson
(below) *Neckpiece,* 1968, sterling silver,
20.3 x 24.2 x 19.1 cm (8 x 9 1/2 x 7 1/2 in.).
Gift of the James Renwick Alliance

Kent Raible
(opposite) *Floating City,* 1996, fabricated
gold, chrome, diamonds, sapphires,
amethysts, chalcedony, and tourmaline,
26.1 x 13.7 x 2.5 cm (10 1/4 x 5 3/8 x 1 in.).
Gift of the James Renwick Alliance

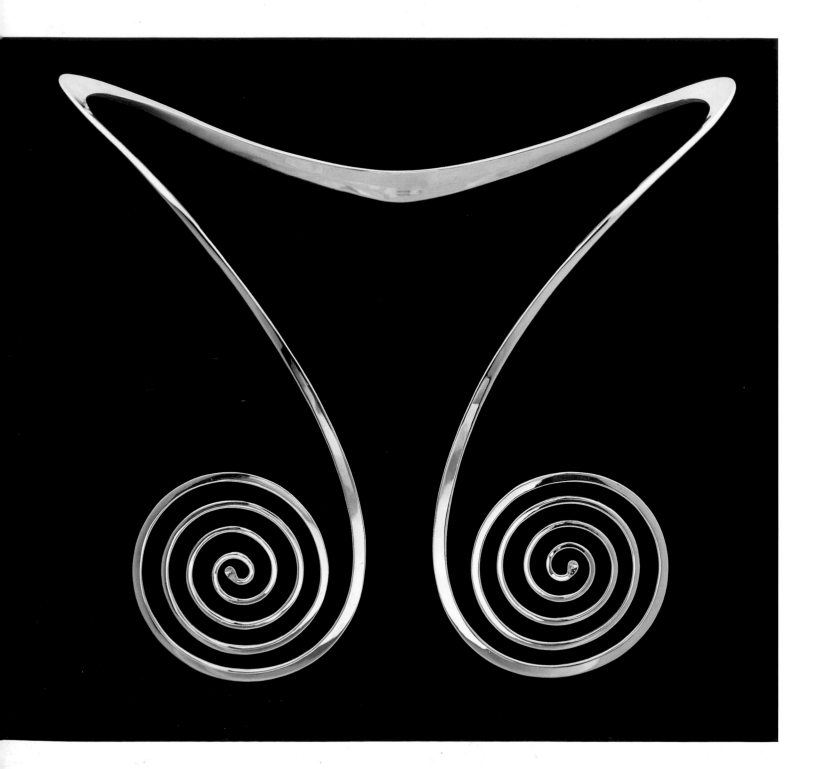

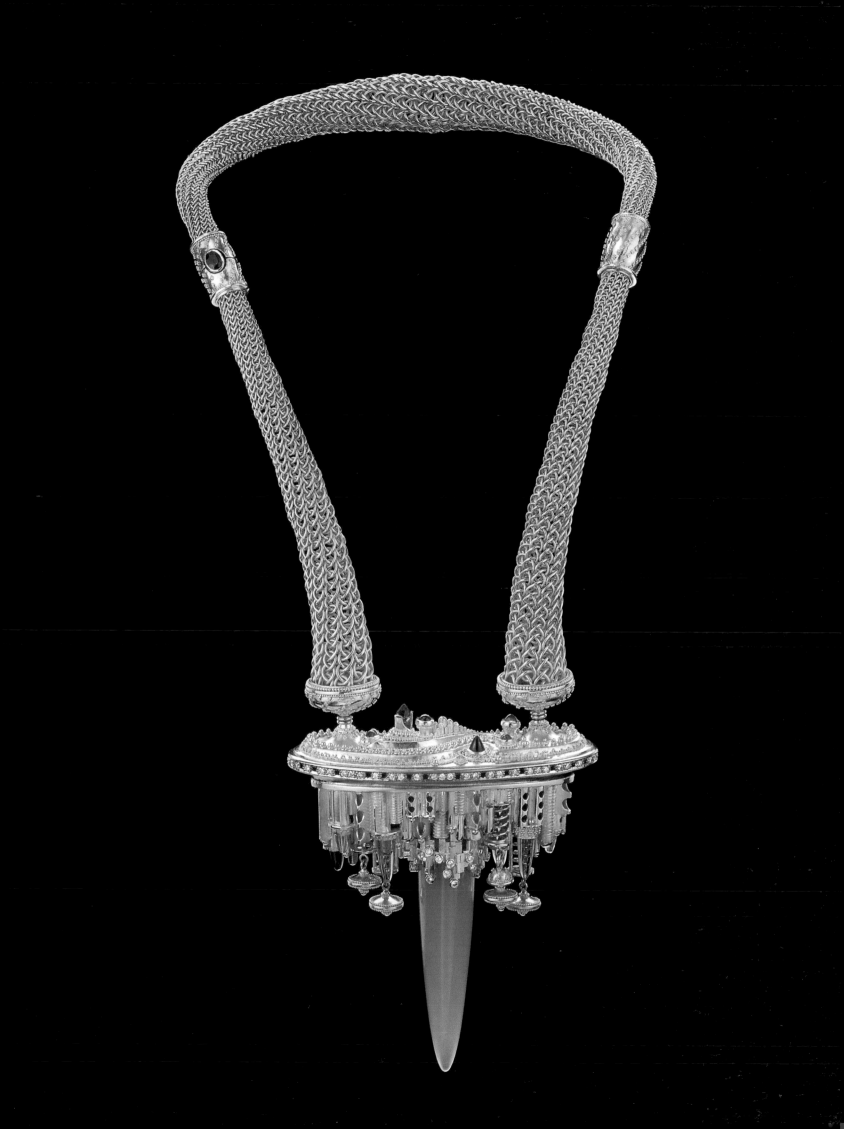

Janet Prip

(below) *Head Vase with Large Lips,* 1988,
bronze with carnauba wax, 34.6 x 16.8
x 5.1 cm (15 5/8 x 6 5/8 x 2 in.). *Head Vase
with Jagged Hair,* 1988, bronze with car-
nauba wax, 30.5 x 19 x 7.9 cm (12 x 7 1/2
x 3 1/8 in.). Gift of the James Renwick
Alliance

Dan Dailey

(opposite) *Huntress,* 1993, bronze, gold-
plated bronze, blown glass, and plate
glass, 82.3 x 61 x 33 cm (32 3/8 x 24 x 13
in.). Gift of the James Renwick Alliance

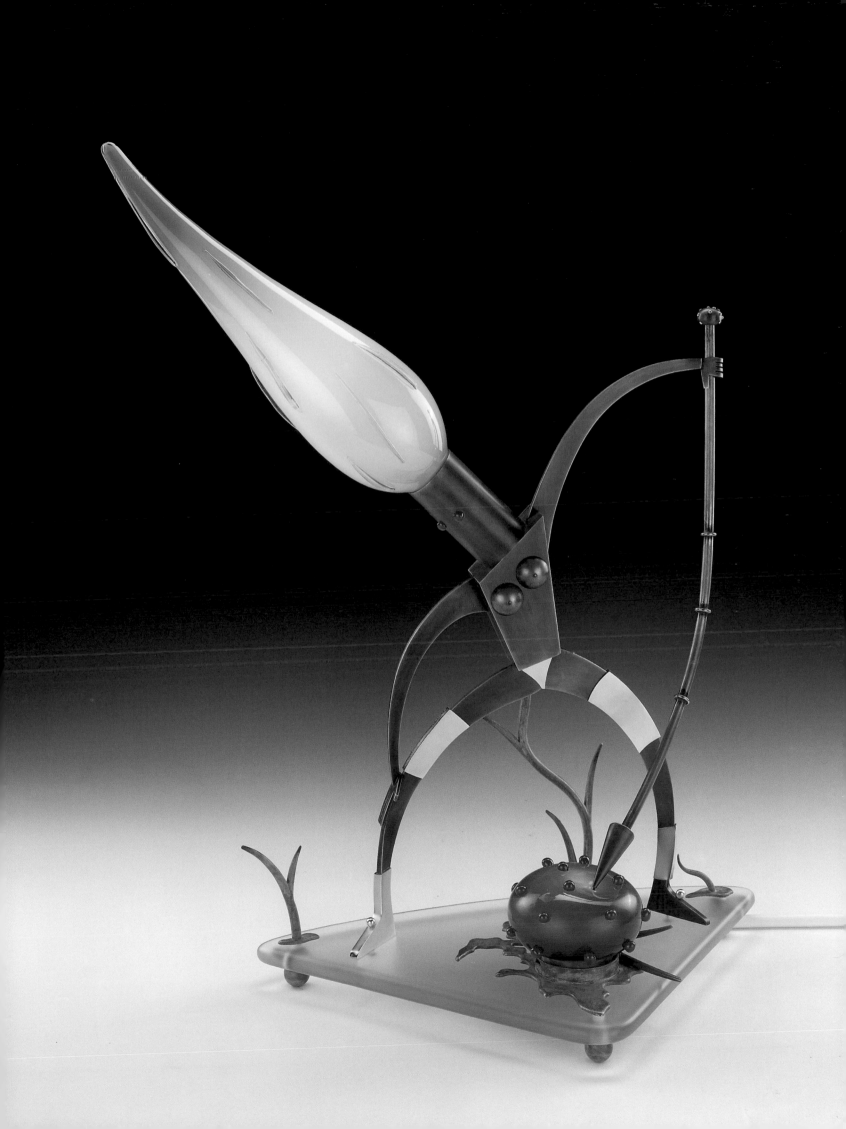

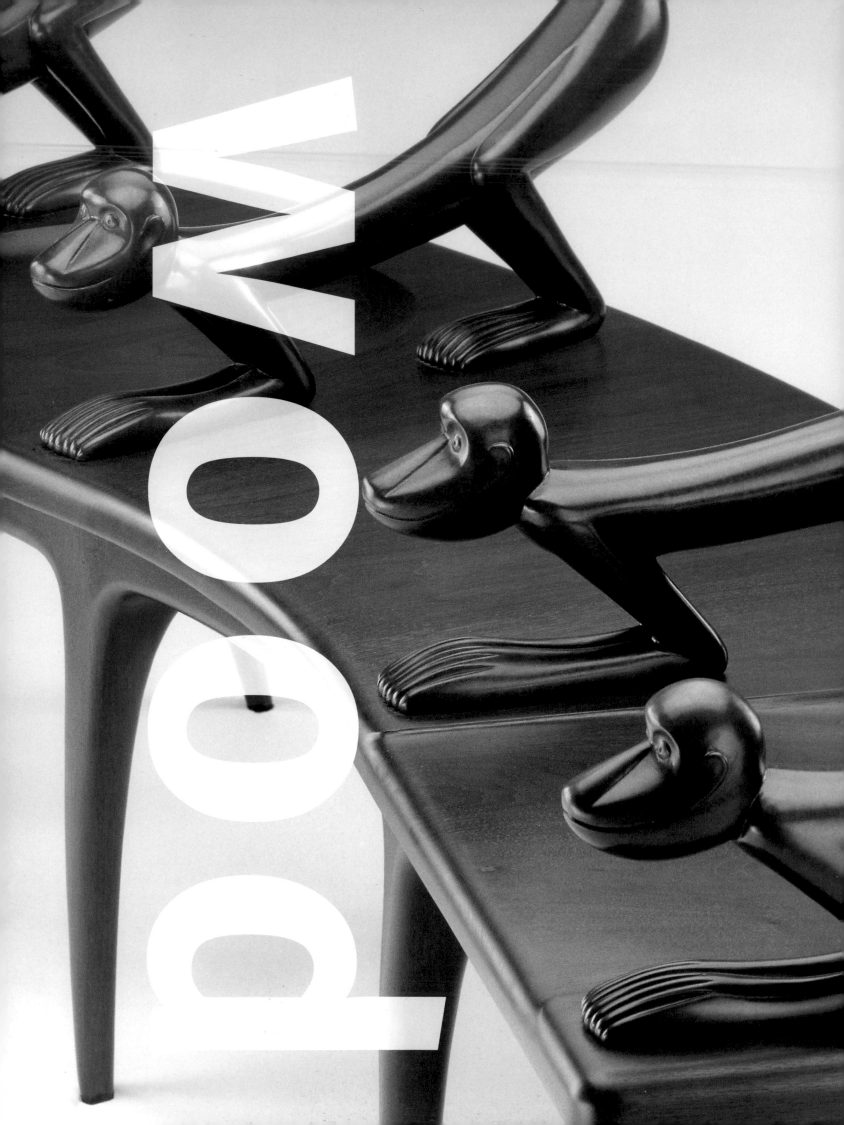

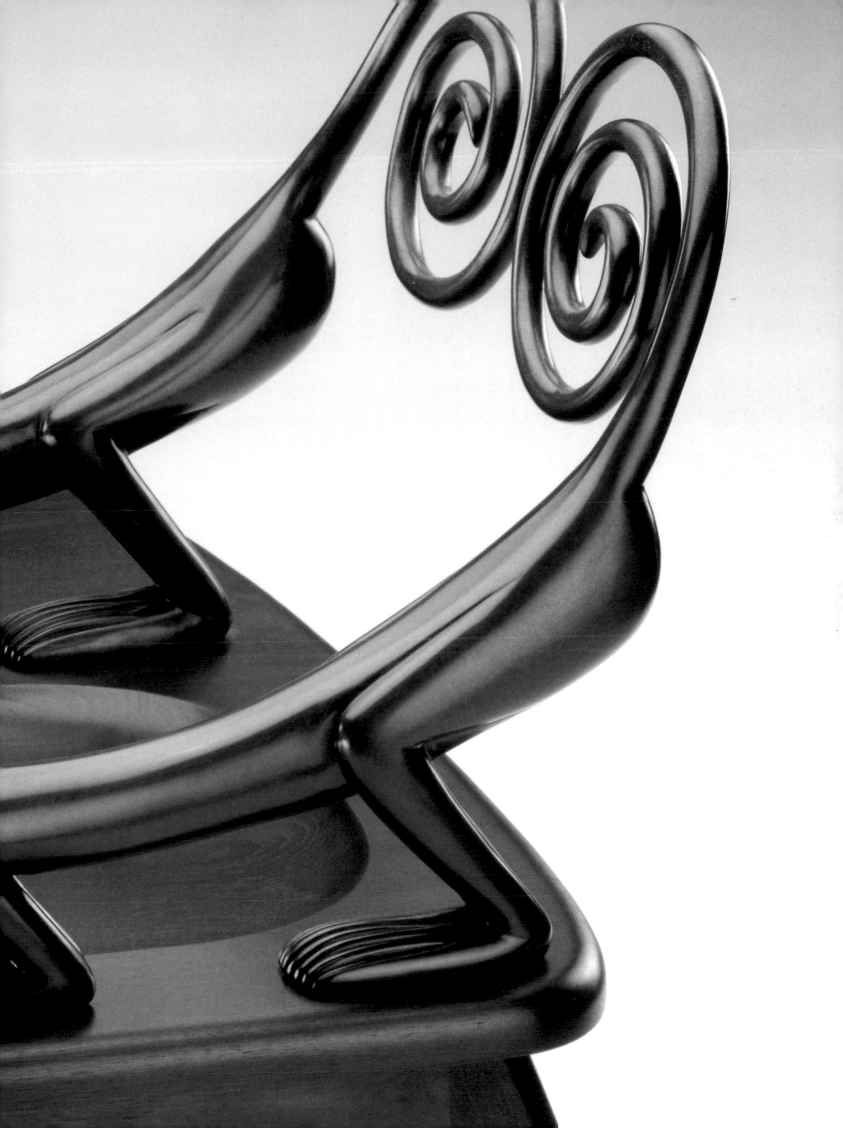

Norm Sartorius

(below) *Spoon from a Forgotten Ceremony*, 1994, dogwood, 3.8 x 45.8 x 7.7 cm (1 1/2 x 18 x 3 in.). Gift of Robyn and John Horn

Bruce Metcalf

(opposite) *Wood Necklace #11*, 1994, fabricated maple, copper, tagua nut, pre-fossil horse tooth, glass eye, Micarta, brass, aluminum, stainless steel, cable, and pigments, 43.2 x 39.4 x 5.2 cm (17 x 15 1/2 x 2 in.). Gift of the James Renwick Alliance

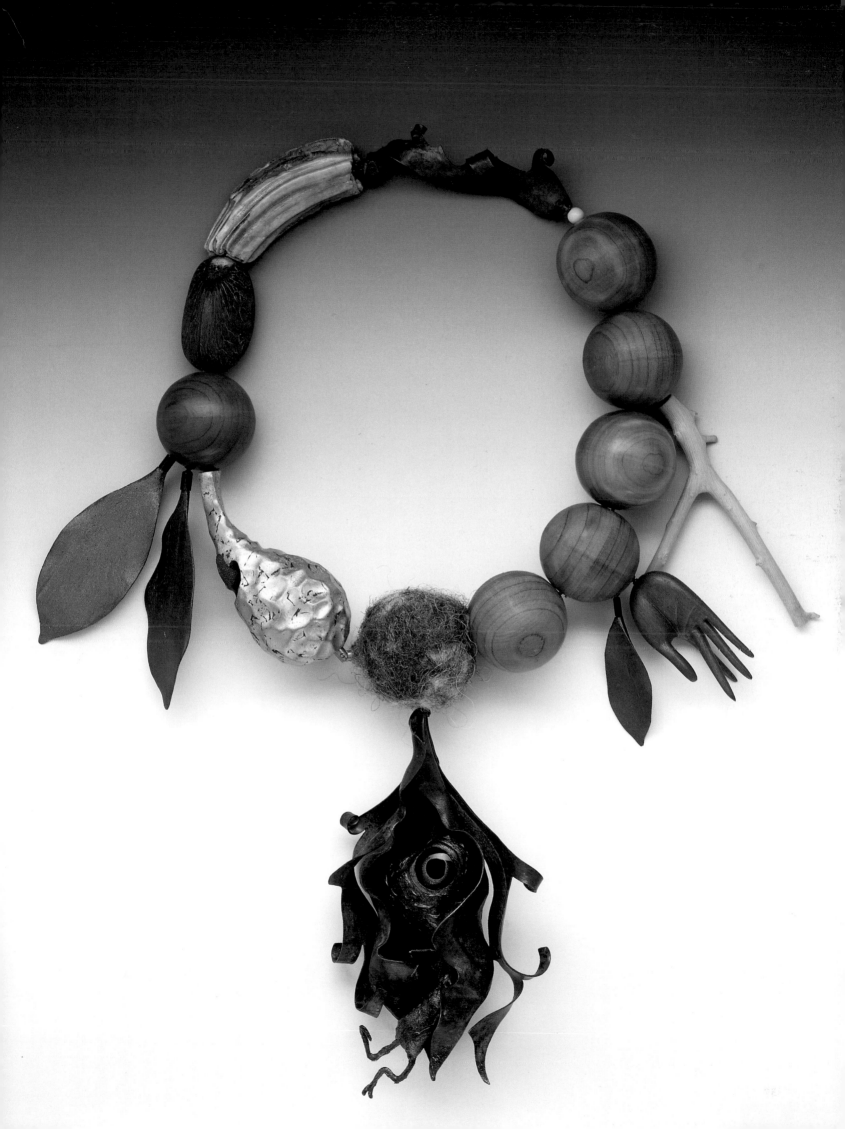

John Cederquist

Ghost Boy, 1992, birch plywood, sitka spruce, poplar, copper leaf, epoxy resin inlay, and analine dyes, 224.2 x 113 x 38.2 cm (88 1/4 x 44 1/2 x 15 in.). Gift of the James Renwick Alliance, Anne and Ronald Abramson and museum purchase

Wendell Castle

(opposite) *Ghost Clock,* 1985, mahogany and bleached Honduras mahogany, 219 x 62.2 x 38.1 cm (86 1/4 x 24 1/2 x 15 in.). Museum purchase through the Smithsonian Institution Collections Acquisition Program

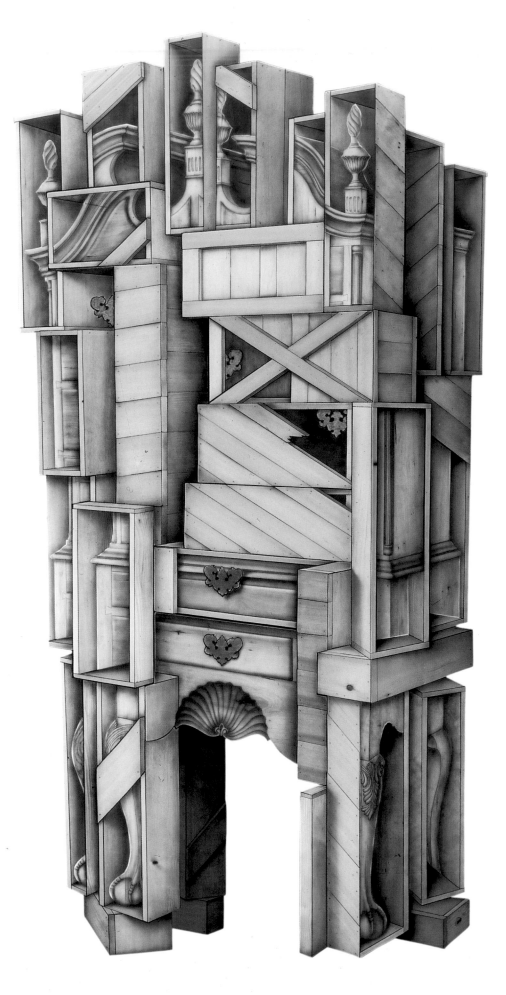

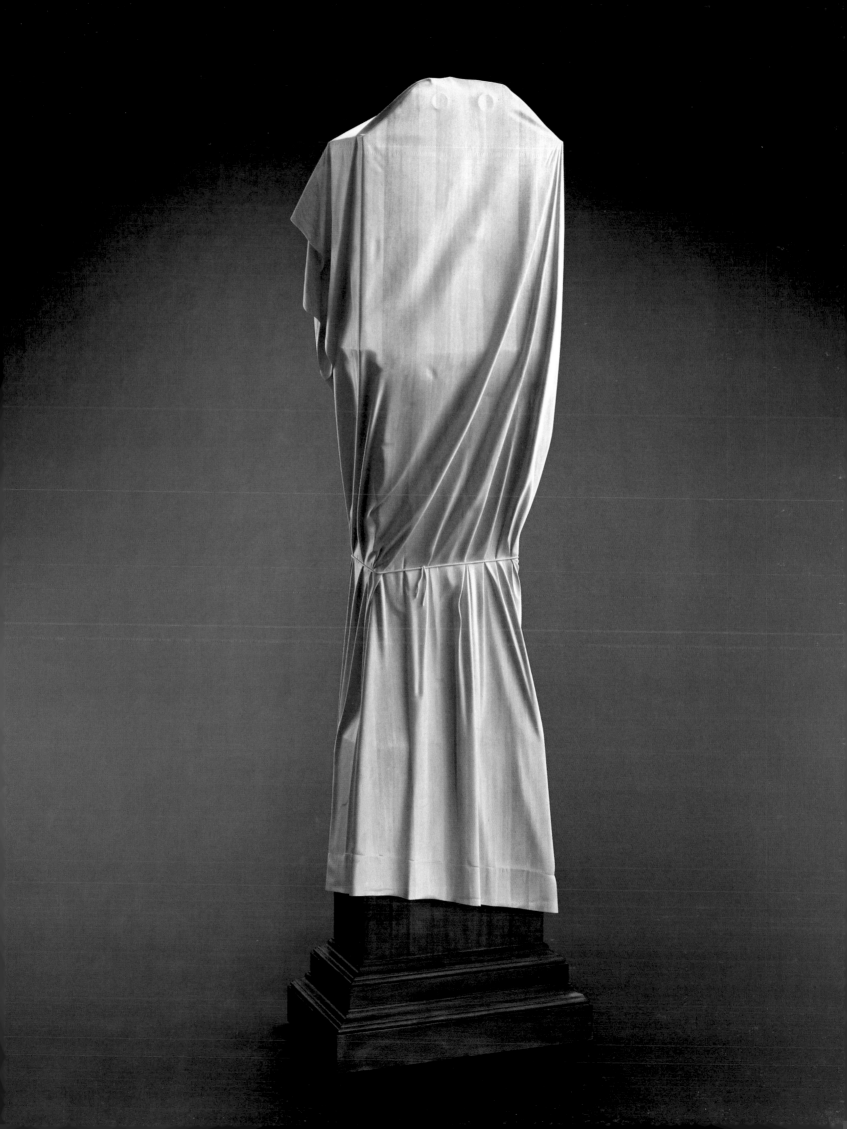

Tom Loeser

(below) *Four by Four*, 1994, painted mahogany and bleached ash, 112.4 x 85.8 x 43.2 cm (44 1/4 x 33 3/4 x 17 in.). Gift of Robert and Gayle Greenhill, Eleanor T. and Samuel J. Rosenfeld, anonymous contributors, and museum purchase

Alphonse Mattia

(opposite) *Atlas, Webster, & Roget*, 1995, fir, bird's-eye maple, curly maple, and painted wood, *Atlas:* 180.3 x 54.6 x 39.3 cm (71 x 21 1/2 x 15 1/2 in.); *Webster:* 170.2 x 49.5 x 41 cm (67 1/4 x 19 3/4 x 16 in.); *Roget:* 181 x 26.7 x 35.6 cm (71 1/4 x 10 1/2 x 14 in.). Gift of Peter T. Joseph

John Dunnigan

(left) *Slipper Chair*, 1990, purpleheart wood with silk upholstery, 60 x 67.4 x 58.4 cm (26 3/4 x 25 1/2 x 23 in.). Gift of the James Renwick Alliance

(right) *Slipper Chair*, 1990, purpleheart wood with silk upholstery, 110.5 x 66.7 x 61 cm (43 1/2 x 26 1/4 x 24 in.). Gift of the James Renwick Alliance

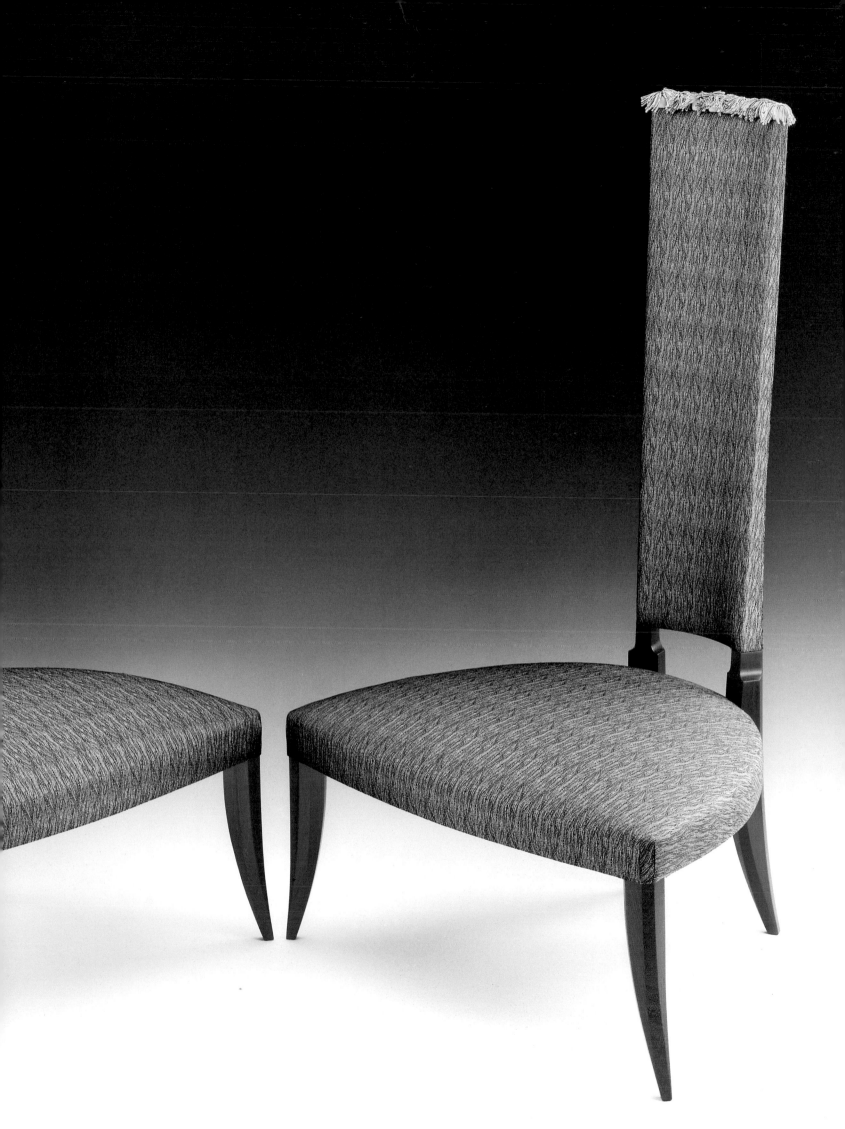

Michael Hurwitz

Rocking Chaise, 1989, laminated ma-
hogany, steel, and paint, 91.4 x 228.6
x 61 cm (36 x 90 x 24 in.). Gift of Anne and
Ronald Abramson, the James Renwick Alli-
ance, and museum purchase through the
Smithsonian Institution Collections Acqui-
sition Program

Sam Maloof

(below) *Michael W. Monroe Low-back Side Chair,* 1995, zircote wood, 75.5 x 57.8 x 56.5 cm (29 3/4 x 22 3/4 x 22 1/8 in.). Gift of Alfreda and Sam Maloof in honor of Michael W. Monroe, Renwick Gallery Curator-in-Charge, 1986–1995

Judy Kensley McKie

(opposite) *Monkey Settee,* 1995, walnut and bronze, 90.2 x 182.2 x 61 cm (35 1/2 x 71 3/4 x 24 in.). Gift of the James Renwick Alliance in honor of Michael W. Monroe, Renwick Gallery Curator-in-Charge, 1986–1995

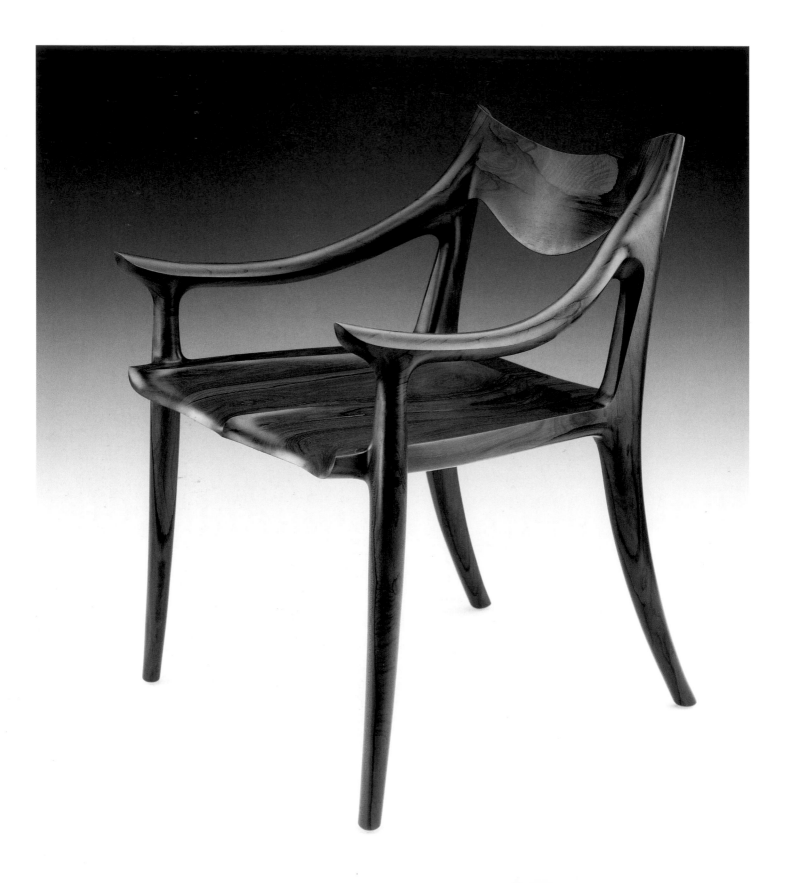

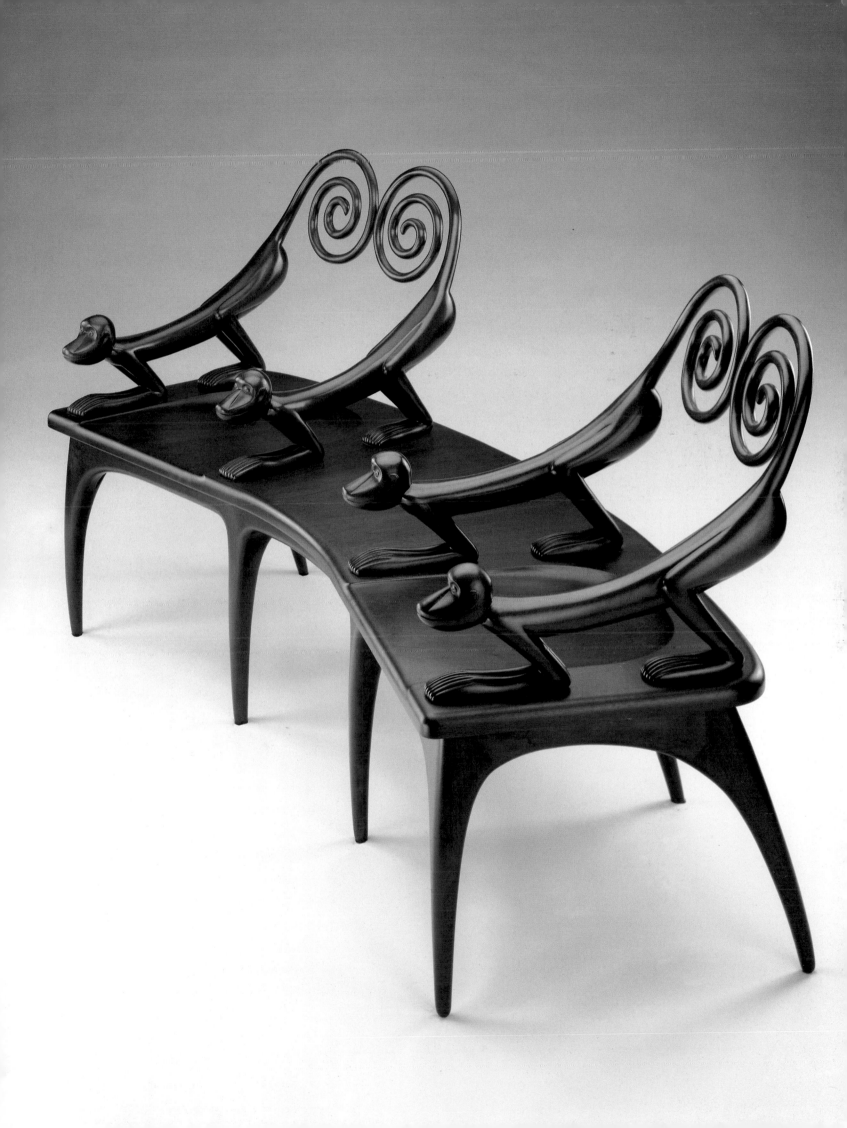

Garry Knox Bennett

(below) *Boston Kneehole Desk,* 1989, Honduras rosewood, maple, aluminum, brick, Fountain head, and antique bronze, 79.4 x 127.6 x 61 cm (31 1/4 x 50 1/4 x 24 in.). Gift of Anne and Ronald Abramson, the James Renwick Alliance and museum purchase through the Smithsonian Institution Collections Acquisition Program

Jere Osgood

(opposite) *Cylinder-Front Desk,* 1989, Australian lacewood, Honduras rosewood, pearwood, and mahogany plywood, 116.5 x 109.9 x 73.7 cm (45 7/8 x 43 1/4 x 29 in.). Gift of the James Renwick Alliance and museum purchase through the Smithsonian Institution Collections Acquisition Program

James Prestini

Bowl, turned birch, 6.7 x 12 cm
(2 5/8 x 4 3/4 in.); *Bowl,* turned Mexican
mahogany, 7 x 15.6 cm (2 3/4 x 6 1/8 in.);
Bowl, turned birch, 5.1 x 28.3 cm (2 x 11 1/8
in.); *Bowl,* turned Mexican mahogany,
14.5 x 24.4 cm (5 11/16 x 9 5/8 in.); *Bowl,*
turned black walnut, 9.5 x 17.1 cm (3 3/4
x 6 3/4 in.), all 1933–53. Gift of the artist

Giles Gilson

Sunset, 1987, painted wood and chrome,
31.2 x 61 cm (12 1/4 x 24 in.). Gift of George
Peter Lamb and Lucy Scardino in memory
of Natalie Rust Lamb

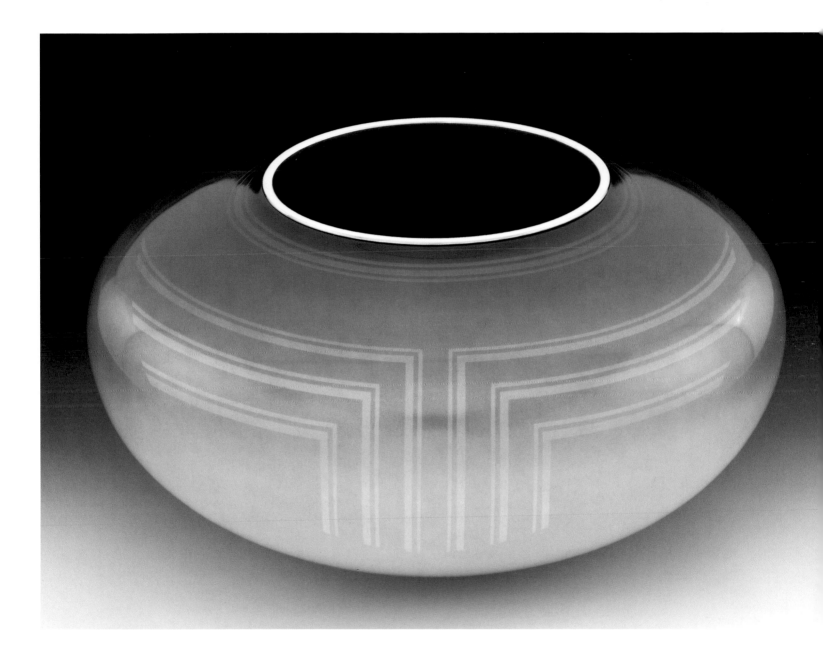

William Hunter

(below) *Cuzco Moon*, 1987, vero wood, 36.2 x 36.8 cm (14 1/4 x 14 1/2 in.). Gift of Jane and Arthur K. Mason on the Occasion of the 25th Anniversary of the Renwick Gallery

Michelle Holzapfel

(opposite) *Vase*, 1989, cherry burl, 38.2 x 31.8 cm (15 x 12 1/2 in.). Gift of Jane and Arthur K. Mason on the Occasion of the 25th Anniversary of the Renwick Gallery

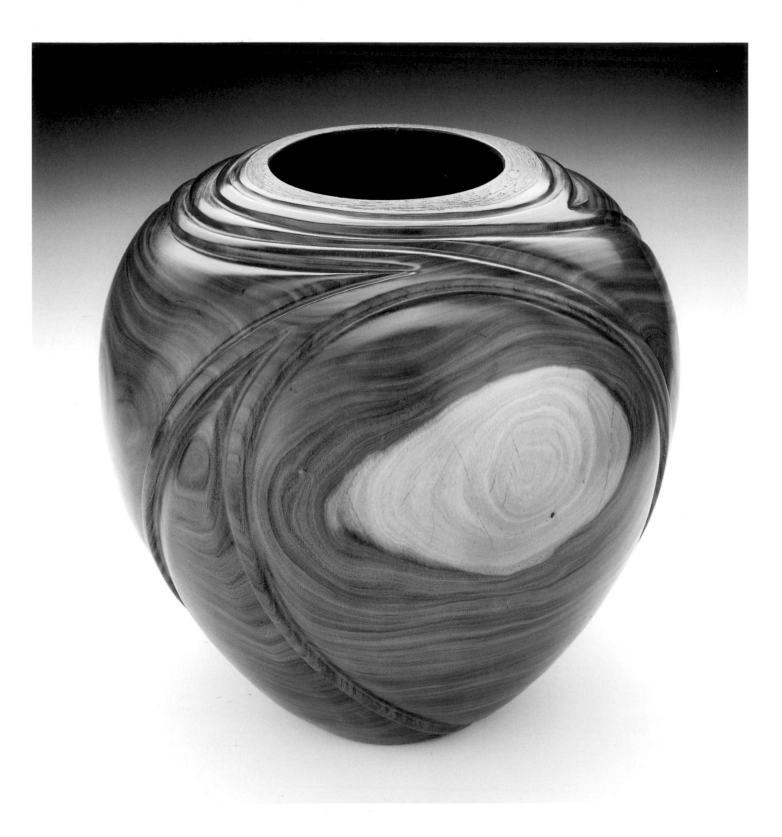

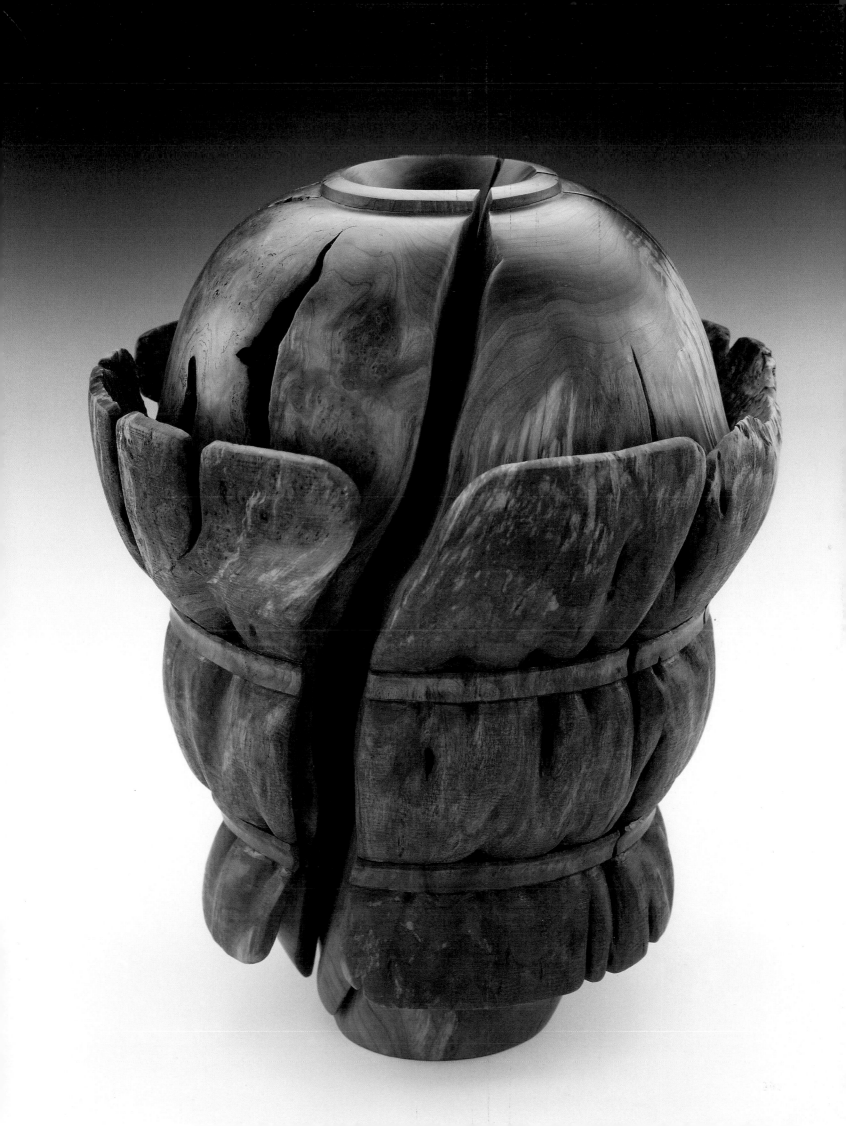

Edward Moulthrop

Rolled-Edge Bowl, 1988–89, turned figured tulip poplar wood, 23.5 x 74.3 cm (9 1/4 x 29 1/2 in.). Gift of the James Renwick Alliance and museum purchase through the Smithsonian Institution Collections Acquisition Program

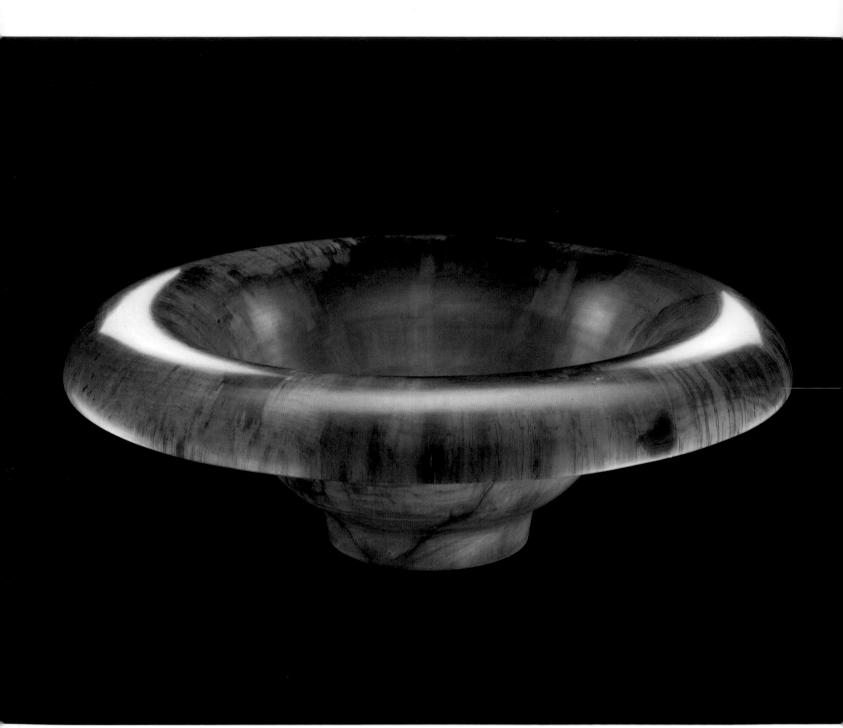

Philip Moulthrop

Figured Tulip Poplar Bowl, 1987, turned
figured tulip poplar wood, 35 x 43.2 cm
(13 3/4 x 17 in.). Gift of David S. Purvis and
the American Art Forum

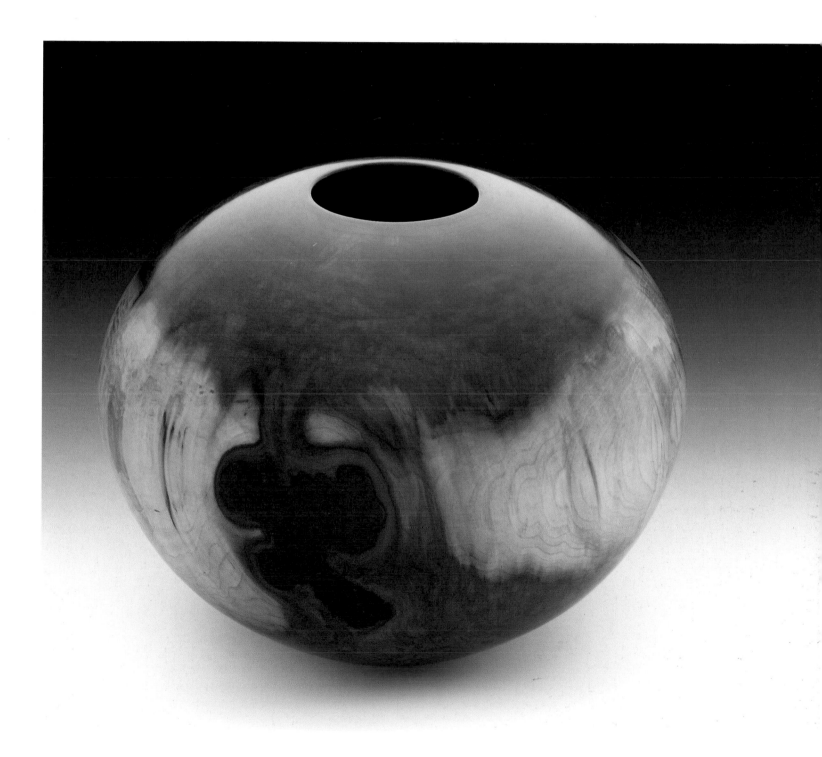

Dan Kvitka

(below) *Vase,* 1987, vero wood, 25.4 x 27.3 cm (10 x 10 3/4 in.), Gift of Jane and Arthur K. Mason on the Occasion of the 25th Anniversary of the Renwick Gallery

Stephen Paulsen

(opposite) *Scent Bottles,* 1995, various tropical hardwoods (left to right): 14 x 4.7 cm (5 1/2 x 1 7/8 in.); 17.8 x 3.8 cm (7 x 1 1/2 in.); 21 x 3.8 cm (8 1/4 x 1 1/2 in.); 16.6 x 5.1 cm (6 1/2 x 2 in.); 13 x 5.5 cm (5 1/8 x 2 1/8 in.). Museum purchase through the Renwick Acquisitions Fund

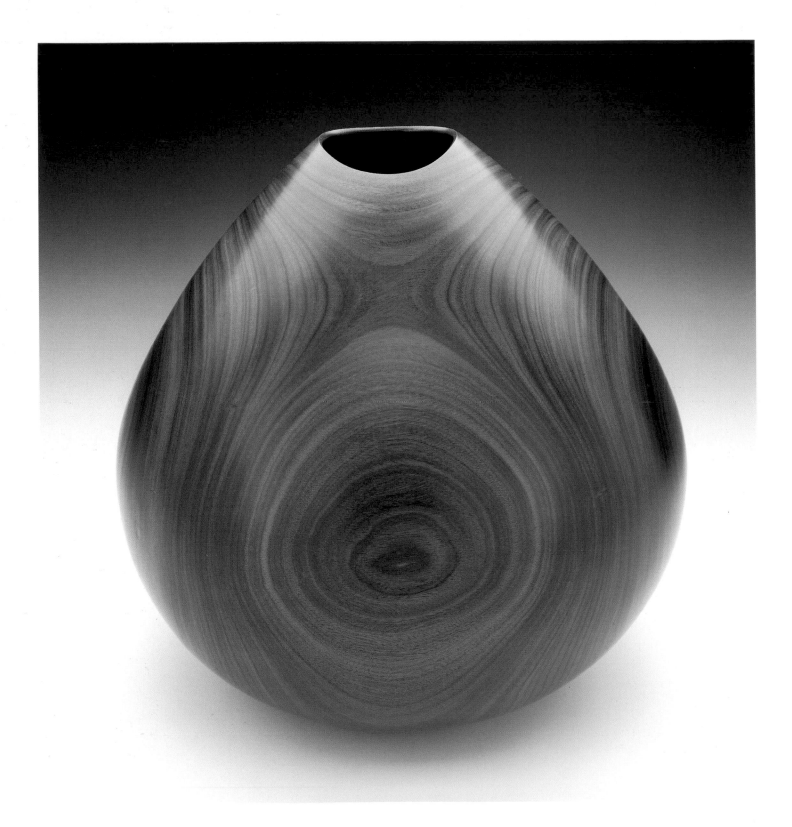

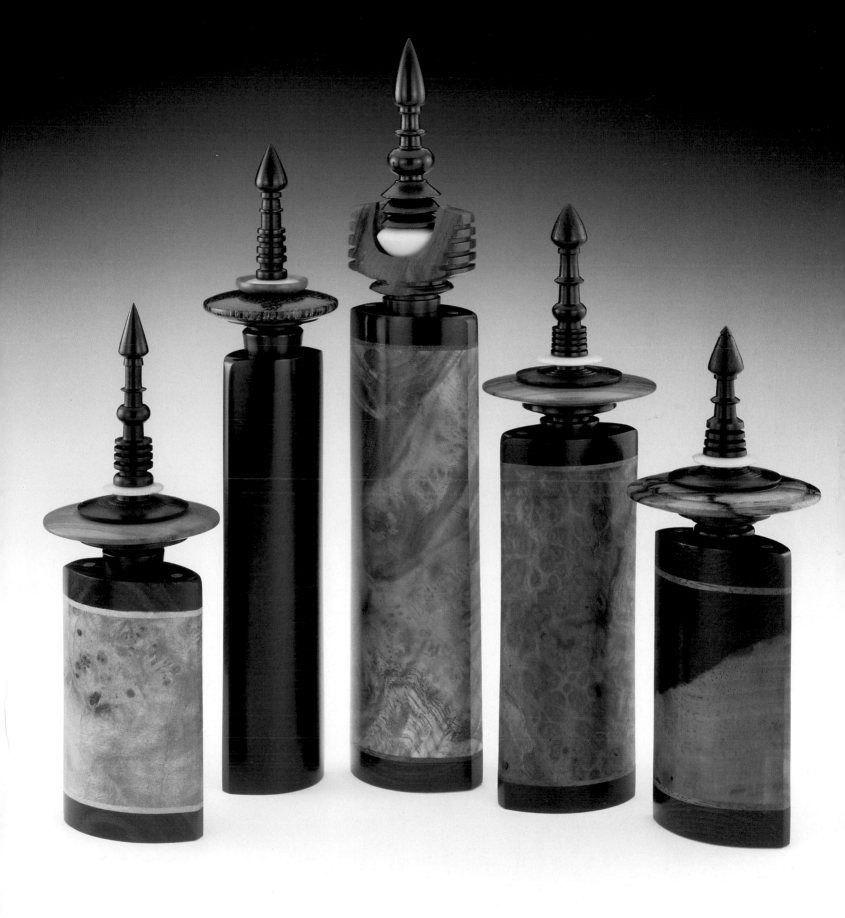

chronology of the renwick gallery

1859–61 Designed by James Renwick, Jr., and R. T. Auchnutz, Corcoran Gallery of Art (CGA) is erected at 17th Street and Pennsylvania Avenue, N.W., to display William Wilson Corcoran's collection of paintings and sculpture.

1861 August 21. With the Civil War under way, the U.S. Army seizes CGA building to use as a warehouse for the storage of records and uniforms for the Quartermaster General's Corps.

1869 May 10. U.S. government returns the building to Corcoran, who immediately deeds the gallery to a nine-man board of trustees.

1869–73 At a cost of $250,000, CGA is restored to its original purpose as an art gallery.

1874 January 19. Portions of CGA—the Hall of Bronzes (first floor), the Main Picture Gallery (Grand Salon), and the Octagon Room—are opened to private visitors.

1877 Trustees announce plan to establish a school of art as part of CGA.

1889 Two-story annex erected at rear of building for Corcoran School of Art.

1890 Collection grows rapidly. Trustees plan for expansion.

1891 April 3. Land purchased at 17th Street and New York Avenue, N.W., for William Wilson Corcoran's new gallery of art.

The Renwick at 25 exhibition of works from the permanent collection celebrated the gallery's twenty-fifth anniversary in 1997.

1897 January 8. Corcoran's art collection moves to the new location.

1899 December 3. U.S. government rents the old CGA building for rapidly expanding Court of Claims.

1901 July 9. U.S. government purchases the building for $300,000 for U.S. Court of Claims.

1956 U.S. Court of Claims outgrows building. Government hearings are held by Senate Committee on Public Works to determine if building should be demolished and a new Court of Claims building erected. Fine Arts Commission seeks to preserve building as outstanding example of period architecture.

1962 December 1. President John F. Kennedy expresses a desire to save old Court of Claims building as an integral part of Lafayette Square project.

1964 Corcoran building included in feasibility study by John Carl Warnecke & Associates, San Francisco, for the restoration and rehabilitation of Lafayette Square. Court of Claims moves out.

1965 June 23. Persuaded by Smithsonian Secretary S. Dillon Ripley, President Lyndon B. Johnson signs executive order transferring old Court of Claims building to Smithsonian "for use as a gallery of arts, craft and design." Building renamed Renwick Gallery in honor of its architect.

1967–71 Renwick Gallery is renovated, involving massive work on the exterior and complete restoration of interior spaces.

1969 March 25. Renwick Gallery is listed on National Register of Historic Places.

National Collection of Fine Arts opens national tour of *Objects USA*. Nine works are acquired for its permanent collection from that exhibition.

1970 January. Dr. Joshua C. Taylor becomes director of the National Collection of Fine Arts.

James Prestini, professor of design, University of California, Berkeley, considered the father of artistic woodturning in America, donates nineteen of his bowls and plates to NCFA.

1971 February. Lloyd E. Herman is appointed administrator of the Renwick Gallery.

1972 January 28. Renwick Gallery opens to the public with eight inaugural exhibitions.

Albert Paley of Rochester, New York, wins competition for custom-designed gates for entrance to Renwick Gallery shop.

1974 January. Michael W. Monroe is appointed associate curator.

1975 Herman organizes *Craft Multiples* exhibition, which includes 133 objects by 126 craft artists, made in editions of no more than ten. Selected from more than 5,000 entries, the objects tour nationwide for three years. Sixty-three of the pieces are acquired for the permanent collection.

1976 January. Albert Paley's *Portal Gates* are installed.

In tribute to the United States Bicentennial, the exhibition *Americas: The Decorative Arts in Latin America in the Era of the Revolution* is presented.

1980 By act of Congress, the National Collection of Fine Arts is renamed the National Museum of American Art.

1980–81 *American Porcelain: New Expressions in an Ancient Art* presents the work of 108 ceramists. Forty-eight pieces are acquired for the collection.

1981 April 26. Dr. Joshua C. Taylor dies unexpectedly in Washington, D.C.

1982 January. Renwick Gallery celebrates tenth anniversary.

March. *Celebration: A World of Art and Ritual* includes more than 600 objects representing sixty-two different folk cultures.

March 17. James Renwick Collectors Alliance is incorporated in Washington, D.C., to assist NMAA "to establish collections of American crafts of significance and superior workmanship."

July. Dr. Charles C. Eldredge becomes director of NMAA.

1983 October. Dr. Elizabeth Broun is appointed assistant director and chief curator of art of NMAA.

1986 May 27–28. Smithsonian-appointed four-member Visiting Craft Committee meets to assess Renwick Gallery and make recommendations on the role of craft at NMAA. Committee recommends that Renwick Gallery be maintained as a separate museum of craft and that emphasis be placed on development of the permanent collection and scholarship in exhibitions and publications.

1987 James Renwick Alliance funds James Renwick Fellowship Program for study and research of American crafts as part of Smithsonian Institution Fellowhip Program. Future funding of the Renwick program is assured by NMAA's commitment to the program the following year.

1988 August. Dr. Charles Eldredge resigns as director of NMAA.

1989 September. Dr. Elizabeth Broun is appointed director of NMAA.

Wendell Castle's *Ghost Clock* is purchased.

1989–90 *Masterworks of Louis Comfort Tiffany* presents sixty-five magnificent stained-glass windows, leaded-glass lamps, and other objects, many never before seen in museums, to largest audience in Renwick's history.

1990 Larry Fuente's *Game Fish* is purchased. The work was shown in the 1990 exhibition *Surface and Structure: Beads in Contemporary American Art*.

1991 Jane and Arthur K. Mason, Washington, D.C., col-

lectors, donate nine exemplary pieces of turned wood. The 1986 exhibition *The Art of Turned Wood Bowls* inspired them to form a collection of these objects.

1992 July 27. MCI Telecommunications Corporation and NMAA enter into an agreement in which MCI will form a corporate collection of American craft, with the Renwick Gallery having the right of first refusal of gifts from the collection.

Patricia and Phillip Frost Prize for Distinguished Scholarship in American Craft is established. First recipients are Ronald C. Naugle and Patricia Cox Crews for *Nebraska Quilts and Quiltmakers* in 1993.

1993 KPMG Peat Marwick donates twenty-two pieces of American craft by eighteen artists to the Renwick, which are shown the following year in the exhibition *KPMG Peat Marwick Collection of American Craft: A Gift to the Renwick Gallery*.

In recognition of "The Year of American Craft: A Celebration of the Creative Work of the Hand," Monroe works with the White House to develop a White House craft collection. Seventy-two works by seventy-seven artists are assembled from all parts of the United States.

1995 April. *The White House Collection of American Craft*, organized by Michael W. Monroe, opens at NMAA and then travels widely throughout the United States.

May. Pennsylvania Avenue between 15th and 17th Streets is closed to vehicular traffic following the bombing of the federal building in Oklahoma City.

June. Michael W. Monroe resigns as curator-in-charge.

Patricia and Phillip Frost Prize for Distinguished Scholarship in American Craft is awarded to Kenneth R. Trapp for *The Arts and Crafts Movement In California: Living the Good Life*.

August. Howard Kottler Endowment for Ceramic Art is established. The $75,000 fund is to be used to purchase ceramics by emerging and mid-career artists.

October. Kenneth R. Trapp, former curator of decorative arts at the Oakland Museum of California, assumes post as curator-in-charge of Renwick Gallery.

November. George Peter Lamb and Lucy Scardino donate thirty turned-wood objects and one alabaster bowl.

1996 Jane and Arthur K. Mason donate a second major gift of nine turned-wood objects and one basket.

1997 March 14. *The Renwick at 25* opens. Celebrating the gallery's twenty-fifth anniversary, the show includes one hundred and one works of art. All are from the permanent collection, with seven promised as future gifts.

June 20. Newly redesigned galleries on second floor open with ninety-two objects from the permanent collection reinstalled in specially designed exhibition cases. James Renwick Alliance provides $50,000 to help underwrite cost of reinstallation.

June 28 and 29. Gala celebration in honor of Renwick Gallery's twenty-fifth anniversary. Family Day on Sunday offers activities designed around objects in the permanent collection.

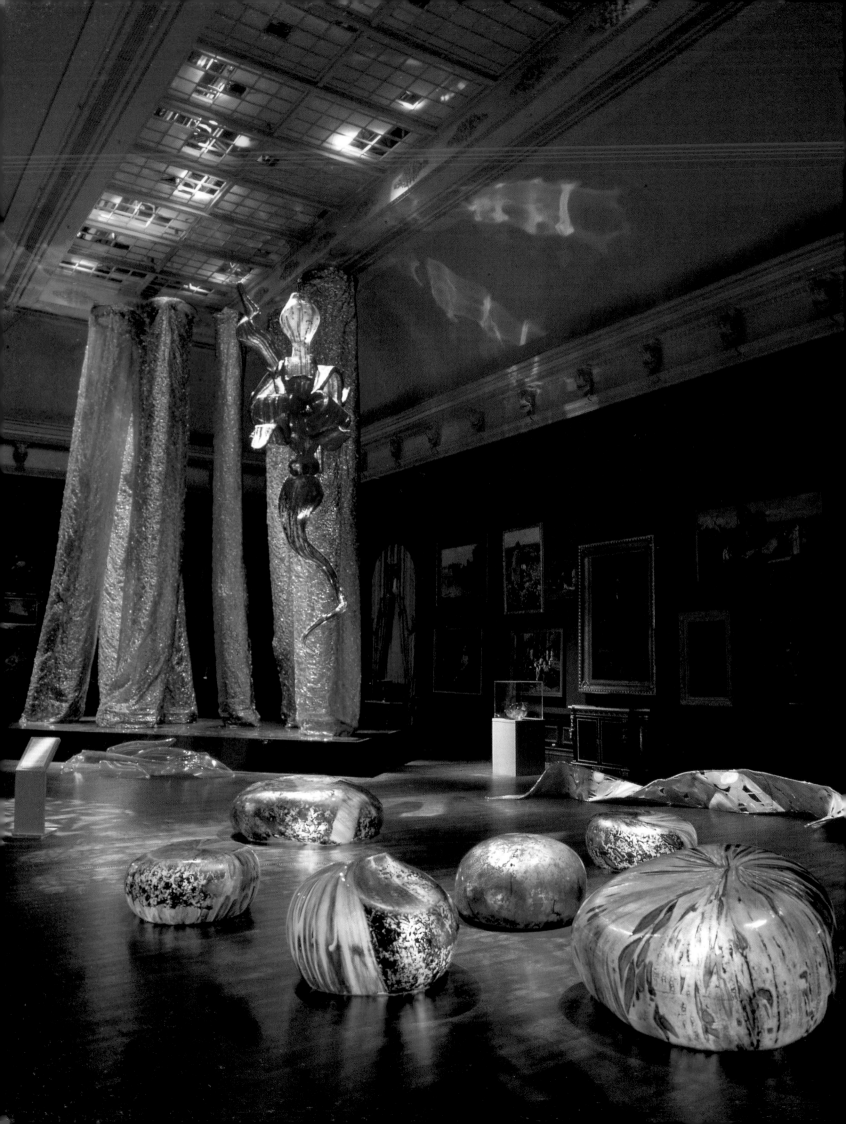

chronology of the james renwick alliance

1981 Meetings are held with Lloyd E. Herman, director of the Renwick Gallery, to discuss the founding of a support group.

1982 The James Renwick Collectors Alliance is founded by a small group of American craft enthusiasts to support public lectures and acquisitions for the Renwick's permanent collection.

The Alliance provides funds for Jody Klein's *Commemorative Quilt* to celebrate the Renwick's tenth anniversary.

1983 The Alliance presents a spring symposium, the precursor of its annual spring Craft Weekend. "Crafts Today: The 1983 National Forum on Connoisseurship and Collecting" includes talks by Smithsonian Secretary S. Dillon Ripley and arts advocate Joan Mondale.

The Alliance initiates the *Renwick Quarterly* to provide news of the gallery's programs and Alliance activities for its members.

The Alliance provides funds for Richard Mawdsley's *Feast Bracelet* and Peter Voulkos's *Rocking Pot* for the Renwick.

1984 The second annual spring Craft Weekend focuses on "Crafts Today: The 1984 National Forum on 20th-Century American Glass," in conjunction with *Harvey K. Littleton: A Retrospective Exhibition*.

The Alliance initiates craft study tours with a trip to Richmond, Virginia. Overwhelming success of this trip leads to establishment of an ongoing program of visits to private collections, museum exhibitions, and artists' studios.

1985 The Renwick exhibition *The Flexible Medium: Art Fabric from the Museum Collection* inspires the theme for the third annual spring Craft Weekend.

The Alliance is awarded $1,000, the first of several grants from the D.C. Commission on the Arts and Humanities and the National Endowment for the Arts, to provide funds for the continuation and expansion of Alliance programs.

The Alliance begins to focus special attention on raising funds for acquisitions for the permanent collection.

1986 The theme of Craft Weekend is "Living with Wood." In conjunction with *The Art of Turned-Wood Bowls*, the Alliance sponsors four days of woodturning demonstrations by master craftsmen in the Renwick's Palm Court.

A grant-in-aid of $10,000 from the D.C. Commission on the Arts and Humanities provides support for programs and long-range planning.

Concerned that the Smithsonian Institution might change the mission of the Renwick Gallery to include programs unrelated to American craft, the Alliance launches a nationwide letter-writing campaign to win support for saving the Renwick as a museum of American craft.

Installation of stage sets designed by Dale Chihuly for the Seattle Opera Company's production of Debussy's *Pelléas et Mélisande*, Grand Salon, Renwick Gallery, April 1994.

1987 The Craft Weekend theme is "Off the Wall, On the Body: A Look at Contemporary Wearable Art."

A Smithsonian-appointed advisory task force recommends continuation of the Renwick's focus on twentieth-century American craft, additional emphasis on scholarly research and writing, and development of a significant collection.

The James Renwick Fellowship in American Crafts is launched with funding from the Alliance.

As a new benefit for members, the Alliance offers them the opportunity to vote on acquisitions for the Renwick's permanent collection.

The organization is renamed the James Renwick Alliance.

1988 The focus of Craft Weekend is "CLAY: An Ancient Art in Its Modern Aesthetic," presented in conjunction with the exhibitions *Clay Revisions: Plate, Cup, Vase* and *American Art Pottery: 1880–1930*, from the Cooper-Hewitt Museum. Joan Mondale is a featured speaker.

The Smithsonian Institution Collections Acquisition Program gives the Renwick $750,000 for acquisitions to be spent over five years, provided that half of this amount is matched by outside resources. The Alliance accepts the challenge to raise the matching funds and conducts its second large-scale direct-mail campaign to attract new members.

Dr. Nancy Corwin and Patricia Malarcher are awarded the first James Renwick Fellowships in American Crafts. The National Museum of American Art decides to fund the program in future years, with supplemental funding available from the Alliance when needed.

1989 "The Driving Force in Craft Art: Concept or Materials?" is a feature of Craft Weekend.

The Alliance bylaws are changed to provide for an enlarged board and an expanded committee structure.

1990 The theme of the Craft Weekend symposium is "American Craft: A Tradition of Excellence,"

which focuses on craft masters and emerging artists.

The Alliance creates the Craft Leaders Caucus to assist in building the nation's preeminent collection of American crafts and to provide a forum for a national network of craft supporters.

1991 Mixed media is the theme of the Craft Weekend symposium "Uncommon Attitudes: Flexing Media Boundaries."

The Craft Leaders Caucus and general membership increase; *Craft Leaders Report*, a newsletter for Caucus members, is initiated. Outreach events are held in Chicago and San Francisco, extending the Alliance's initiatives and increasing support for the Renwick Gallery as a truly national museum.

1992 The James Renwick Alliance observes its tenth anniversary.

"The Role of the Renwick in the Development of 20th-Century Craft Art" is the theme of Craft Weekend, which includes talks by Lloyd Herman and artists Dale Chihuly (glass), Albert Paley (metal), and Cynthia Schira (fiber).

The Alliance sponsors a reception for the installation *American Crafts: The Nation's Collection.*

1993 The Craft Weekend symposium focuses on "Living with Craft: Inside and Out."

Three fellows are appointed to study at the Renwick, and the Alliance sponsors two of them.

1994 The Craft Weekend symposium features artists whose work and words explore the theme "Tell Us a Tale—The Craft Artist as Storyteller."

Glassmaker Dale Chihuly visits the Renwick for the exhibition of his stage sets designed for the Seattle Opera Company's production of Debussy's *Pelléas et Mélisande.*

The first Patrons Dinner is held as a major fundraising event

Supported by a matching grant from the D.C. Commission on the Arts and Humanities, out-

Festival of Craft Education, Renwick Gallery, April 26–27, 1997, sponsored by the Renwick Gallery and the James Renwick Alliance

Richard Marquis (glass), Richard Mawdsley (metal), Eleanor Moty (jewelry), Philip Moulthrop (turned wood), and Betty Woodman (clay).

In a first-time endeavor, the James Renwick Alliance, Art Alliance for Contemporary Glass, and Creative Glass Center of America co-sponsor a special curators' program for Glass Weekend in Millville, New Jersey.

1996 "A Madcap Teapot Party" is the focus of Craft Weekend. The Alliance sponsors events with the Corcoran Gallery of Art, Smithsonian Women's Committee, and Washington Craft Show.

The education outreach committee coordinates new initiatives for a partnership including the Renwick Gallery, Corcoran Gallery of Art, Kennedy Center, and D.C. public schools.

1997 The Alliance observes its fifteenth anniversary.

Craft Weekend includes a two-day Festival of Craft Education that brings to the Renwick representatives of more than two dozen craft schools from across the country to introduce alternative programs and opportunities in art education.

"A Sentimental Journey," the theme of the anniversary gala, honors the Alliance's founding members and the newly instituted "Masters of the Medium Awards": Harvey Littleton (glass), Sam Maloof (wood), Albert Paley (metal), Ed Rossbach (fiber), and Peter Voulkos (clay).

The Alliance donates $50,000 to NMAA to help reinstall the Renwick's permanent collection.

The Alliance approves a donation of $20,000 to help underwrite the publication of a book on the history and collection of the Renwick Gallery.

From 1982 to 1997, the Alliance has provided financial support for the acquisition of a total of 102 works, either by outright funding or matching grants to help the National Museum of American Art purchase craft objects.

reach efforts are significantly expanded to benefit the city's public schoolchildren.

1995 "In Praise of Craft" is the theme of Craft Weekend, which includes "Conversation with Seven Masters of the Media." Events honor retiring curator-in-charge Michael Monroe and artists John Cederquist (furniture), Lia Cook (fiber),

— *compiled by Elmerina L. Parkman*

artists' biographies

Renie Breskin Adams born 1938

Born in Michigan City, Indiana, Renie Breskin Adams earned three degrees from Indiana University: B.A., psychology, 1960; M.A., anthropology, 1965; and M.F.A., fiber, 1973. She taught art at the University of Wisconsin, Madison, from 1973 to 1977 and since 1977 has taught art at Northern Illinois University.

Adams's embroideries are indebted to her early studies in drawing and painting and her interest in anthropology. Drawing liberally from her doodles and from imagery available in publications and museums, she creates pictograms that are often enigmatic. Although the viewer may be unable to decipher the imagery, there is nonetheless a sense of storytelling.

Adams presents a range of rich hues, densely textured surfaces, and compositions often drawn from art history, ranging from Cézanne to western Asian carpets. Although Adams's embroideries sometimes have the spirit of outsider art, her work is too sophisticated to be mistaken for the totally intuitive.

Anni Albers 1899–1994

The daughter of a furniture manufacturer, Anni Albers (*née* Fleischmann) was born in Berlin. After studying art with a private tutor, and then with impressionist painter Martin Brandenburg, she continued her training at the School of Applied Art in Hamburg and the Bauhaus in Weimar and Dessau. At the Weimar Bauhaus she met abstract artist Josef Albers, whom she married in 1925. She was a part-time instructor and acting director of the Bauhaus weaving workshop from 1930 to 1933. The couple left Nazi Germany and accepted teaching positions at Black Mountain College, North Carolina, where Anni Albers was an assistant professor of art from 1933 to 1949.

Albers was the first weaver to have a solo exhibition at the Museum of Modern Art, in 1949, and the second recipient of the American Craft Council's Gold Medal for "uncompromising excellence" in 1980.

Ralph Bacerra born 1938

Born in Garden Grove, California, Ralph Bacerra earned a B.A. degree in 1961 at Chouinard Art Institute in Los Angeles, where he studied with Vivika Heino, whom he later succeeded as chairman of the ceramics department. Bacerra is currently chairman of the ceramics department at Otis College of Art and Design in Los Angeles.

Bacerra borrows from Chinese, Japanese, and Persian pottery and fabric designs to create visually energized works in which both form and surface receive his full attention. He adorns the surface with multilayered glazes of rich colors, china paints, and lusters that exploit the curves and crevices of a vessel to its maximum decorative potential.

Howard Ben Tré born 1949

Born in Brooklyn, New York, Howard Ben Tré earned a B.S.A. degree in ceramics at Portland State University, Oregon, in 1978 and an M.F.A. degree in sculpture and glass at the Rhode Island School of Design, Providence, in 1980. He now lives and works in Providence. Ben Tré was awarded National Endowment for the Arts fellowships in 1980, 1984, and 1990 and also received Rhode Island State Council on the Arts fellowships in 1979, 1984, and 1990. He was the recipient of the Boston Society of Architects Art & Architecture Collaboration Award in 1993. Unlike studio glass artists, Ben Tré casts his sculptures in a glass factory with the help of industrial equipment and trained assistants.

Garry Knox Bennett born 1934

Born in Alameda, California, Garry Knox Bennett is a self-taught studio furniture maker who uses traditional fine woodworking techniques for both synthetic and natural materials. He attended the California College of Arts and Crafts in Oakland from 1959 to 1962 and then worked as a metal sculptor. After managing his own successful jewelry and metal-plating business, he began to create metal sculpture. As he attempted to produce larger works of art and began to incorporate wood, this led him to making furniture. Bennett is known for gracefully combining wood with disparate materials such as aluminum, glass, precious and industrial metals, and plastic laminates.

Sonja Blomdahl born 1952

Born in Waltham, Massachusetts, Sonja Blomdahl earned a B.F.A. degree in 1974 at Massachusetts College of Art, where she studied with Dan Dailey. In 1976 she spent six months at Glasskolan, the Orrefors glass factory in Sweden. In 1978, while working as Dailey's assistant at Pilchuck Glass School in Stanwood, Washington, she observed Italian glassblower Checco Ongaro's use of the *incalmo* technique, which involves joining two bubbles of blown glass. This technique suited Blomdahl's exploration of symmetrical form and color in glass spheres.

Blomdahl has held teaching positions at Pratt Fine Arts Center in Seattle, Haystack Mountain School of Crafts in Deer Isle, Maine, and the Appalachian Center in Smithville, Tennessee.

Wendell Castle born 1932

Born in Emporia, Kansas, Wendell Castle earned a B.F.A. degree in sculpture in 1958 and an M.F.A. in industrial design in 1961 at the University of Kansas. From 1962 to 1969 Castle taught at the Rochester Institute of Technology and then joined the faculty of the State University of New York in Brockport. In 1980 he established the Wendell Castle School, a nonprofit educational institution offering instruction in furniture design and fine woodworking. In 1988 the school was incorporated into the furniture-making program at Rochester Institute of Technology.

A self-taught craftsman, Castle has been in the forefront of contemporary art furniture design for more than three decades. Renowned for his superb workmanship and his development of lamination techniques, Castle creates furniture that combines exotic materials and imaginative designs with a whimsical approach to his craft.

John Cederquist born 1946

Born in Altadena, California, John Cederquist earned a B.A. degree in art in 1969 and an M.A. in crafts in 1971 at California State University at Long Beach. Since 1976, he has taught two- and three-dimensional design at Saddleback College in Mission Viejo, California.

Cederquist's involvement with the contemporary woodworking movement was largely influenced by Wendell Castle. Cederquist's early work adhered to the prevailing aesthetic of sculptural anthropomorphic forms that emphasized the qualities of wood. Fascinated by perspective and the illusion of depth and space that can be suggested on a two-dimensional plane, he began to explore imagery within the context of traditional furniture forms, creating *trompe-l'oeil* illusions of ambiguity and disquieting presence. Cederquist draws his imagery from numerous graphic sources, including Japanese woodblock prints, comic strips, television, and advertising. In the mid- to late 1980s he began to use the image of classic American high chests in conjunction with shipping crates to create elaborate fractured images that bring to mind cubism.

Dale Chihuly born 1941

Born in Tacoma, Washington, Dale Chihuly studied with Harvey Littleton, founder of the studio glass movement, at the University of Wisconsin and received an M.F.A. degree from the Rhode Island School of Design in 1968. Chihuly was a co-founder of the Pilchuck Glass School in Stanwood, Washington, and is former director of the glass program at the Rhode Island School of Design. He currently works in Seattle, where he collaborates with and directs a team of glassblowers to produce his signature chandeliers, sea forms, baskets, and cylinders.

Among his many honors are the Louis Comfort Tiffany Foundation Award in 1967 and a Fulbright fellowship to Murano,

Italy, in 1968. In 1993 Chihuly designed stage sets for the Seattle Opera Company's production of Debussy's *Pelléas et Mélisande*. In another site-specific installation, Chihuly traveled to Italy to display his massive chandeliers over Venetian canals in a 1996 exhibition entitled *Chihuly Over Venice*.

Lia Cook born 1942

Born in Ventura, California, Lia Cook studied theater at San Francisco State University before receiving her B.A. and M.A. degrees (1965 and 1973 respectively) at the University of California, Berkeley. The recipient of five National Endowment for the Humanities fellowships and numerous other awards, since 1975 she has taught at the California College of Arts and Crafts in Oakland.

Cook combines painting and weaving to create unique woven paintings in which textiles are both subject and object. She constructs her sumptuously colored and intricately patterned wall hangings from flat strips of painted abaca paper and dyed rayon. Since the late 1980s, she has deliberately employed pictorial imagery of draped fabric in her weavings, hoping to redress the current undervaluation of fabric in our culture and, through the sensory suggestion of touch, emphasize its direct connection with human experience.

Margret Craver born 1907

Born in Kansas City, Missouri, Margret Craver graduated in 1929 from the University of Kansas, where she developed a lifelong interest in hollowware and jewelry design. Her metalsmithing class did not offer instruction in techniques, nor were tutorial programs available elsewhere in the country, so Craver went to Europe. She studied with Baron Erik Fleming in Sweden and became a catalyst for promoting metalsmithing in America after World War II.

Motivated by the lack of rehabilitative therapy for wounded soldiers while serving as a hospital volunteer, and through her association with the New York City metal refinery of Handy and Harman, Craver trained occupational therapists in metalsmithing. She also convened workshop conferences to teach the process to art teachers so that adequate instruction could be obtained in America. Craver rediscovered *en résille*, a difficult French seventeenth-century enameling technique, in which the metal is suspended within the enamel rather than serving as a backing for it.

William Daley born 1925

William Daley was born in Hastings-on-Hudson, New York. A major figure in American studio ceramics, he began his art career on the G.I. Bill after World War II, earning a B.S. degree at the Massachusetts College of Art and an M.A. degree at Columbia University.

Daley has consistently demonstrated that his thin-walled vessels in concave and convex shapes can be made into architectonic objects. He hand-builds all objects and leaves them unglazed so as not to diminish their angles and lines. Surface

areas are burnished to offer tonal variations in the clay.

From 1957 to 1990, Daley was a professor of ceramics and industrial design at the University of the Arts in Philadelphia.

Richard DeVore born 1933

Born in Toledo, Ohio, Richard DeVore earned a B.Ed. degree with an art major in 1955 at the University of Toledo. In 1957 he received an M.F.A. from Cranbrook Academy of Art in Michigan, where he studied ceramics with Maija Grotell, who influenced his decision to make working with clay his life calling. In 1966 DeVore became head of the ceramics department at Cranbrook, where he exercised considerable influence as a teacher.

Emphasizing irregularity and studied spontaneity, DeVore enlivens the commonplace. In his mature work he dispenses with color, except for subtle variations almost lost in viewing, to concentrate on form and finish. A conscious erotic element in DeVore's ceramics creates a tension between what is seen and what is suggested. The manner in which he handles the clay has references to the human body. Even DeVore's dry finish brings to mind the parchment-like translucency of skin.

Dominic Di Mare born 1932

Born in San Francisco, Dominic Di Mare grew up in Monterey, California, where his father owned and operated a commercial fishing boat. In the mid-1960s Di Mare, by then a San Francisco high school art teacher and a self-taught studio weaver, was in the vanguard of the American fiber-art revolution. Fiercely three-dimensional and composed of a variety of yarns and natural fibers, his early sculptural hangings reveal the influence of tribal art forms.

In 1970 Di Mare began to hand-make rag papers. Reaching into the slurry to lift up a layer of pulp stirred deep-seated memories of fishing trips off the coasts of California and Mexico. The bulky sheets of paper appeared like "frozen waves." Inspired by these boyhood memories, Di Mare stopped weaving and began to fabricate enigmatic sculptures from handmade papers, polished hawthorne twigs, and feathers.

In 1977 and 1981 Di Mare received National Endowment for the Arts fellowships and in 1987 was made a fellow of the American Craft Council.

Rick Dillingham 1952–1994

Born in Lake Forest, Illinois, Rick Dillingham earned a B.F.A. degree at the University of New Mexico in 1974 and an M.F.A. degree at Claremont Graduate School, California, in 1976. As a volunteer, he spent time restoring Native American clay vessels for the Department of Anthropology at the University of New Mexico. This tedious piecing together of clay shards inspired his hand-built ceramic vessels, which he formed and then broke, reassembling the pieces after painting and glazing them.

A guest curator of many exhibitions and a lecturer on Native American pottery, Dillingham also showed his own work throughout the country. Among his many other interests, he established Dillingham Press, which published books and articles.

Fritz Dreisbach born 1941

Born in Cleveland, Fritz Dreisbach is the recipient of four degrees: a B.A. in 1962 from Hiram College, Ohio; an M.A.T. in 1963 from Oberlin College, Ohio; an M.A. in 1965 from the University of Iowa; and an M.A. in 1967 from the University of Wisconsin, Madison, where he worked as an assistant to Harvey Littleton.

Dreisbach has taught at the School of the Toledo Museum of Art, Pilchuck Glass School in Stanwood, Washington, and Penland School of Crafts in North Carolina. A founding member of the Glass Art Society in 1971, he served two terms as president.

A major catalyst in the studio glass movement, Dreisbach has long experimented with the chemistry of glass, as well as with color, optics, and shape to increase the motility of his work. He has studied the history of glass, drawing particular inspiration from Venetian *latticinio* glass of the Italian Renaissance and early American glass.

John Dunnigan born 1950

Born in Providence, Rhode Island, John Dunnigan earned a B.A. degree in English literature in 1972 at the University of Rhode Island and an M.F.A. in furniture design in 1980 at the Rhode Island School of Design, where he studied with Tage Frid. Dunnigan was a part-time instructor of furniture design from 1980 to 1996, when he became a full-time professor in the school's newly established Department of Furniture Design.

Dunnigan's refined and elegantly crafted studio furniture has been inspired by seventeenth- and eighteenth-century American pieces. His work displays a sensitivity to the wood he sculpts for his furniture, which is embellished with beautifully upholstered fabrics or inlaid wood.

Dunnigan was the recipient of two awards from the Rhode Island State Council on the Arts in 1990 and 1994.

Robert Ebendorf born 1938

An eclectic jeweler and metalsmith, Robert Ebendorf was born in Topeka, Kansas. He earned a B.F.A degree in 1958 and an M.F.A. in 1963 at the University of Kansas. A Fulbright grant enabled Ebendorf to study in 1963 at Norway's State School for Applied Arts and Crafts. Upon receiving a Louis Comfort Tiffany Foundation grant, he returned to Norway from 1965 to 1966 to work at Norway Silver Designs in Fredrikstad.

Ebendorf has worked as a jewelry design consultant in Mexico City, Oslo, Norway, and Vicenza, Italy. A founding member and past president of the Society of North American Goldsmiths, he has taught at Stetson University in Florida, University of Georgia, Haystack Mountain School of Crafts in Deer Isle, Maine, Penland School of Crafts in North Carolina, and the State University of New York, New Paltz.

Alma Eikerman 1908–1995

Born in Pratt, Kansas, Alma Eikerman earned a B.S. degree in 1934 at Kansas State College in Emporia and an M.S. in 1942 at Columbia University. She subsequently taught jewelry design at

Wichita State University in Kansas and in 1947 joined the faculty of Indiana University in Bloomington. While on sabbatical in 1950, Eikerman studied Scandinavian silversmithing with Karl Gustav Hansen in Copenhagen, which was to become the foundation of her hollowware. Eikerman retired from teaching at Indiana University in 1978, having been honored with the title of Distinguished Professor.

Eikerman's legacy at Indiana University was an exceptional metals program that inspired two generations of artists. A founding member of the Society of North American Goldsmiths, she received the Indiana Governor's Art Award and the American Craft Council's Gold Medal in 1993.

Fred Fenster born 1934

Born in the Bronx, New York, Fred Fenster earned a B.S. degree in 1956 at City College of New York and an M.F.A. in 1960 at Cranbrook Academy of Art. After completing his studies, Fenster briefly worked for a company engaged in silversmithing and industrial fabrication in metal. He then operated a shop for one year, selling his jewelry and other objects. In 1961 he joined the faculty of the University of Wisconsin at Madison, where he is a professor of art and education.

As a metalsmith, Fenster has been strongly influenced by the pure, simple forms of Scandinavian design. He creates gold and silver jewelry and silver, copper, and pewter hollowware that affirm his commitment to making functional objects that are works of art.

Fenster has received the American Pewter Guild award in 1984, as well as research grants in 1986, 1991, and 1993 from the University of Wisconsin.

Arline Fisch born 1931

Arline Fisch was born in Brooklyn, New York, and received a B.S. degree in art education from Skidmore College and an M.A. from the University of Illinois. In 1956–57 she studied silversmithing at the School of Arts and Crafts in Copenhagen and in 1966–67 returned to Denmark for further training in metalsmithing. Since 1961, she has taught full time at San Diego State University.

Fisch has played a central role in the revitalization of jewelry as a contemporary art form. Her outstanding contribution has been the introduction of weaving techniques into the field of jewelry making. Employing flattened gold and silver wire, she knits, braids, plaits, and crochets lightweight, flexible forms with dense, light-reflective patterns, subtle textures, and glowing color. She first encountered artistic jewelry in the Egyptian collection of the Metropolitan Museum of Art, which she frequently visited as a child. Along with other historical ornaments, these early impressions continue to influence the form and meaning of her work. In 1985 Fisch was declared a "Living Treasure of California" by the State Assembly.

Larry Fuente born 1947

Born in Chicago, Larry Fuente studied at the Kansas City Art Institute from 1967 to 1968, after which he followed friends to

California. Since the late 1960s, Fuente has concentrated on producing a body of work that is marked by an obsessive interest in surface ornamentation. He delights in covering readily identifiable forms with beads, plastic baubles, buttons, and mass-produced items of no intrinsic value, transforming the mundane into unique objects.

Size is no deterrent to Fuente, who once spent five years coating a 1960 Cadillac sedan with one million brightly colored beads, sequins, buttons, plastic lawn ornaments, and other items. Such works are related to a Latino popular-culture tradition in which automobiles and other objects are embellished with a profusion of brightly colored ornaments.

William Harper born 1944

Born in Bucyrus, Ohio, Harper received a B.S. degree in 1966 and the following year an M.S. in art education from Case Western Reserve University. He also studied advanced enameling at the Cleveland Institute of Art.

Harper began his career as an abstract painter but in the early 1960s switched to enameling to achieve more intense colors. Fascinated by the supernatural aura of ritual objects such as amulets, charms, and tribal power figures, in the early 1970s he began to produce brightly enameled necklaces and brooches in gold, silver, and gemstones, as well as nonprecious and found objects that evoke a similar mysterious power. Many of his recent pieces are mythical and ironic self-portraits that suggest intense introspection.

Harper was awarded a National Endowment for the Arts fellowship in 1978 and NEA grants in 1979 and 1980. In 1980 and 1985 he received fellowships from the Florida Arts Council.

Wayne Higby born 1943

Born in Colorado Springs, Wayne Higby received a B.F.A. degree in 1966 from the University of Colorado in Boulder and an M.F.A. degree in 1968 from the University of Michigan. He received fellowships from the National Endowment for the Arts in 1973, 1977, and 1988, and from the New York Foundation for the Arts in 1985 and 1989. In 1992 Higby was named an honorary professor by the Hubei Academy of Arts, Wuhan, People's Republic of China. He has served on the faculties of the University of Nebraska and the Rhode Island School of Design and currently teaches at the New York State College of Ceramics at Alfred University.

Since the early 1970s, Higby has explored the fusion of form and surface decoration through panoramic western vistas depicted on the surfaces of his earthenware bowls and covered boxes. These scenic embellishments are imaginative reinterpretations of the austere Colorado landscape of his childhood. Covering the concave interior as well as the convex exterior of the object, the two-dimensional, illusionary image completely penetrates the three-dimensional form, unifying surface and shape.

Michelle Holzapfel born 1951

Born in Woonsocket, Rhode Island, Michelle Holzapfel studied at Marlboro College, Vermont, from 1969 to 1970 and from 1993

to 1995 at Vermont College and Norwich University in Vermont, where she earned a B.A. degree. Holzapfel's father was a machinist who designed and built the first lathe she used for turning the table legs of her husband's furniture. The process of turning on the lathe seemed natural to Holzapfel, so she continued turning wooden vessels and objects, a primarily self-taught venture, for twenty years.

Despite the fact that she turns wood, Holzapfel maintains that she is not a vessel maker. She uses wood-lathe turning in conjunction with carving to create visually compelling and tactilely inviting sculptural forms. Intrigued by illusionistic effects, Holzapfel has used wood in some instances to suggest other materials.

Mary Lee Hu born 1943
Born in Lakewood, Ohio, Mary Lee Hu earned a B.F.A. degree in 1965 at Cranbrook Academy of Art and an M.F.A. in 1967 at Southern Illinois University, where she first explored weaving wire—a characteristic of her jewelry.

Hu creates unique jewelry by weaving metal threads as if they were textiles. Over the years, her style has evolved, but her techniques and materials have remained consistent—her hands are her primary tools. Always conscious of the wearer of her jewelry, she seeks to create objects that adorn rather than overpower the individual.

Hu has researched body adornment in many places, including Taiwan, Hong Kong, Tibet, New Zealand, Australia, and Papua New Guinea. She is a past president of the Society of North American Goldsmiths and a professor of art at the University of Washington.

William Hunter born 1947
Born in Long Beach, California, William Hunter earned a B.A. degree in 1972 at California State University at Dominguez Hills. With the purchase of a woodturning lathe in 1969, he undertook this work as an untutored amateur. Before long, he was creating functional production pieces that he sold in craft fairs on the West Coast.

In 1973 Hunter moved to El Portal, California, on the edge of Yosemite Valley. In 1978 he abandoned production work in order to concentrate on one-of-a-kind pieces that offered greater creative rewards. In the early 1980s Hunter, in collaboration with his wife, Marianne, created sumptuous pieces embellished with enamels and gems. At this time Hunter turned ivory, amber, fossilized walrus tusk, and cast plastic, as well as exotic woods. Hunter acknowledges the influence of work by Isamu Noguchi, Alberto Giacometti, and Constantin Brancusi.

Hunter has moved from vessel forms to open spirals that are purely sculptural in inspiration and orientation. These open turnings are a technical tour de force, bringing to mind the geometric perfection of floral patterns and nautilus chambers.

Michael Hurwitz born 1955
Born in Miami, Florida, Michael Hurwitz attended Massachusetts College of Art from 1974 to 1975 and earned a B.F.A. degree at Boston University, where he studied with Jere Osgood and Daniel Jackson in the program in artisanry. Since 1985, he has taught in the woodworking department at the University of the Arts in Philadelphia.

Awarded an artist-in-residence fellowship to the Dominican Republic in 1985, Hurwitz developed an interest in primitive art. A six-month stay in Japan in 1988 stimulated his interest in that country's art and architecture, which has also influenced his work. Among contemporary furniture artists, Hurwitz is in the forefront of investigating the possibilities of giving new wood an elusive character by manipulating the surface texture and color. Hurwitz is the recipient of four National Endowment for the Arts fellowships.

Sidney Hutter born 1954
Born in Champaign, Illinois, Sidney Hutter earned a B.S. degree in art at Illinois State University in 1977 and an M.F.A. in 1979 at Massachusetts College of Art in Boston. He has been an instructor in cold-glass techniques at Boston University's program in artisanry and at the Massachusetts College of Art's School of Continuing Education.

Although Hutter was initially trained in hot-glass techniques and traditions, his principal influences remain the geometrically inspired designs of cubism, constructivism, and the Bauhaus. Describing himself as an "industrialist," he employs the mechanical methods of the plate-glass factory—cutting, grinding, beveling, polishing, sandblasting, drilling, and laminating. To ensure geometric clarity in his work, Hutter studied drafting technology at the Massachusetts Institute of Technology's Lowell Institute in 1979–80. The artist's pristine sculptures are carefully engineered and constructed from laminated sections of commercial plate glass, using invisible glue. Light is absorbed and reflected, emphasizing purity of form and material.

Michael James born 1949
A grandson and great-grandson of textile-mill workers, Michael James was born in New Bedford, Massachusetts. He earned a B.F.A. degree at the University of Massachusetts at Dartmouth and an M.F.A. degree at Rochester Institute of Technology, specializing in painting and printmaking. James's nontraditional quilts reveal his fascination with color and form, employing endless combinations to add a spatial context to a two-dimensional surface. He has been particularly influenced by the designs of Amish quilts.

James has traveled throughout the world to give lectures and workshops on quilts. The author of *The Quiltmaker's Handbook: A Guide to Design and Construction* and *The Second Quiltmaker's Handbook: Creative Approaches to Contemporary Quilt Design*, he was awarded an honorary Doctor of Fine Arts degree by his alma mater, the University of Massachusetts at Dartmouth, and is a member of the Quilters' Hall of Fame.

Mariska Karasz 1898–1960
Self-taught embroiderer Mariska Karasz arrived in the United States from her native Hungary at the age of sixteen. The influ-

ence of Hungary's rich folk-art tradition is reflected in her early work. As her interest in fiber art developed, Karasz began to incorporate silk, linen, cotton, wool, thread, hemp, horsehair, and wood into her fiber hangings. Her materials were carefully chosen for their texture, color, and any unusual quality, such as an inconsistent dye in the yarn.

Joey Kirkpatrick born 1952 Flora Mace born 1949

The first women to teach glassblowing at Pilchuck Glass School in Stanwood, Washington, Joey Kirkpatrick and Flora Mace met there in 1979 and began their collaboration, returning to the school each year as instructors or to work with other glass artists. Born in Des Moines, Iowa, Kirkpatrick earned a B.F.A. degree in drawing in 1975 at the University of Iowa and took graduate classes in glass at Iowa State University from 1978 to 1979. Born in Portsmouth, New Hampshire, Mace earned a B.S. degree in 1972 at Plymouth State College in New Hampshire and took graduate classes in glass in 1975 at the University of Utah. She earned an M.F.A. in 1976 at the University of Illinois in Champaign-Urbana.

Howard Kottler 1930–1989

Born in Cleveland, Howard Kottler earned a B.A. degree in biological sciences in 1952, an M.A. in ceramics in 1956, and a Ph.D. in ceramics in 1964, all at Ohio State University. He studied with Maija Grotell at the Cranbrook Academy of Art, where he earned an M.F.A. degree in 1957. That same year he was awarded a Fulbright grant for study in Finland.

Before moving west in 1964 to teach at the University of Washington in Seattle, Kottler created traditional ceramic work. Exposure to California funk—a new movement that rejected established art theories—gave Kottler license to go wild and use his art to satirize American popular culture. In his subsequent work Kottler applied glazes and decals to ready-made ceramic objects, rarely modeling and casting his clay.

Marvin Lipofsky born 1938

Born in Barrington, Illinois, Marvin Lipofsky earned a B.F.A. degree in industrial design in 1962 at the University of Illinois in Champaign-Urbana. He earned M.S. and M.F.A. degrees in sculpture in 1964 at the University of Wisconsin, where he studied with Harvey Littleton. From 1964 to 1972, Lipofsky taught in the Department of Design at the University of California at Berkeley. He founded the glass department at the California College of Arts and Crafts in 1967.

Since 1970, Lipofsky has traveled to Finland, Czechoslovakia, Italy, Japan, Australia, and other countries to work with master glassblowers in numerous factories. A founding member of the Glass Art Society, he lives and works in Berkeley, California.

Harvey Littleton born 1922

Born in Corning, New York, Harvey Littleton is considered the father of the studio glass movement in the United States. After serving with the U.S. Signal Corps during World War II, he studied industrial design at the University of Michigan, earning a

B.D. degree in 1947. In 1951 he received an M.A. degree from the Cranbrook Academy of Art. That year he accepted a teaching position in the Department of Art and Art Education at the University of Wisconsin, remaining on the faculty until 1977.

Littleton's initial specialty was ceramics, but by the late 1950s he was exploring the possibility of creating studio glass. Through research sponsored by the Toledo Museum of Art in 1962, he developed equipment and a formula for melting glass at lower temperatures, enabling him to blow glass in a studio rather than in the usual factory setting. This breakthrough led Littleton to play a major role in introducing glassblowing in college and university craft programs. His own program at the University of Wisconsin fostered the talents of a generation of glass artists, including Dale Chihuly and Fritz Dreisbach.

In 1983 Littleton was awarded the Gold Medal of the American Craft Council. He is the author of *Glassblowing: A Search for Form*, published in 1971.

Sam Maloof born 1916

Born in Chino, California, Sam Maloof is a 1934 graduate of Chino High School. He worked as a graphic artist before being encouraged by his wife to pursue woodworking. Having no formal training in the field, he persevered through trial and error to become one of America's preeminent makers of handcrafted furniture.

Maloof was the first woodworker elected as a fellow of the American Craft Council and the first recipient of a Louis Comfort Tiffany Foundation grant. He was awarded a MacArthur Foundation fellowship in 1985. One of his rocking chairs—regarded by many craft artists as the most difficult type of furniture to make—was the first piece of contemporary furniture selected for the White House Collection in 1982.

Richard Marquis born 1945

Born in Bumblebee, Arizona, Richard Marquis earned a B.A. degree in 1969 and an M.A. in 1971 at the University of California at Berkeley, where he studied glass and ceramics. On a 1969 Fulbright fellowship to study at the Venini factory in Venice, Italy, Marquis was introduced to the ancient *millefiori* and *murrini* glass techniques, in which thin rods (*millefiori*) or thin chips (*murrini*) of multicolored glass are fused together as one rod, which is then embedded in blown glass and twisted to produce linear, spiral, and geometric patterns. Marquis is credited with being the first twentieth-century American glass artist to use these techniques. His work is primarily inspired by California funk—an art movement of the late 1960s that rejected traditional art theories.

Marquis has taught at the University of California, Los Angeles, Penland School of Crafts in North Carolina, Pilchuck Glass School in Stanwood, Washington, and Haystack Mountain School of Crafts in Deer Isle, Maine.

Richard Mawdsley born 1945

Born in Winfield, Kansas, Richard Mawdsley earned a B.S. degree in education in 1967 at Kansas State Teachers College and

an M.F.A. in 1969 at the University of Kansas. He has taught metalsmithing at the University of Kansas, the Wichita Art Association, Illinois State University, and since 1978 at Southern Illinois University in Carbondale. A member of the Society of North American Goldsmiths, Mawdsley has served as its president and as a member of the board of directors.

Mawdsley is fascinated by the precious metals crafted in Europe centuries ago. He preserves this tradition by making intricately designed and meticulously crafted objects and jewelry using precious metals and stones. Mawdsley's works are also inspired by his childhood interest in machinery. While spending summers on his grandfather's farm in Kansas, Mawdsley came across many old pieces of equipment, including a 1926 combine that has influenced the design and shape of many of his objects.

Harrison McIntosh born 1914

Born in Vallejo, California, Harrison McIntosh attended the Art Center School in Los Angeles in 1938 and studied with ceramist Glen Lukens at the University of Southern California in 1940, Albert King in Los Angeles in 1947, Richard Petterson at the Claremont Graduate School in California from 1948 to 1952, Bernard Leach at a Mills College seminar in 1950, and Marguerite Wildenhain at Pond Farm in Guerneville, California, during the summer of 1953. McIntosh taught at Otis Art Institute in Los Angeles with Peter Voulkos during the summer of 1959. Strong early influences on McIntosh's work were Bauhaus design, Swedish ceramics of the 1950s, and nature.

One of the most respected functional potters working in the United States today, McIntosh is recognized for his simple classical thrown forms in stoneware. He embellishes his pieces with geometric designs painted in bold or muted colors. Understated glazes reinforce the timeless substance of his art.

Judy Kensley McKie born 1944

Born in Boston, Judy Kensley McKie earned a B.F.A. degree in painting in 1966 at the Rhode Island School of Design in Providence. A self-taught furniture maker, she approached this work out of necessity in order to furnish her home. She continued to excel in the craft, learning through trial and error, and worked in a furniture-making cooperative until she resolved to create one-of-a-kind pieces.

McKie derives inspiration from ancient Greek and Egyptian art, Pre-Columbian, African, Indian, and Eskimo cultures, and folk art. She was the recipient of a Massachusetts Artists' Foundation fellowship in 1980, a Certificate of Design Excellence award in 1986, and a Louis Comfort Tiffany Foundation award in 1989.

John McQueen born 1943

Born in Oakland, Illinois, John McQueen earned a B.A. degree at the University of South Florida in Tampa in 1971 and an M.F.A. degree at the Tyler School of Art at Temple University in 1975. He was the recipient of fellowships from the National Endowment for the Arts in 1977, 1979, and 1986.

McQueen's baskets are created from the materials he finds near his rural New York State farm, including twigs, bark, flowers, weeds, and vines—anything that comes from the earth. Although his baskets are in the shape of vessels, they do not function as containers. Increasingly they relate to trees. Commenting on the source of inspiration for his work, McQueen has stated: "I am a basketmaker but before baskets I made sculpture. The transition came during a time I was working with sod (lawn grass). I worked this living material into works of art by planting it in cages of metal and forcing it to grow down toward a grow light instead of up toward the sun. From these pieces I moved to ideas surrounding the way man uses trees as metaphors for himself in nature."

Bruce Metcalf born 1949

Born in Amherst, Massachusetts, Bruce Metcalf earned a B.F.A. degree in 1972 at Syracuse University and an M.F.A. at the Tyler School of Art of Temple University in 1977. Metcalf taught at Kent State University in Ohio from 1981 to 1991. He has been a contributing editor of *Metalsmith* magazine for nearly two decades and teaches at the University of the Arts in Philadelphia.

Metcalf uses various materials, including wood, metal, and Plexiglas, and diverse techniques for his jewelry, small sculptures, and wall reliefs. Employing disparate images drawn from personal experience, he contrasts familiar, mundane objects with the unfamiliar in an effort to create whimsical yet restrained works of art that comment on the human condition.

John Paul Miller born 1918

Born in Huntington, Pennsylvania, John Paul Miller earned a diploma in 1940 at the Cleveland Institute of Art and then taught three-dimensional design there for forty-three years.

Miller has made a significant contribution to American metalwork by reviving the ancient technique of granulation, which involves attaching tiny gold granules to a gold surface without solder. When the granules and the surface are heated, their molecules are exchanged and affixed to each other.

Skilled in granulation as well as in forging and cloisonné enameling, Miller is adept at combining all three techniques to create exquisite jewelry.

Edward Moulthrop born 1916

Born in Cleveland, Edward Moulthrop earned a B.A. degree in architecture in 1939 at Case Institute of Technology and an M.F.A. at Princeton University in 1941.

Trained as an architect, Moulthrop is a self-taught woodturner and a major figure in the contemporary woodturning movement in America. He creates enormous architectonic vessels made of woods indigenous to the southeastern region of the country, where he lives and works. He particularly favors rotted wood, which, when turned, reveals striations on the vessel's surface. To produce his vessels, Moulthrop uses mammoth cutting tools of his own design, a large-scale lathe he also made, and polyethylene glycol.

Moulthrop has received many awards, including two medals from the American Institute of Architects in 1978 and 1980 and the Georgia Governor's Award in the Arts in 1981.

Gertrud Natzler 1908–1971 **Otto Natzler** born 1908
Born in Vienna, Austria, Gertrud Natzler graduated from the Vienna Handelsakademie in 1926 and later took classes in drawing, painting, and ceramics. Also born in Vienna, Otto Natzler graduated from the Bundeslehranstalt für Textile-Industrie in 1927 and worked as a textile designer. Both of them studied ceramics with Franz Iskra in Vienna in 1934 before organizing their own workshop in 1935. Married in 1938, the Natzlers fled Nazi-occupied Austria and immigrated to the United States, where they settled in Los Angeles.

During their thirty-six years of collaboration, Gertrud threw the clay and formed it into simple pristine vessels, while her husband glazed and fired the vessels. Their objects are distinguished by the varied glazes on the surface, each glaze tested carefully by Otto and applied with consideration of the clay form with which it is paired.

Albert Paley born 1944
Born in Philadelphia, Albert Paley earned B.F.A. and M.F.A. degrees at Tyler School of Art, Temple University, in 1966 and 1969 respectively. In 1969 he joined the faculty of the School for American Craftsmen at Rochester Institute of Technology, and the following year established gold- and metalsmithing studios in his Rochester home. He has also taught at the State University of New York at Brockport.

Seeking to transform the jeweler's art, Paley reinvented every aspect of the traditional pendant, necklace, or brooch in order to highlight the relationship of the piece to the body. The most advanced of these "wearable sculptures" recapitulate and reinforce bodily structure and movement.

Paley was a highly successful jewelry artist in 1974 when he won the Renwick Gallery's national design competition and was awarded the commission to design decorative metalwork doors for the gallery shop. His *Portal Gates* opened the door to a new career for Paley, leading to numerous commissions and world renown for his monumental architectural ironwork and sculpture. Paley's ironwork pays homage to European art nouveau and American abstract expressionism.

Earl Pardon 1926–1991
Born in Memphis, Tennessee, Earl Pardon earned a B.F.A. degree in painting at the Memphis Academy of Arts in 1951, and that year he joined the faculty of Skidmore College, Saratoga Springs, New York. In 1959 he was awarded an M.F.A. degree in painting from Syracuse University. He taught at Skidmore from 1951 until 1989, except for the period from 1954 to 1955 when he served as director of design for Towle Silversmiths.

One of the pioneers of the post-World War II studio craft movement, in the early 1950s Pardon was instrumental in developing wide interest in art jewelry. Trained as a fine artist rather than in traditional jewelry making, he maintained an interest in painting and sculpture that influenced his work with metals, and vice versa. For much of his four-decade-long career, Pardon worked simultaneously as a painter, sculptor, and jewelry maker. Enameling provided a logical means of integrating his interests in painting and studio jewelry. His intricate arrangements of flat, colorful segments in brooches and neckpieces reveal his abiding interest in formal concerns.

Thomas Patti born 1943
Born in Pittsfield, Massachusetts, Tom Patti earned B.S. and M.S. degrees in industrial design in 1967 and 1969 respectively at Pratt Institute School of Art and Design in Brooklyn, New York. In 1969 he studied perception theory with Rudolph Arnheim at the New School for Social Research in New York and the following year studied glass at Penland School of Crafts in North Carolina.

Since childhood, Patti has been blind in one eye, which has contributed to his interest in perception. His fascination with art and science is expressed in glass by creating spatial voids and depth to manipulate scale and perception. Patti works glass in an inventive and distinctive manner to create exquisitely precise vessel-oriented forms. Despite their small size, Patti's sculptures have a commanding presence.

Ronald Hayes Pearson 1924–1996
Born in New York City, Ronald Hayes Pearson attended the University of Wisconsin from 1942 to 1943 and, after service in the U.S. Merchant Marine, continued his studies at the School for American Craftsmen at Alfred University from 1947 to 1948. In 1949 he enrolled in the Reed & Barton Silver Company's special design program. A founding member of the Society of North American Goldsmiths, Pearson taught jewelry making at leading craft schools and designed flatware for major silver companies.

Pearson's long and distinguished career as a jeweler and metalsmith was honored in 1976 when he was elected a fellow of the American Craft Council and in 1987 when he was awarded an honorary doctorate from the Portland School of Art in Maine for his contributions to American jewelry design.

Yvonne Porcella born 1936
Born in Watsonville, California, Yvonne Porcella earned a B.S. degree in nursing from the University of San Francisco in 1958 and subsequently became a self-taught fiber artist, author, and teacher. Porcella developed an interest in textiles in 1962 when she wanted to know how to make fabric for her own clothing. In studying the process of weaving and fabric production, she examined handwoven material to learn about color, construction, and pattern. Porcella began collecting ethnic textiles from many different parts of the world, particularly Japan, Afghanistan, and Russia, which have provided the inspiration for her wearable art, quilts, and other fiber works.

James Prestini 1908–1993
Born in Waterford, Connecticut, James Prestini had a varied career as a mathematician, engineer, sculptor, professor of design, and woodturner. His artwork was influenced by his father, an Italian stonecutter, and by the Bauhaus aesthetic of László Moholy-Nagy and Mies van der Rohe. From 1922 to 1924, Prestini attended a trade school in Westerly, Rhode Island, as an

apprentice machinist. He earned a B.S. degree in mechanical engineering at Yale University in 1930 and attended Yale's School of Education in 1932. He also studied at the University of Stockholm in 1938 and the Illinois Institute of Technology in 1939.

Prior to becoming a professor of design at the University of California at Berkeley from 1956 to 1975, Prestini turned thin-walled bowls and plates in rich hardwoods from 1933 to 1953. This work would lead to his being referred to as the father of the contemporary woodturning movement in the United States. With emphasis on form and finish, Prestini created elegantly simple designs that embody restraint—the very essence of timeless design.

John Prip born 1922

Born in New York City, John Prip is a fourth-generation metalsmith. Prip's family moved to Denmark, where he lived for fifteen years and absorbed the age-old craft skills and guild traditions of Scandinavian silversmithing. He served an apprenticeship with master silversmith Evald Nielsen and subsequently graduated from the Copenhagen Technical College in 1942. In 1948 Prip returned to America, where he was invited to set up the metalsmithing department of the School for American Craftsmen at Alfred University in New York, which was subsequently absorbed into the Rochester Institute of Technology in 1950.

After teaching at the school for six years, Prip worked for three years as an industrial designer for Reed & Barton Silver Company. He then returned to teaching, first at the School of the Museum of Fine Arts, Boston, and then at the Rhode Island School of Design for eighteen years, retiring in 1981.

Ed Rossbach born 1914

Born in Chicago, Ed Rossbach earned a B.A. degree in 1940 at the University of Washington, an M.A. in 1941 at Columbia University, and an M.F.A. in 1947 at Cranbrook Academy of Art. Rossbach has taught textile design at the University of California at Berkeley and has a special interest in textiles created off the loom. This interest led him to experiment with basketry, using unconventional materials such as plastics.

In recognition of Rossbach's distinguished work, he was elected a fellow of the American Craft Council in 1975 and named a "Living Treasure of California" by the Creative Arts League in Sacramento.

Adrian Saxe born 1943

Born in Glendale, California, Adrian Saxe studied at the Chouinard Art Institute in Los Angeles from 1965 to 1969 and earned a B.F.A. degree at California Institute of the Arts, Valencia, in 1974. Saxe's vessels are nonfunctional. Often adorned with small sculptural appendages, they have classical shapes and traditional glazes.

Saxe is a professor of design at the University of California at Los Angeles, where he has taught for almost twenty-five years. Saxe has received many honors and fellowships, including a six-

month residency at the experimental atelier of the Manufacture National de Sèvres in France.

Cynthia Schira born 1934

Born in Providence, Cynthia Schira earned a B.F.A. degree at the Rhode Island School of Design and an M.F.A. degree at the University of Kansas, where she has been on the faculty since 1976. Schira's textiles have been inspired by the landscape of the Kansas plains, as well as her training and experience in textile centers in France, China, India, and Japan, and her study of ancient Peruvian textiles.

Kay Sekimachi born 1926

Born in San Francisco, Kay Sekimachi studied at the California College of Arts and Crafts in Oakland from 1946 to 1949. In 1949 she took up weaving on the loom and became so adept at the labor-intensive process that she is often referred to as a "weaver's weaver." Today, almost fifty years after she began to work in fiber, Sekimachi is recognized as a pioneer in resurrecting it as a medium of artistic expression.

Sekimachi uses the loom to construct three-dimensional sculptural forms. In the early 1970s she used nylon monofilament to create hanging quadruple tubular woven forms to explore ideas of space, transparency, and movement. Inspired by her ancestral homeland of Japan, Sekimachi repeatedly returns to that ancient culture for ideas.

Sekimachi eschews color in order to reinforce the sculptural qualities of her forms and emphasize the natural properties of her chosen materials. Enamored with antique Japanese paper, she has created a series of standing geometric postlike forms that suggest ancient totemic figures.

Robert Sperry born 1927

Born in Bushnell, Illinois, Robert Sperry earned a B.A. degree at the University of Saskatchewan, a B.F.A. in 1953 at the School of the Art Institute of Chicago, and an M.F.A. in 1955 at the University of Washington. Early in his ceramic career Sperry found inspiration at the Archie Bray Foundation in Montana, where he worked with Peter Voulkos and Rudy Autio. An influential ceramist, Sperry was on the faculty of the University of Washington from 1955 until his retirement in 1982, serving as head of the ceramics department for twenty-two years.

Therman Statom born 1953

Born in Winterhaven, Florida, Therman Statom studied at the Pilchuck Glass School in Stanwood, Washington, and earned a B.F.A. degree in sculpture in 1974 at the Rhode Island School of Design and an M.F.A. in sculpture in 1980 at Pratt Institute School of Art and Design in Brooklyn, New York.

The recipient of National Endowment for the Arts fellowships in 1980, 1982, and 1988 and a Ford Foundation grant in 1977, Statom was commissioned in 1993 to create works for the Los Angeles Central Public Library and Los Angeles County Metro Rail.

Susan Stinsmuehlen-Amend born 1948

Born in Baltimore, Susan Stinsmuehlen-Amend was educated at Hood College, Indiana University at Bloomington, and the University of Texas at Austin. While living in Austin, she studied with glass artists Narcissus Quagliata and Paul Marioni. The owner of the Renaissance Glass Company in Austin from 1973 to 1987, Stinsmuehlen-Amend also was a designer for the firm. She is currently an independent artist in Ojai, California.

A former member and president of the board of directors of the Glass Art Society, Stinsmuehlen-Amend has served as a guest artist and lecturer at many schools, including Penland School of Crafts, Rhode Island School of Design, and Pilchuck Glass School. She completed notable commissions in New York City at the Jewish Museum and the AT&T Foundation headquarters in 1992–93.

Peter Voulkos born 1924

Peter Voulkos was born in Bozeman, Montana. After serving in the U.S. Army Air Force from 1943 to 1946, he entered Montana State College, earning a B.S. degree in 1951 and, the following year, an M.F.A. degree at California College of Arts and Crafts in Oakland. Returning to Montana in 1952, he established a pottery workshop in Helena. In 1953 while teaching a three-week summer course at Black Mountain College in North Carolina, Voulkos met innovative figures in the arts such as Josef Albers, Robert Rauschenberg, and John Cage, which significantly influenced the direction of his work.

In 1954 Voulkos became chairman of the new ceramics department at Otis Art Institute in Los Angeles. His pottery shop soon became the mecca for artists in the area, launching the Los Angeles clay movement, with Voulkos as its leader. Despite the accolades for his work, Voulkos began to feel constrained by the traditional forms of pottery. His Black Mountain connections led to his meeting Franz Kline and other abstract expressionist artists in New York. Absorbing their ideas, he sought to use clay as an expressive, sculptural medium and began to execute many works on a monumental scale.

In 1959 Voulkos became professor of design and sculpture at the University of California at Berkeley.

Beatrice Wood born 1893

Born in San Francisco, Beatrice Wood was raised in New York City. At the age of nineteen she abandoned her privileged background and went to Paris, where she studied acting at the Comédie Française and drawing at the Académie Julian. Returning to New York, she acted with a French repertory company from 1914 to 1916. During these years she made friends with members of the Dada group of artists, including Marcel Duchamp.

In 1928 Wood moved to California. Her first exposure to ceramics was an adult-education course at Hollywood High School, which she had taken to learn how to make a teapot to match some luster-glaze plates she had bought in Holland. A deepening interest in ceramics led her to study with renowned potters Otto and Gertrud Natzler.

In 1948 Wood moved to Ojai, California, where she has continued to live ever since, and began to produce the iridescent luster surfaces that have made her famous. Before Wood, luster had generally been a surface decoration on a previously glazed form, but she used in-glaze luster produced during a single glaze firing. Although Wood did not invent this technique, she imparted to it and the ceramic medium a new expressiveness and theatricality.

Betty Woodman born 1930

Born in Norwalk, Connecticut, Betty Woodman attended the School for American Craftsmen at Alfred University in New York from 1948 to 1950. She has taught in the Fine Arts Department of the University of Colorado.

A leading ceramist whose inventive forms and painterly use of color have won her international renown, Woodman began her career making simple functional pottery. Although her ambitious experiments with clay have wrought great changes in her work, it still refers to some practical function even if her baroque, expressive forms are no longer strictly utilitarian. Woodman's art has been inspired by diverse sources, ranging from Etruscan and Minoan to Tang and majolica ceramics.

The recipient of fellowships from the National Endowment for the Arts in 1980 and 1986, Woodman has also been a guest artist at the experimental atelier of the Manufacture National de Sèvres in France.

Claire Zeisler 1903–1991

Born in Cincinnati, in the mid-1940s Claire Zeisler attended the Institute of Design in Chicago (now part of the Illinois Institute of Technology), where she studied sculpture with émigré artist Alexander Archipenko. She subsequently studied with Bea Swartchild, a Chicago weaver who stimulated Zeisler's interest in fiber art.

In the early 1960s Zeisler began to turn away from the loom in favor of knotting and wrapping the fibers. Her three-dimensional, freestanding works helped to create a fiber revolution by liberating the medium from its dependence on the weaving process.

picture copyrights

Abrasha, *Hanukkah Menorah*, ©1995 Abrasha; Evelyn Ackerman, *Stories from the Bible*, ©1984 Evelyn Ackerman; Renie Breskin Adams, *Fear, Laughter, and the Unknown*, ©1978 Renie Breskin Adams; Rudy Autio, *Listening to the East Wind*, ©1987 Rudy Autio; Garry Knox Bennett, *Boston Kneehole Desk*, ©1988 Garry Knox Bennett; Wendell Castle, *Ghost Clock*, ©1985 Wendell Castle; Lia Cook, *Crazy Too Quilt*, ©1989 Lia Cook; Fritz Dreisbach, *Ruby Wet Foot Mongo*, ©1990 Fritz Dreisbach; John Dunnigan, *Slipper Chairs*, ©1990 John Dunnigan; Arline Fisch, *Spirit Box Brooch*, ©1989 Arline M. Fisch; Larry Fuente, *Game Fish*, ©1988 Larry Fuente; William Harper, *Self-Portrait of the Artist as a Haruspek*, ©1990 William Harper; Wayne Higby, *Temple's Gate Pass*, ©1988 Wayne Higby; Michael Hurwitz, *Rocking Chaise*, ©1989 Michael Hurwitz; Michael James, *Rehoboth Meander: Quilt #150*, ©1993 Michael F. James; Mariska Karasz, *Skeins*, ©1952 F. Schumacher and Co.; Harvey Littleton, *Four Seasons*, ©1977 Harvey K. Littleton; Tom Loeser, *Four by Four*, ©1994 Tom Loeser; Sam Maloof, *Michael W. Monroe Low-back Side Chair*, ©1995 Sam Maloof; Judy Kensley McKie, *Monkey Settee*, ©1995 Judy Kensley McKie; John McQueen, *Untitled #192*, ©1989 John McQueen; Philip Moulthrop, *Figured Tulip Poplar Bowl*, ©1987 Philip C. Moulthrop; Jere Osgood, *Cylinder-Front Desk*, ©1989 Jere Osgood; Albert Paley, *Pendant*, ©1973 Albert Paley; Janet Prip, *Head Vases*, ©1988 Janet Prip; D. X. Ross, *Brooch*, ©1990 D. X. Ross; Norm Sartorius, *Spoon from a Forgotten Ceremony*, ©1994 Norm Sartorius; Adrian Saxe, *Untitled Covered Jar*, ©1980 Adrian Saxe; Richard Shaw, *Carrie*, ©1992 Richard Shaw; Patti Warashina, *Convertible Car Kiln*, ©1971 M. Patricia Warashina; Beatrice Wood, *Tides in a Man's Life*, ©1988 Beatrice Wood

photograph credits

All color photography by Bruce Miller. Frontispiece by Gray Crawford. Mildred Baldwin: pages 15, 174; Bill Fitz-Patrick, p. 25; Margaret Harman: pages 15 (top), 20, 24; Gene Young: pages 12, 26, 27